CM

WITHDRAWN

CHiHULY
THROUGH THE LOOKING GLASS

CHIHULY

THROUGH THE LOOKING GLASS

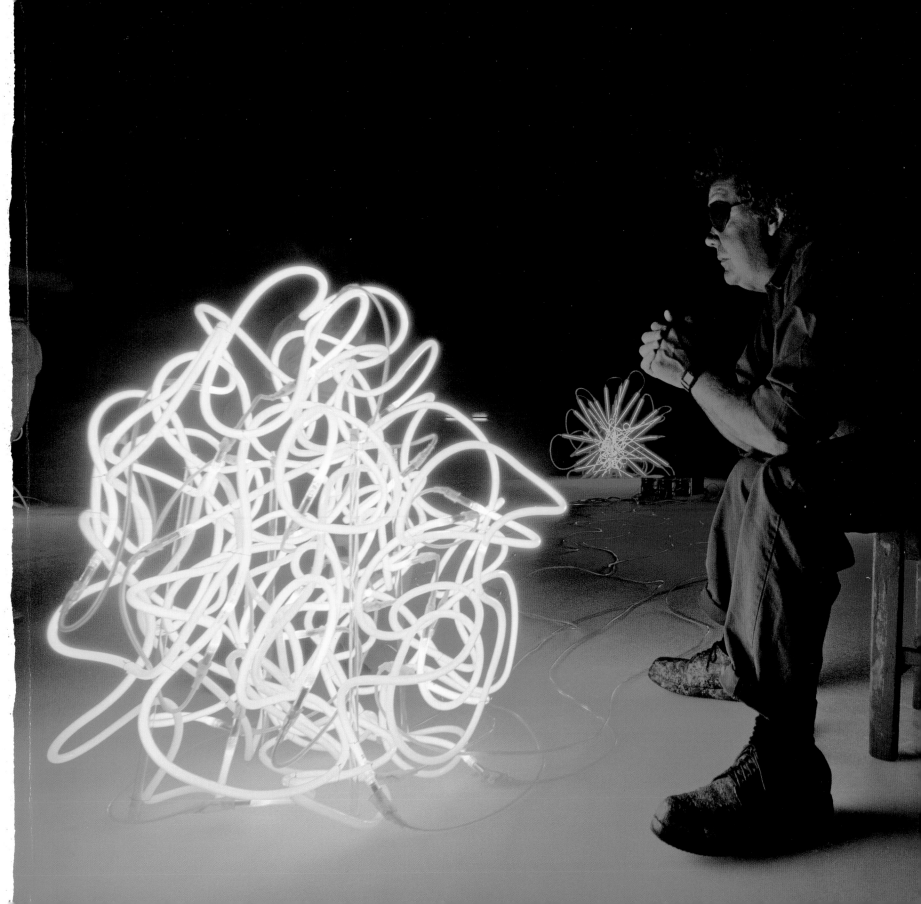

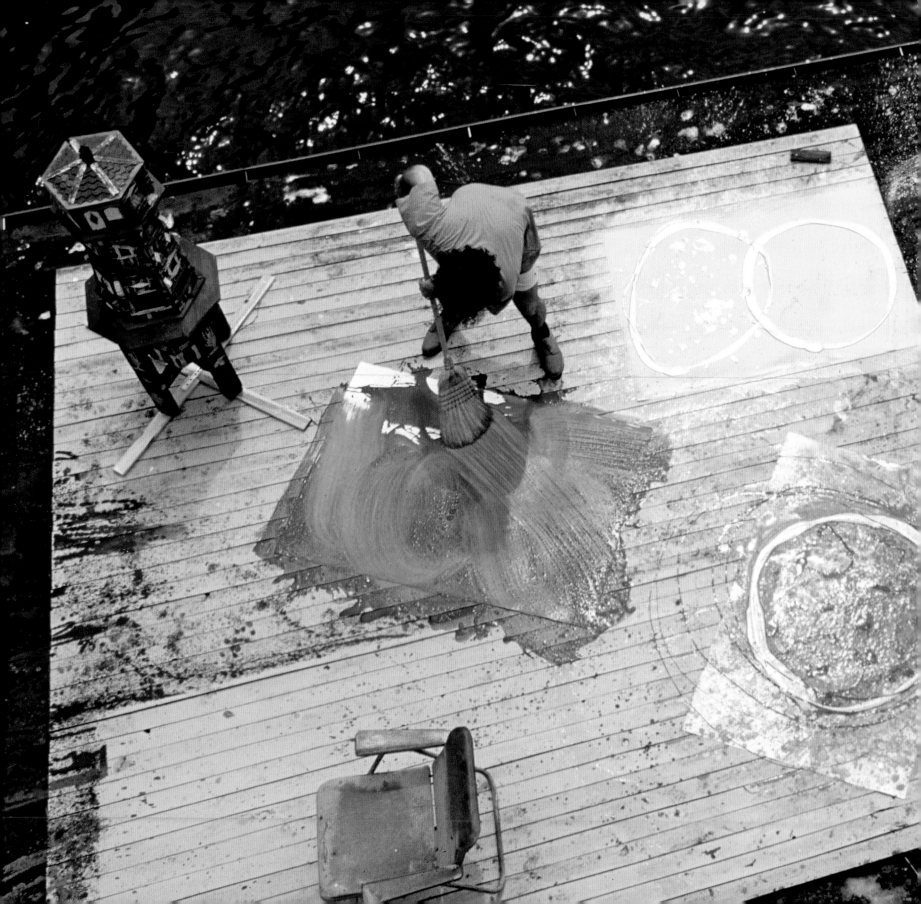

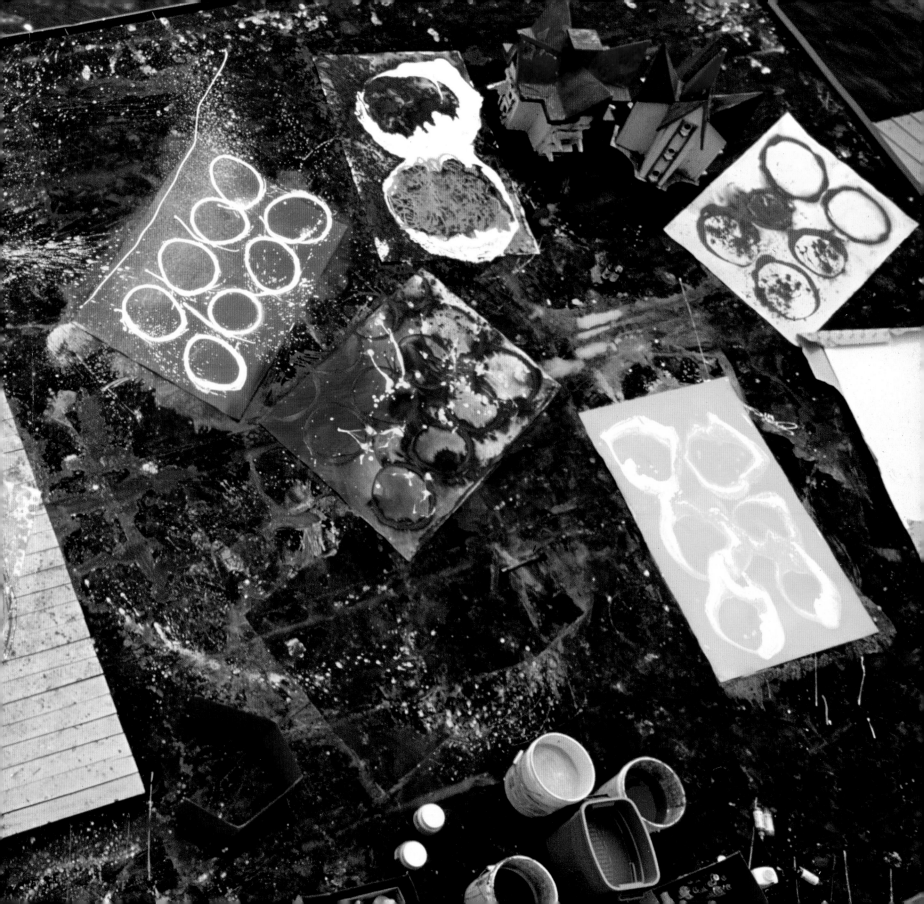

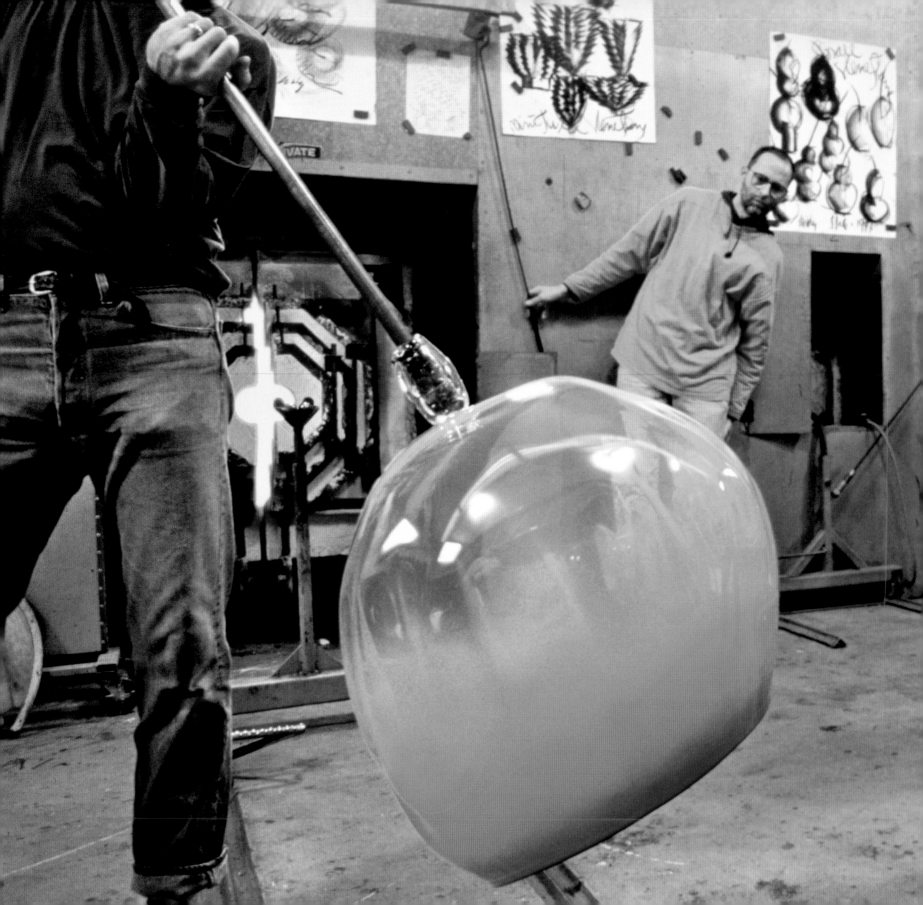

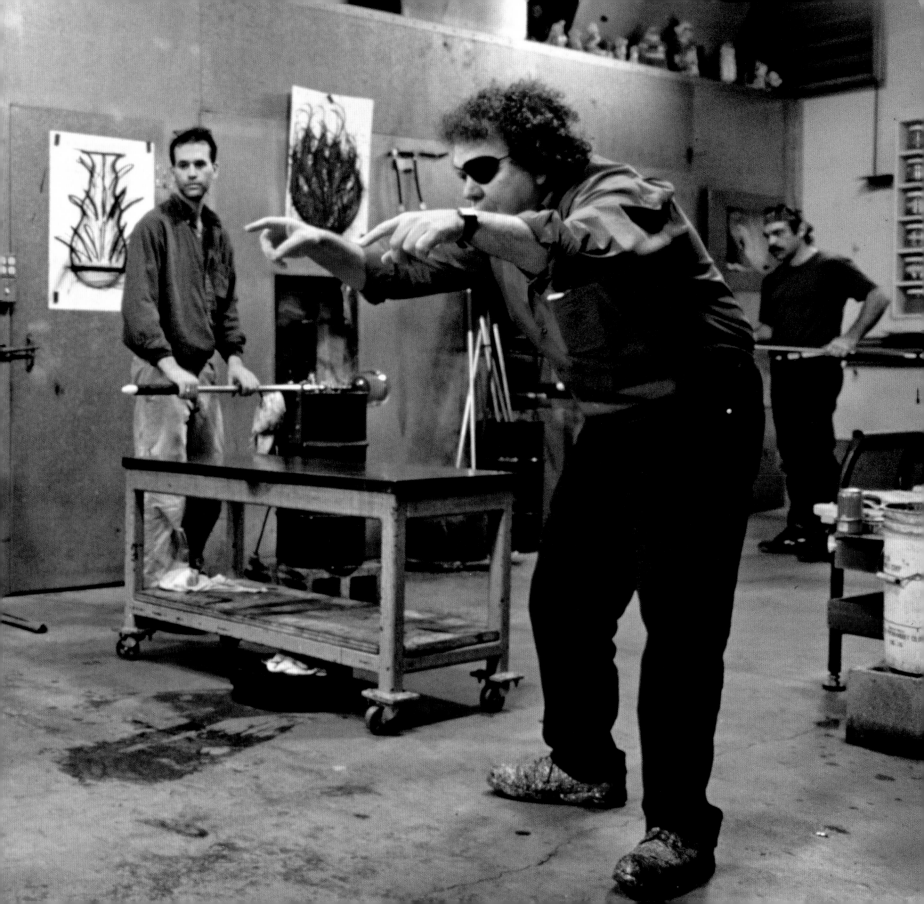

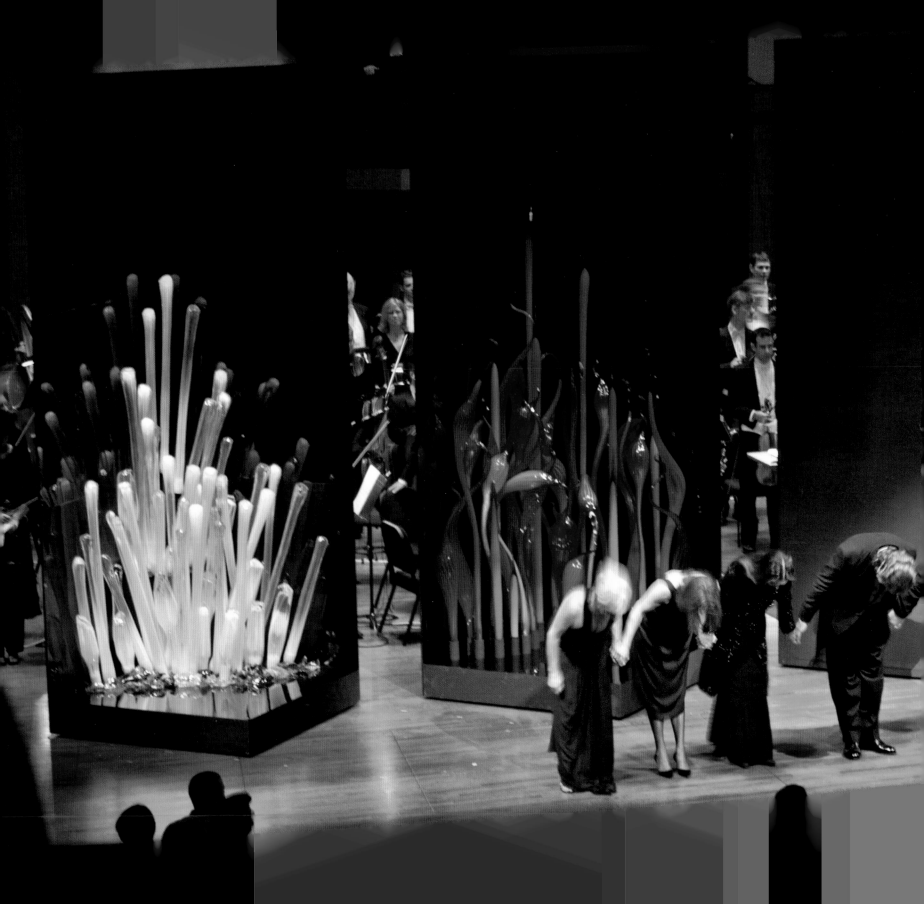

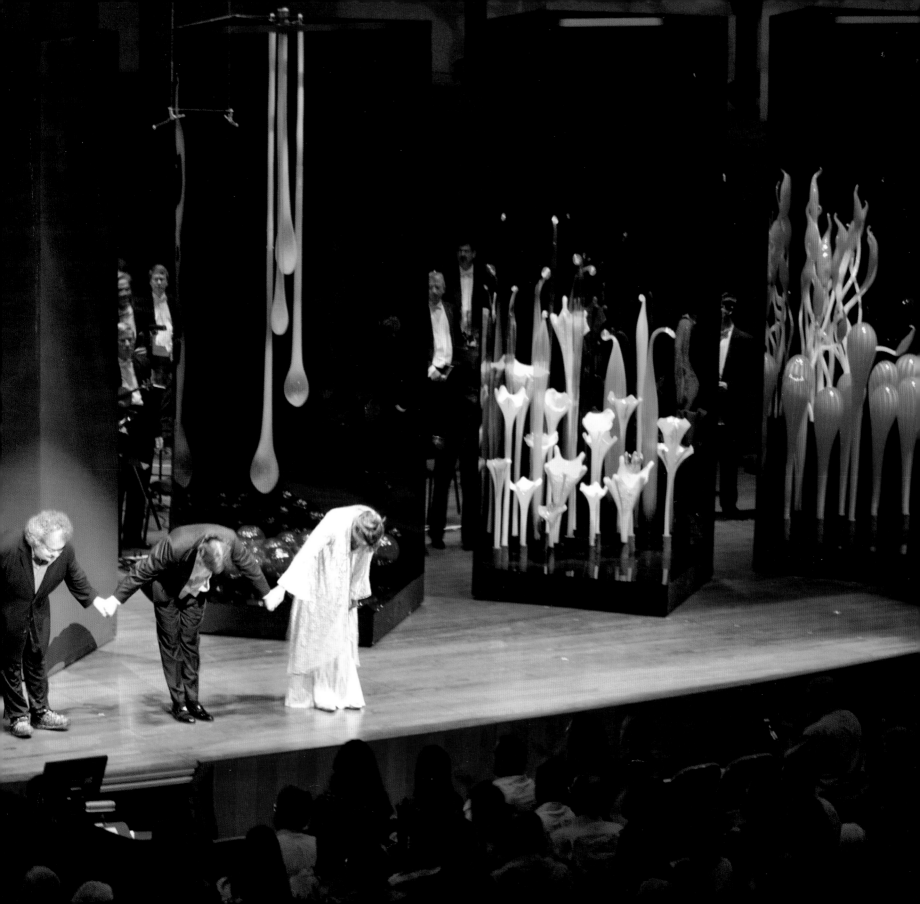

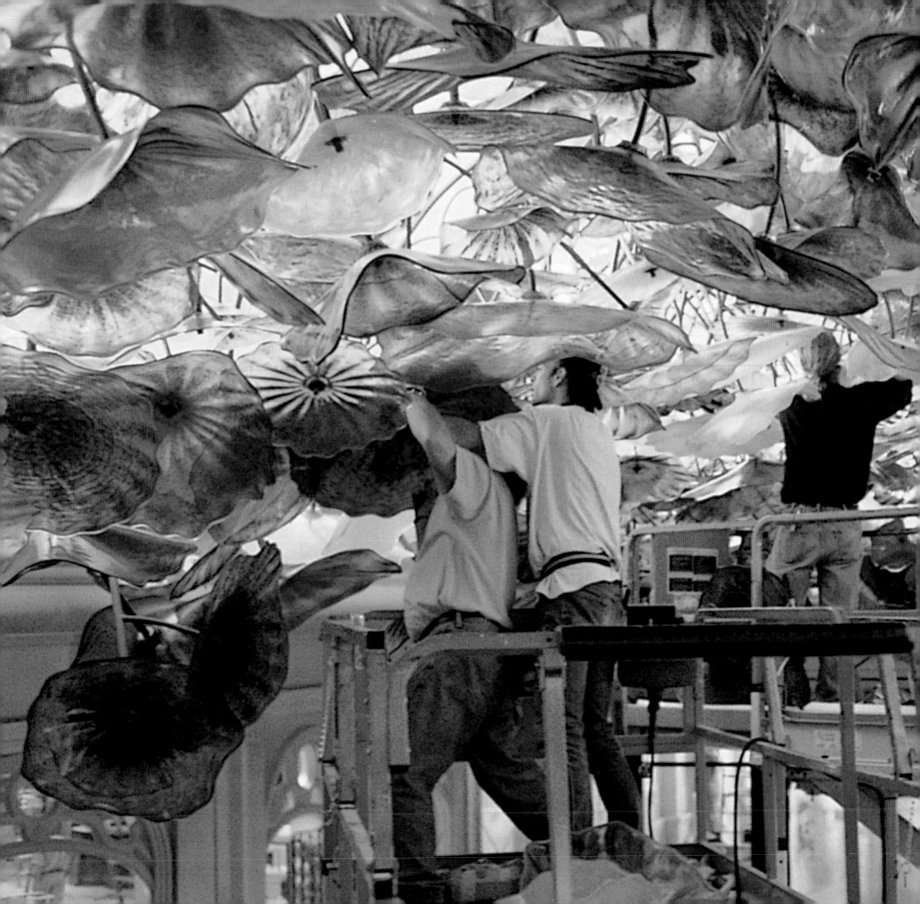

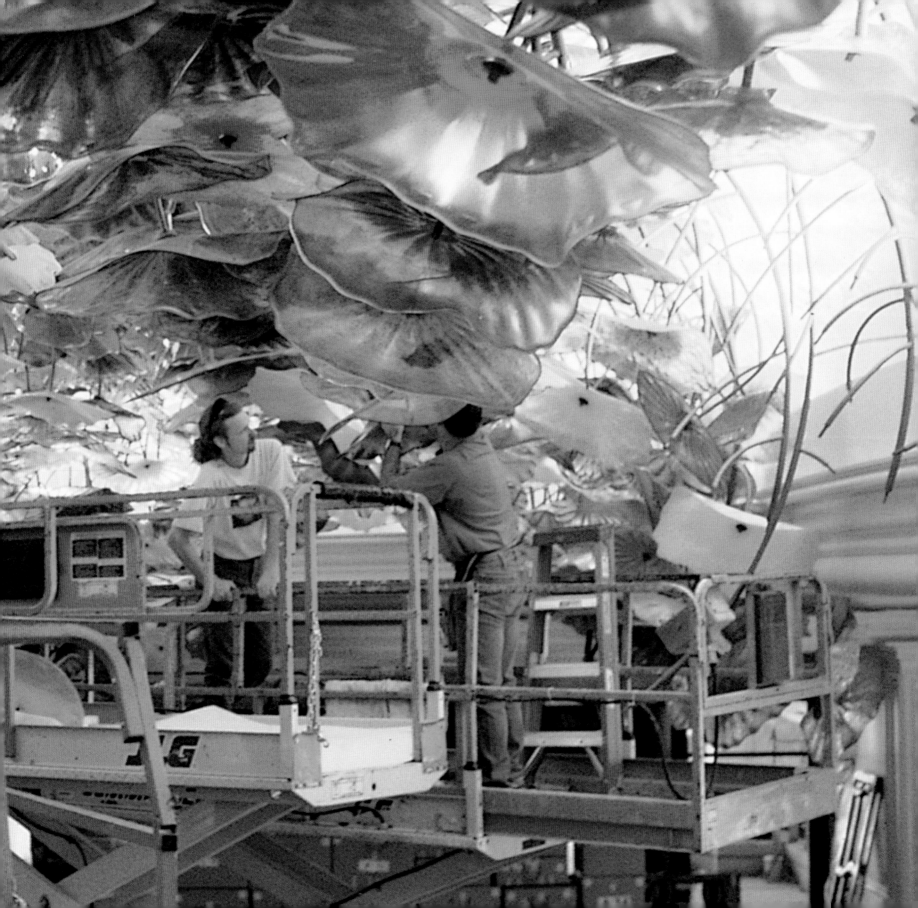

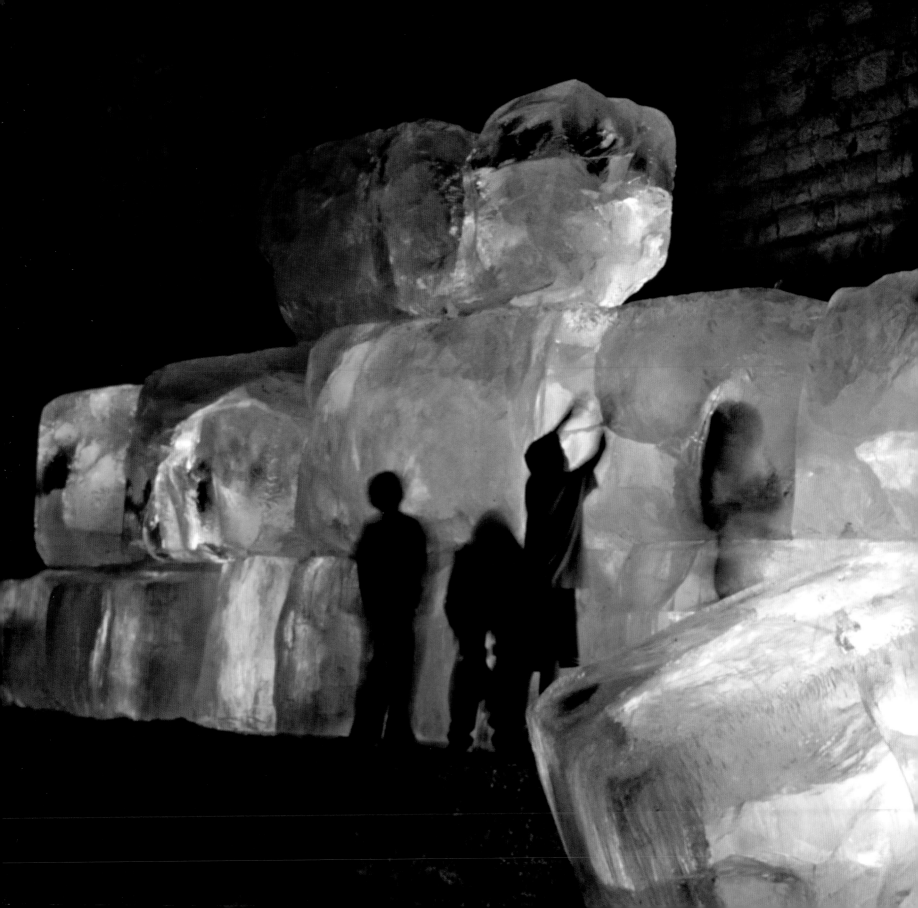

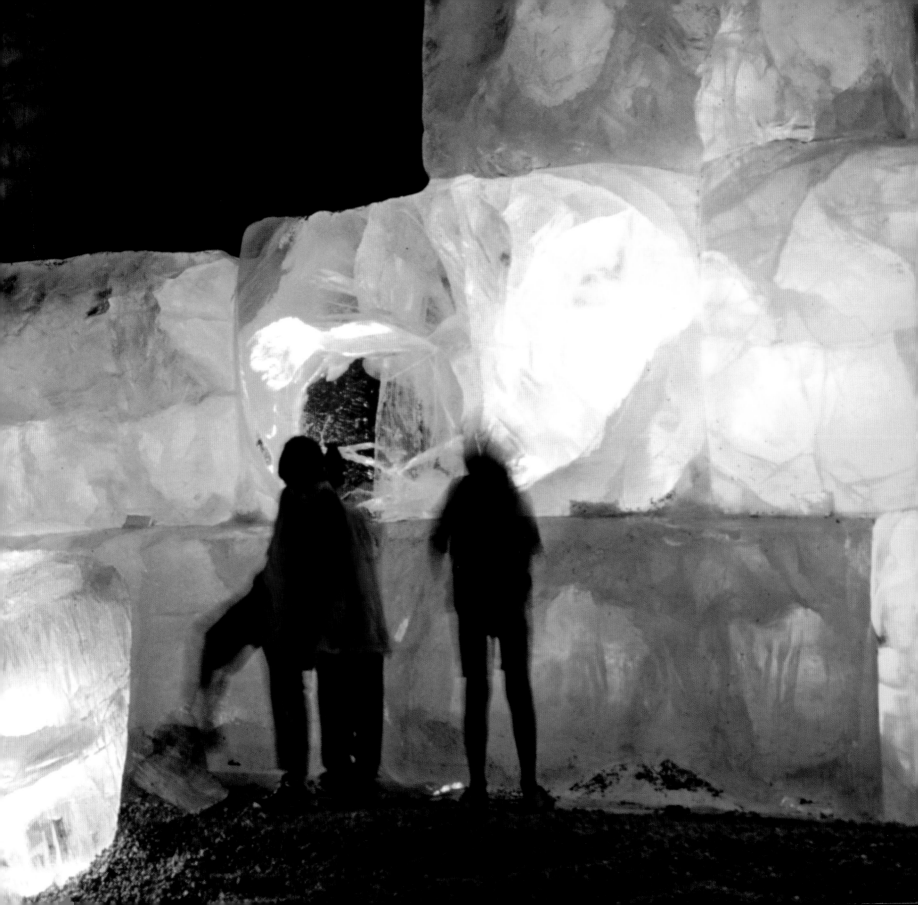

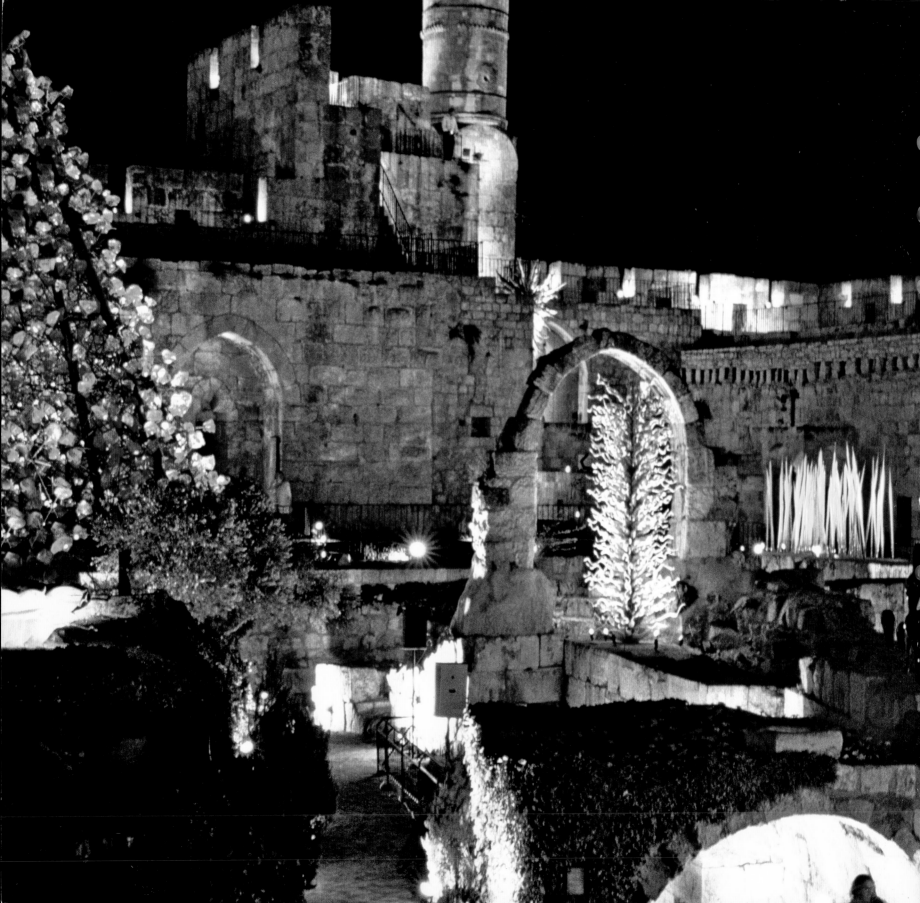

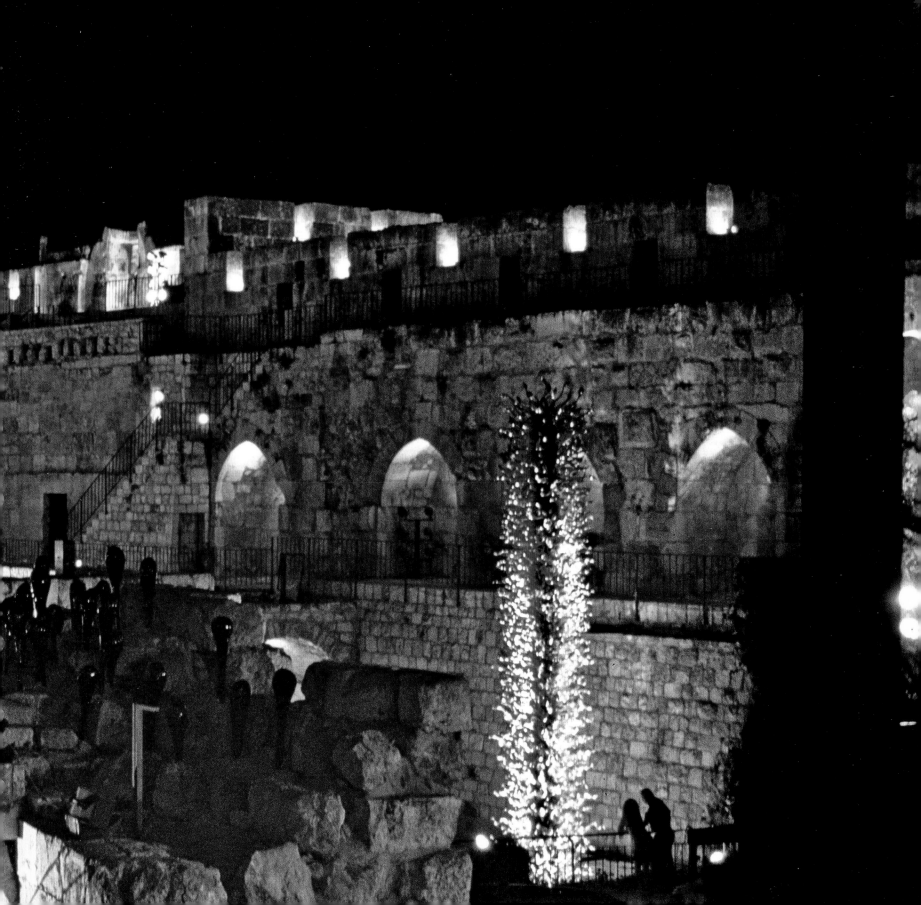

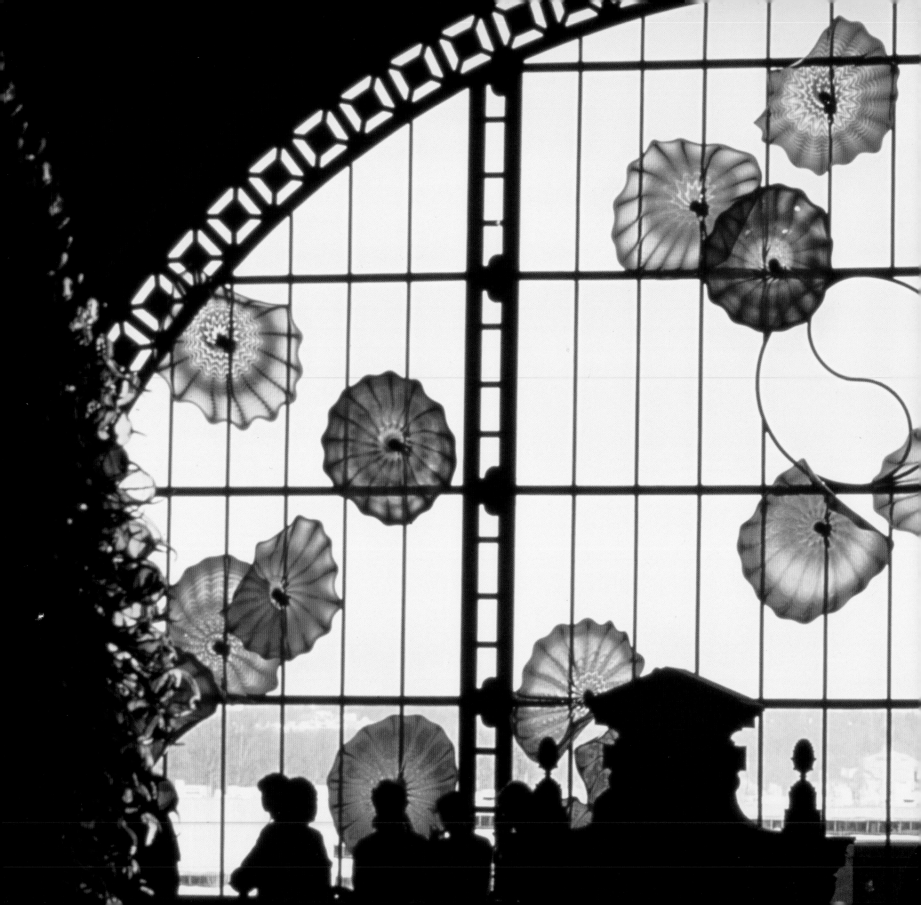

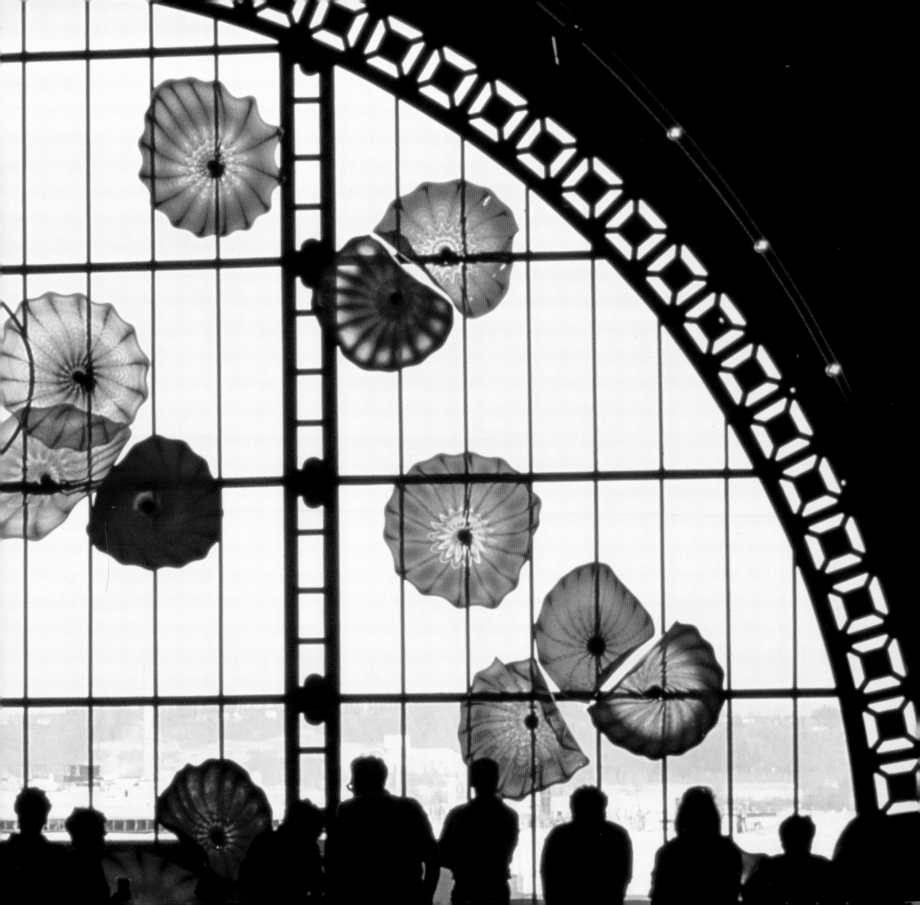

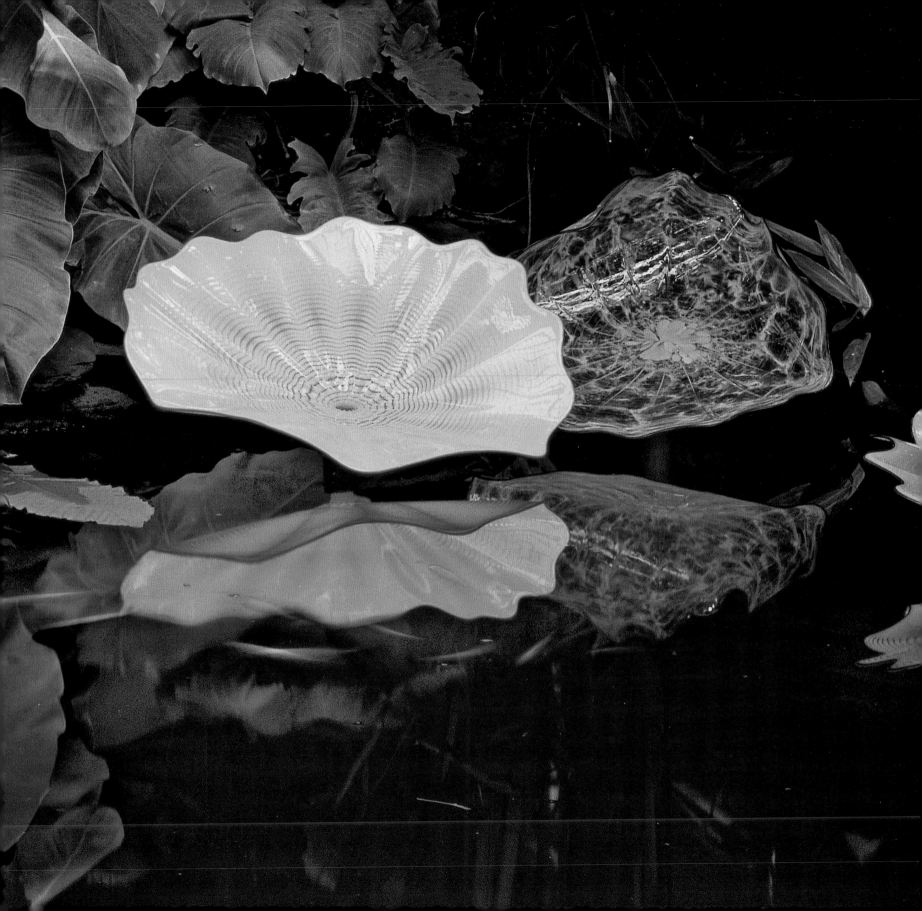

CHIHULY

THROUGH THE LOOKING GLASS

Gerald W. R. Ward

MFA PUBLICATIONS
Museum of Fine Arts, Boston

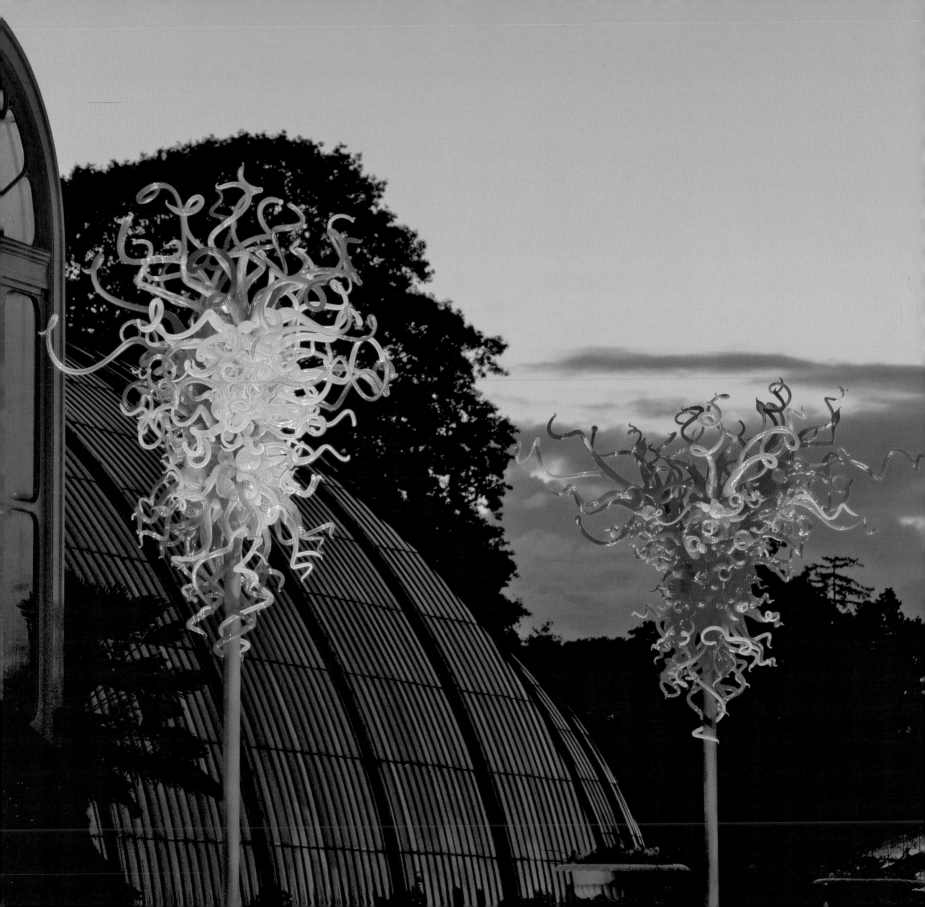

CONTENTS

DIRECTOR'S FOREWORD

JUST A FEW YEARS AGO, on the Fourth of July, I had the pleasure of watching the fireworks over Lake Union in Seattle from the perspective of Dale Chihuly's Boathouse. Although the annual celebration was spectacular, the true fireworks were taking place inside the Chihuly hotshop, where Dale and his team of glassblowers have for decades created some of the world's most distinguished and distinctive modern works of art in glass. It is a pleasure to bring that pyrotechnic glass to the Museum of Fine Arts, Boston, for "Chihuly: Through the Looking Glass."

Located in Seattle and Tacoma for many years, Dale also has important connections to Boston and New England. He studied and later taught at the Rhode Island School of Design in Providence for many years. During that time, an exhibition that included Diné (Navajo) blankets at the MFA in the early 1970s served as an initial source of inspiration for his ongoing interest in Native American baskets and photographs of Native Americans by Edward Curtis, and for his collecting of Indian trade blankets. The MFA started collecting Chihuly's glass and drawings in 1983, and he was featured in our popular exhibition "Glass Today by American Studio Artists" in 1997. Our Calderwood Courtyard was also transformed by several dozen *Niijima Floats* in the winter of 1998.

"Chihuly: Through the Looking Glass," however, provides a full and rounded look at the work of this important artist of the twentieth and twenty-first centuries. In this exhibition, one can clearly see and experience his ability to transform spaces with his extraordinary works in glass. Employing his rich vocabulary of *Chandeliers*, *Towers*, *Ikebana*, *Venetians*, *Persians*, *Reeds*, and other forms, Chihuly has fashioned dynamic spaces suffused with light and color that will delight our visitors.

We are profoundly grateful to JoAnn McGrath and the Highland Street Foundation for their generous support of this exhibition. A grant from the Art Alliance for Contemporary Glass, in recognition of Dale Chihuly's seminal role in the studio glass movement that will celebrate its fiftieth anniversary in 2012, has also helped make this book possible. Our thanks also go to Daphne Farago, who recognized the importance of Dale Chihuly at an early date and graciously lent some seminal works from her collection to the Museum to be displayed prior to and during the course of the exhibition.

MALCOLM ROGERS
Ann and Graham Gund Director
Museum of Fine Arts, Boston

SPONSOR'S FOREWORD

THE HIGHLAND STREET FOUNDATION is delighted to support "Chihuly: Through the Looking Glass" at the Museum of Fine Arts, Boston. Dale Chihuly's wondrous creations, on display in the MFA's beautiful new Art of the Americas wing, will give an international public the chance to experience the spectrum of his vibrant career.

This exhibition catalogue celebrates the remarkable career of an iconic glass artist at an important moment in the history of both contemporary glass and the Museum of Fine Arts, Boston. Dale Chihuly has described himself as "more choreographer than dancer, more supervisor than participant, more director than actor." How lucky we are to witness this innovative artist's ability to transcend hands-on creation in Boston, our home, at one of the great art museums of the world.

Beyond his artistry, Dale Chihuly donates his name and his artwork to benefit nonprofit organizations that help the community. The trustees of Highland Street Foundation and Dale Chihuly share the goal of making the arts accessible for children and families, potentially fostering a new generation of creative artists. We are honored to continue our partnership with the Museum of Fine Arts, Boston, and we hope "Chihuly: Through the Looking Glass" inspires a sense of pleasure, pride, and discovery for each and every visitor.

HIGHLAND
STREET
foundation

ACKNOWLEDGMENTS

THIS EXHIBITION AND its accompanying publication are indebted to the vision of Malcolm Rogers, Ann and Graham Gund Director, and of Katie Getchell, Deputy Director, both of whom have provided guidance and support since the project's inception. I would also like to add a personal note of thanks to JoAnn McGrath and the Highland Street Foundation for making this exhibition and publication possible. I am also grateful to Sharon Karmazin, David Denn, Doug Anderson, and the entire Art Alliance for Contemporary Glass, for a grant of funds that have helped make this book a reality.

It is a pleasure to acknowledge the assistance of Dale Chihuly and his talented staff. The unfailingly helpful and genial members of the Chihuly Studio in Seattle and Tacoma were invaluable resources at every step. I am also pleased to acknowledge the work of the photographers, listed elsewhere, whose stunning pictures are the core of this volume.

At the Museum of Fine Arts, I am grateful to Patrick McMahon, Director of Exhibitions and Design, for entrusting me with this assignment and for his enthusiastic leadership. Tsugumi Maki Joiner, Chris Newth, and Gillian Fruh of that department have also been of great assistance. In MFA Publications, this book took its initial shape under the direction of Mark Polizzotti; Emiko Usui capably assumed the editorial reins after Mark's departure, and I am thankful to them both. Jodi Simpson and Terry McAweeney turned the manuscript into a book with their exemplary copyediting and production skills. Cynthia Randall shouldered the daunting task of designing a Chihuly book and has succeeded admirably.

In the Art of the Americas department, I would like to thank Elliot Bostwick Davis, John Moors Cabot Chair, Art of the Americas, and Erica Hirshler, Croll Senior Curator of American Paintings; Erica suggested the title for the exhibition. I am especially grateful to my decorative arts colleagues: Kelly H. L'Ecuyer, Ellyn McColgan Curator of Decorative Arts and Sculpture, Art of the Americas; Dennis Carr, Assistant Curator of Decorative Arts and Sculpture; and Nonie Gadsden, Carolyn and Peter Lynch Curator of American Decorative Arts and Sculpture. Each of them made helpful suggestions and offered their own unique viewpoint, and each took on many departmental tasks while I was called away by this project. Others who helped in myriad ways as the project progressed include Katie DeMarsh, Toni Pullman, Danielle Kachapis, Jamieson Bunn, and Meredith Crawford. Edward Saywell, Chair, Linde Family Wing and Head of the Department of Contemporary Art and MFA Programs; Jen Mergel, Robert L. Beal, Enid L. Beal and Bruce A. Beal Senior Curator of Contemporary Art; and Emily Zilber, Ronald C. and Anita L. Wornick Curator of Contemporary Decorative Arts, generously allowed me to poach on their nominal territory. Thomas Michie, the Russell B. and Andrée Beauchamp Stearns Senior Curator of Decorative and Sculpture, Art of Europe, shared his own perspective on Chihuly. Lois Solomon, Rob Worstell, and others helped with programming for the exhibition, and Hannah Goodwin worked with the Chihuly staff to make the exhibition as accessible as possible. Tomomi Itakura deftly handled the design aspects of the exhibition for the Museum, and it was promoted brilliantly through the efforts of Kim French, Dawn Griffin, Kelly Gifford, and their staff. Jill Kennedy-Kernohan helped facilitate the arrangements for the complex installation, and Melissa Gallin supplied essential development assistance.

Many other people have made important contributions to this project. The noted collector Daphne Farago kindly lent some early Chihuly *Cylinders* to the Museum to be displayed in the Sharf Visitor Center prior to and during the course of the exhibition. Rock Hushka, Director of Curatorial Administration and Curator of Contemporary and Northwest Art at the Tacoma Art Museum, offered a tour of his museum's important and seminal Chihuly collections and installations on his day off, and I am most appreciative of that opportunity to see the objects with him. Jonathan L. Fairbanks, the Katharine Lane Weems Curator Emeritus, American Decorative Arts and Sculpture, shared his reminiscences of his and the Museum's interactions with Chihuly in the 1980s and 1990s and made many helpful suggestions.

Barbara McLean Ward also provided her keen scholarly advice and sage editorial direction; as always, I am thankful for this and for so much else.

GERALD W. R. WARD
Katharine Lane Weems Senior Curator of
American Decorative Arts and Sculpture
Museum of Fine Arts, Boston

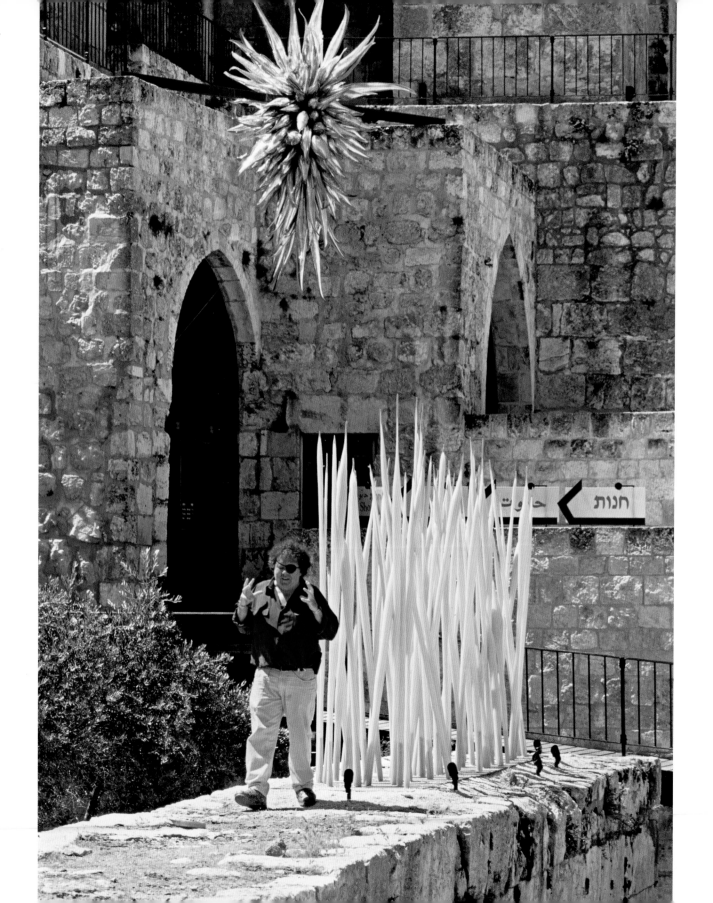

CHiHULY
THROUGH THE LOOKING GLASS

"One night [in 1965] I melted a few pounds of stained glass in one of my kilns and dipped a steel pipe from the basement into it. I blew into the pipe and a bubble of glass appeared. I had never seen glassblowing before. My fascination for it probably comes in part from discovering the process that night by accident. From that moment, I became obsessed with learning all I could about glass."

In the course of his long career, Dale Chihuly has revolutionized the ancient art of blown glass, moving it into the realm of large-scale sculpture and establishing this inherently fragile but also surprisingly permanent material as a vehicle for installation and environmental art. Although many people think of Chihuly principally as the maker of individual pieces of studio glass, he has in fact been an installation artist since he began his work in the mid- and late 1960s. He has been remarkably consistent in this regard, and his projects have continued to expand in size and scope during the past four decades. These projects differ dramatically: some are long-term or permanent, many are ephemeral; some are outdoors, others transform museum or dealers' galleries, while still others occupy the liminal space of a botanical garden or glasshouse; many are public, others enrich private homes and corporate offices. His ongoing work in this vein—large-scale, alternate realities achieved through the magical properties of transparent and translucent materials—is perhaps his greatest contribution as a significant artist of the late twentieth and early twenty-first century.

Chihuly has long had an interest in interior design, and early in his career worked for John Graham Architects, a prominent Seattle interior-design firm. But his interest in glass and desire for more ambitious, energetic projects soon propelled him into the world of studio art. The 1960s were an era of experimentation and boundary-breaking in most aspects of society, including the art world. Installation art, defined most simply as "a dedicated space in which one artistic vision or aura is at work, setting forth various kinds of phenomena," is a longstanding artistic tradition that was embraced by many artists in the early twentieth century and also resonated with others who came of age during the era of the Vietnam War and the so-called counterculture. These installations could take a nearly infinite variety of forms, from the wrapping of large buildings and structures by Christo and Jeanne-Claude to environmental earthworks,

< Dale Chihuly with *Yellow Spears* and *Star*, Tower of David Museum of the History of Jerusalem, Jerusalem, Israel, 1999

Glass Forest #1
In collaboration with James Carpenter
Museum of Contemporary Crafts, New York, 1971
46.5 sq. m (500 sq. ft.)

from period rooms to surreal assemblages. One characteristic of installation art is that it provides a sensory experience that amplifies and intensifies one's enjoyment of the individual pieces composing it, often without a requisite background in the history of art. "The viewer [of installation art] is in the present, experiencing temporal flow and spatial awareness. The time and space of the viewer coincide with the art, with no separation or dichotomy between the perceiver and the art. In other words, life pervades this form of art."[1] "Life pervades this form of art" describes many Chihuly projects: although not direct representations of specific forms, they are strongly evocative of natural organic life, of flora and fauna from flowers to seashells, wasp nests and trees, roots and icicles, feminine floats and masculine reeds.

Chihuly has acknowledged, in particular, the importance of Christo and Jeanne-Claude many times: they are "among the artists who have inspired me the most. I really connect with the way they do [their projects]." Chihuly has expressed his admiration for their "unique undertakings," such as the *Valley Curtain* in Rifle, Colorado, where they draped a wide valley in their characteristic orange fabric (1970–72), and their *Wrapped Reichstag* in Berlin (conceived in 1971 but not completed until 1995). Chihuly is most impressed by the "amazing" scale and complexity of their projects, noting that they had twelve hundred people working on the Reichstag project.[2] He also takes pride in the large number of people required to complete his own projects.

Not only are Chihuly's installations themselves staggering, so too is the number of them completed over his career. Chihuly's Web site documents more than fifty museum, public, and "temporary" installations (not counting his earliest work), which are categorized into fourteen

different series. From this wealth of material, several high spots and turning points emerge. "Chihuly Over Venice" (1996) and "Chihuly in the Light of Jerusalem 2000" are two of his most important efforts, each notable for the teamwork required, their sheer complexity, the audacity with which they were conceived, the chutzpah required to make them happen, and the resultant international renown that they brought to the artist. The installation in the Garfield Park Conservatory in Chicago (2001–2) marked a new highly successful experiment of creating "gardens of glass," an effort that has been repeated with equal success a number of times in other glasshouses, in which Chihuly's glass objects fit comfortably to an uncanny degree, augmenting and heightening the beauty of the natural specimens. Other examples, such as the *Fiori di Como* at the Bellagio Hotel in Las Vegas, only reinforce Chuhuly's mastery of this form of art. Although many other glass artists have created important installations and architectural features, none has been as consistent or important in defining this realm of the glassmaker's art.[3]

Spaces are truly at the heart of Chihuly's art. As he has acknowledged, "What I've always really been interested in is space. Even when I made a single *Cylinder* or *Macchia*, my interest was always in space. I was thinking not of the object itself, but how the object would look in a room."[4] Chihuly's ability to envision magnificent spectacles of color and light makes him a great artist; his personal skill at marshalling the forces of a large team able to take a vision from the mind of its creator to the eye of the beholder makes him a great leader. Those twin abilities—artist and executive, visionary and practical man of business—have propelled Chihuly to the position of international prominence that he enjoys today, as his work continues to delight the eye and please the mind of people around the globe.

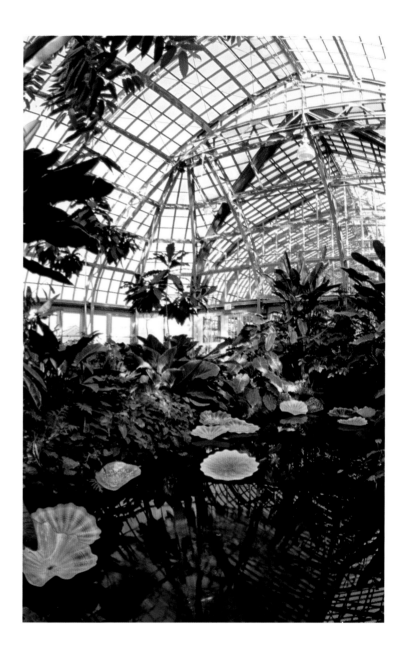

Persian Pond
Garfield Park Conservatory
Chicago, Illinois, 2001

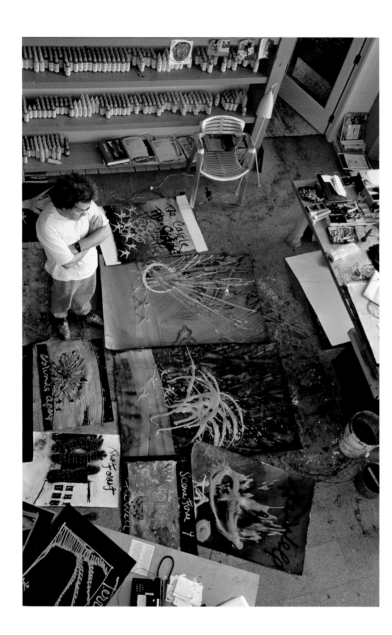

Chihuly working at the Boathouse on concept drawings
for Debussy's opera *Pelléas et Mélisande*
Seattle, Washington, 1992

Chihuly's Methods: The Process of Creativity

"Glassblowing is a little like making a drawing, or the way that I
draw anyway, which is very spontaneous, fast, immediate. I don't
work it over. I do the damn thing and get it over with. I don't go
back in and work on it. I'd rather just start over. Same with the
glassblowing. Make the piece, get it done and finish it. You just
have to go with this wonderful material the way it wants to go."

Although he principally employs two traditional art forms—
drawing and glassmaking—Dale Chihuly's working methods,
like those of any artist, are uniquely his own. Creatively, he
has vast reserves of energy, a spongelike ability to draw
upon natural and human sources, a deep trust in spontane-
ity, and the discipline to work hard and to work quickly. He
is driven to create objects that people will enjoy, that don't
necessarily carry a great deal of political or polemical bag-
gage. Chihuly is always eager to get on with the work—to
let it evolve through doing, rather than through meticulous
planning ahead of time. Such a method, although seemingly
improvisational and informal, requires a skilled technical
staff led by an artist with a solid understanding of the
working properties of his materials, attained through years
of experience. It also reflects another tenet of Chihuly's cre-
ativity: his desire to push the limits of his chosen material—
to create things no one has seen before, to make the largest
and heaviest or the thinnest and lightest objects that the
properties of glass can sustain. This belief in experimentation
and the drive to shatter boundaries brings with it a willing-
ness to, on occasion, fail and then try again—a trait underly-
ing an abiding sense of self-confidence and self-direction.
His work does not follow what he calls a "logical progres-
sion"; rather, he likes "to be motivated by new things. If I
had to do the same thing all of the time, I would get bored
out of my mind."[5] Chihuly's ideas often come, as he puts it,
from his "gut," from "deep down."[6] "The ideas just come as
they come."[7]

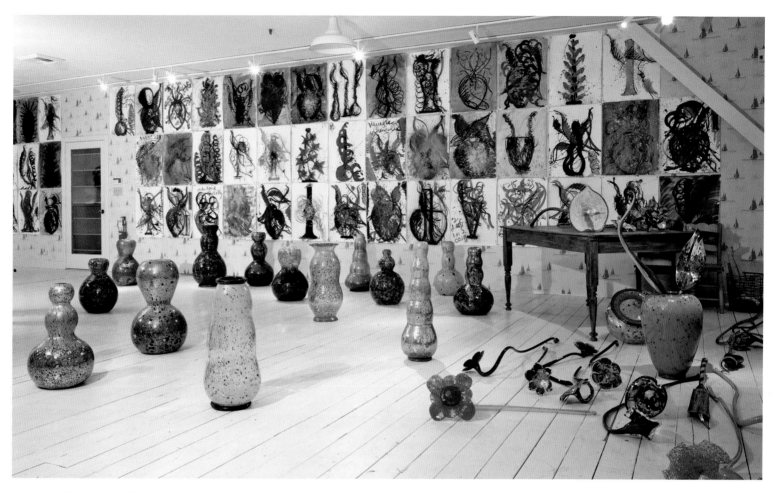

Composing *Ikebana* in front of *Drawing Wall* at the Boathouse
Seattle, Washington, 1991

Practically, Chihuly has a firm belief in teamwork (always a necessity in blowing glass on any scale). Since 1983, he has been based in Seattle and Tacoma, Washington, where he has developed a sizeable and formidable team of artists, engineers, riggers, and other support staff that allow him to maintain a demanding exhibition schedule and fulfill many public and private commissions. He communicates his ideas to his glassblowers and gaffers through drawings and oral communication at the time of initial creation and later assembly. Many great glass artists—Lino Tagliapietra, Pino Signoretto, James Carpenter, William Morris, Richard Royal, Martin Blank, Joey DeCamp, James Mongrain, Benjamin Moore, Flora Mace, Joey Kirkpatrick, and many more—have served with Chihuly.[8] Each of these artists brings a basic vocabulary of skills to the team, but also provides their own special contribution.

Chihuly also assembles skilled professionals from fields other than his own to bring his visions to reality. For example, for the *Fiori di Como* installation at the Bellagio in Las Vegas, as well as other similar projects, Chihuly assembled "glassblowers, architects, engineers, shippers, installers, and fabricators—over 100 in all." This team installed a single work of some 2,000 individual pieces suspended at various heights and occupying about 195 square meters (2,100 square feet). "Color was the most difficult aesthetic challenge, and the structure was the most difficult technical challenge."[9]

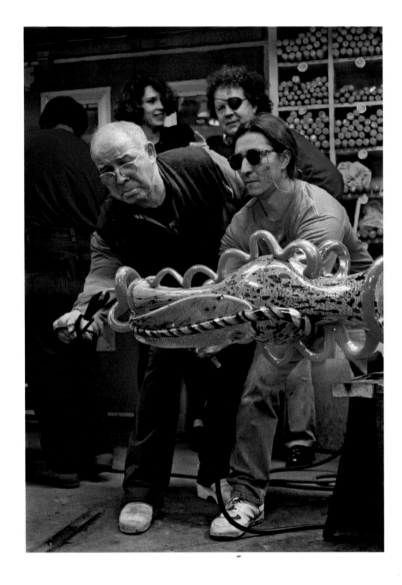

Lino Tagliapietra, Chihuly, and
Tony Jojola in the Boathouse hotshop
Seattle, Washington, 1990

Technically, Chihuly likes to manipulate glass as simply as possible, using few tools and molds, and allowing gravity, movement, and centrifugal force to act upon the molten material.[10] Much of the current Chihuly hotshop—its scale, work rhythms, and core materials—would look familiar to a seventeenth-century glassblower. Techniques such as manipulating the blowpipe, swirling a gather (a mass of molten glass), inserting molten glass into small molds, rolling and flattening gathers on a stainless-steel table known as a marver, and shaping pieces with small hand tools are still very much in evidence in the Chihuly hotshop today.

Though practicing a venerable craft, Chihuly nevertheless pushes its boundaries, developing new techniques or extending traditional ones in conjunction with his team of glassblowers. At the core of Chihuly's early *Cylinders* was the "pick-up drawing technique," in which lines of thin glass forming a drawing were laid out on a marver, and then picked up and transferred to a hot glass cylinder through rolling.[11] This technique revolutionized glassmaking in that the image became "fully integrated into the form rather than laid or inlaid onto it—a dramatic concept not just within the history of glass"; the glass vessels became "Chihuly's canvases."[12] Other works take traditional forms to their extremes: *Niijima Floats* are seemingly simple round forms enlarged to gargantuan sizes that test the ability of the glass to hold its shape; some large *Persians* also push the capabilities of glass as a material. For the *Macchia* series, he explored numerous color combinations and developed a new means of creating layers of glass within a given vessel, adding a course of white glass between multiple layers of color. In addition, small chips of colored glass (called "jimmies," a reference to the candy sprinkles added to ice cream, or "frit") gave the series the spotted appearance that led to its Italian name.[13]

In his installations and environments, Chihuly also experiments with plastic, neon and argon, and ice. He selects glass and these other materials because of his admiration of their unique properties and the results that they allow him to attain; in essence, he is attracted by their shared capacity to transmit light and their concomitant ability to create an extraordinary color palette. "When you are working with transparent materials, when you're looking at glass, plastic, ice, or water, you're looking at light itself. The light is coming through, and you see that cobalt blue, that ruby red, what-ever the color might be—you're looking at the light and the color mixed together."[14] Chihuly often refers to his "obses-sion" with color, a theme in his work self-evident to even the most casual observer. A concurrent theme is his equally strong, lifelong fascination with water (even glass is a super-cooled liquid, always theoretically ready to return to its fluid state). His familiarity with and understanding of the proper-ties of his chosen materials, not only their mysterious ability to transmit light and color but also their capacity to be shaped into an almost limitless range of organic forms, have defined Chihuly as an artist.

Although many people are involved in the creation of Dale Chihuly's glass, Chihuly himself retains a firm hand on the aesthetic tiller. He thinks of himself as a film director, or perhaps an orchestra conductor, who channels the unique talents and individual skills of his crew toward a unified goal—the realization of his artistic vision. "I often think that had I not been a sculptor or an artist, I might have liked being a film director or an architect."[15] He assembles thoughts, ideas, and opinions from his team, and then draws his own conclusions.[16] He often references his relationship to the ateliers of Renaissance masters, who similarly made use of skilled specialists while maintaining aesthetic control. In these Renaissance shops, division of labor and use of spe-

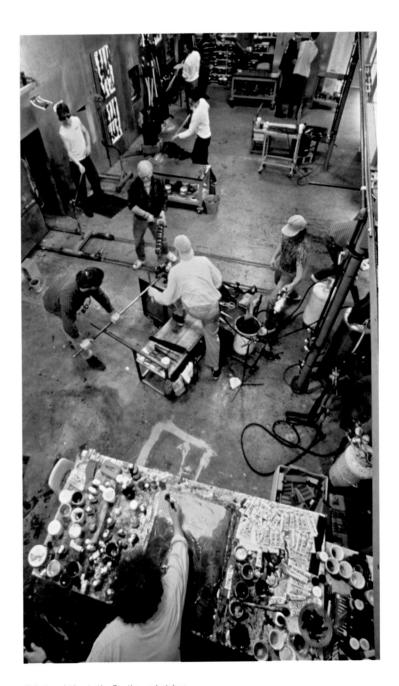

Chihuly painting in the Boathouse hotshop
Seattle, Washington, 1991

Kelso's Beacon Drawing
1997
152.4 x 101.6 cm (60 x 40 in.)

> *Basket Drawing*
2002
106.7 x 76.2 cm (42 x 30 in.)

cialists were common, but the final product usually bore only the signature or mark of the master.[17] More recent parallels to Chihuly, in the world of American glass, include the operation of Louis Comfort Tiffany.[18]

Drawing is a key element in the Chihuly glassmaking process. While it provides Chihuly with a means of release for his pent-up energy, it also allows for nonverbal communication with his fellow artists (although Chihuly does not shy away from traditional verbal communication). As Chihuly once explained in connection with the *Venetian* series, "All I have to do is make a drawing, put it up on the wall next to the furnace, and Lino [Tagliapietra] interprets it in his own way."[19] This means of artistic transmission, while always an important part of Chihuly's creative process, became increasingly significant after he lost the vision in his left eye as a consequence of an automobile accident in 1976 and after a later mishap further limited his physical glassblowing abilities. As he notes in greater detail:

> Drawing really helps me to think about things. Because I don't blow glass anymore, maybe I get a little frustrated—I'm not as hands-on as I used to be. So I'm able to draw and work with a lot of color and that inspires me. Maybe it inspires the glassblowers too, to see me back there working on ideas. I rely very heavily on them to look at the drawings and on the gaffers—the head glassblowers—to see things in the drawings and to talk about it—sort of a symbiotic relationship that goes back and forth.[20]

Chihuly's drawings are significant works in their own right as well as important working tools. In style, they are in many ways modern manifestations of the action or gesture paintings developed in the 1940s by Jackson Pollock and others, which are also characterized by a sense of energy released and a full use of the picture plane.

Chihuly's Working Environment

"It's important for my creativity to live and be around my work. And also to work and live in spaces that don't feel like a house or like rooms. I love to be on the water. I was very fortunate to get the Boathouse, so if I want to go down and talk with the glassblowers and discuss what's going to happen that day, I can."

Dale Chihuly's personal spaces during the last thirty years have served as backdrops for his art. While all artists need a studio, Chihuly has created several major work areas, offices, storage facilities, and other spaces that are on a different scale from the spaces of many, perhaps most, contemporary artists. This infrastructure is necessary for making his art, for accommodating some eighty-five members of his team, and for maintaining the necessary logistical support for exhibiting and marketing the art of Dale Chihuly throughout the world.

Chihuly's epicenter is the Boathouse, the renovated Pocock boatbuilding factory on the waterfront of Lake Union in Seattle acquired by Chihuly in 1990. Constantly evolving, today it consists of a number of themed spaces, each of which echoes or is connected in its own way to the Chihuly oeuvre. Central to the Boathouse is the hotshop, where Chihuly's glass is made. Running eight hours a day, seven days a week, the shop contains on one side four "glory holes," small furnaces where the glass is heated and reheated. To the left is a bank of annealing ovens, which hold the finished pieces as they are slowly cooled to avoid breakage. Manipulation of hot glass gathers takes place in the work space in front of the glory holes, as the hot viscous material is withdrawn from the fire on a metal blow pipe and then blown and shaped using gravity and centrifugal force; simple paddles, tongs, shears, and other tools; and human breath. On the opposite side are floor-to-ceiling tiers of pigeonholes containing raw materials: imported

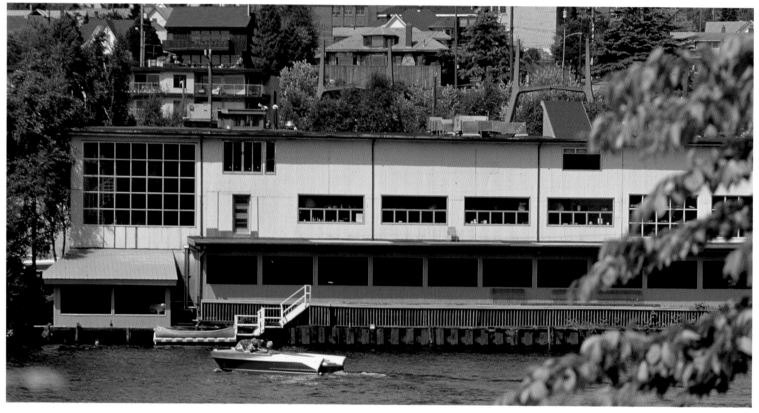

The Boathouse
Seattle, Washington, 1994

German glass color rods in as many as three hundred varieties, and glass powder and frit blended specifically by the shop over time to achieve various effects. At one end of the hotshop is a wall of samples of the various horns, leaves, and other specialized parts that go into the creation of *Chandeliers* and other large sculptures.[21] On a recent visit, five glassblowers were at work in the hotshop early in the morning, making leaves for a clear glass *Chandelier*. As the soundtracks of *Pirates of the Caribbean*, *Superman*, and other films played in the background, the craftsmen went about their work calmly and largely silently, moving in a smooth, experienced manner that appeared deceptively casual.

The adjacent Lap Pool room contains a long rectangular pool. With a *Chandelier* above and a rectangular section of *Persians* and other forms embedded in its bottom, the pool unites Chihuly's fascination with water and its power as a source of his creativity: "Water is really important to me. I love to be on the ocean, I love baths, I love showers, I love swimming, and I think a lot when I'm in the water."[22] Nearby restrooms are embellished with a collection of first-edition children's books, displayed flat against the wall on open shelves in order to highlight their dust jackets. Displays of items from Chihuly's diverse collections—tin toys, shaving brushes, small Buddhas—abound throughout the hallways

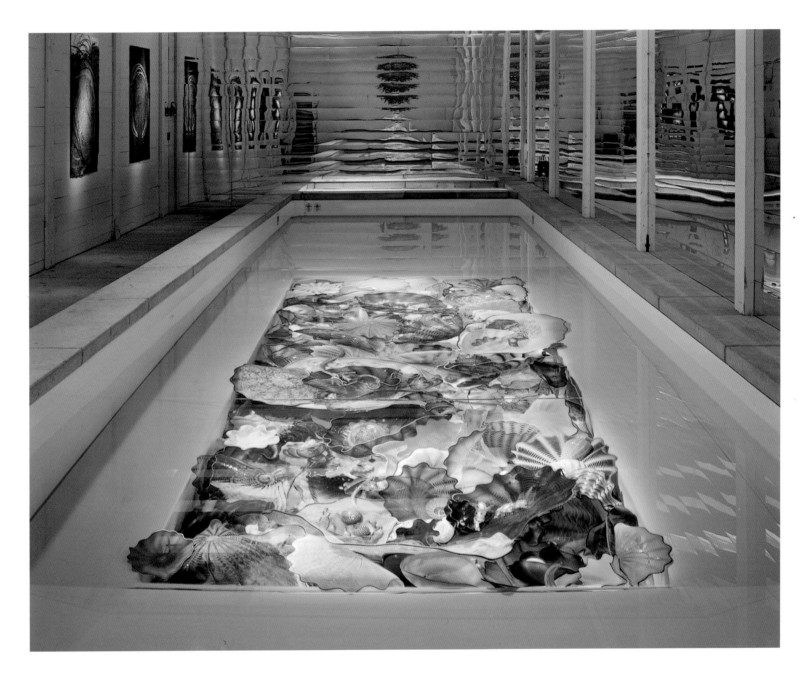

Lap Pool
The Boathouse
Seattle, Washington, 1994
3.7 x 16.5 x 1.2 m (12 x 54 x 4 ft.)

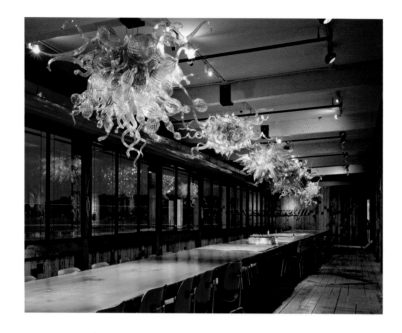

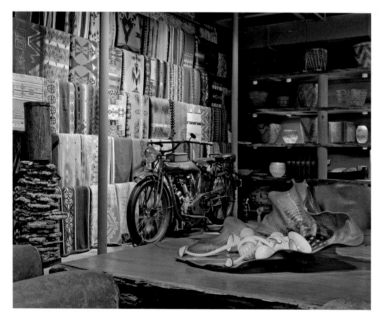

Above: Evelyn Room *Chandeliers*, The Boathouse, Seattle, Washington, 1999
Below: Northwest Room, The Boathouse, Seattle, Washington, 2007

and various rooms of the Boathouse. The Evelyn Room runs the full length of the building on the water side, containing an array of several *Chandeliers* hanging above an impressive table made from a single piece of Douglas fir some 25.6 meters (84 feet) long. A row of European carnival masks extends high along the interior wall, which is also adorned with Chihuly's drawings.

Other spaces in the Boathouse include a guest room once used principally for Chihuly's close colleague, the late Italo Scanga, and it too includes artful displays of Chihuly's collections. In 2001, Chihuly created a large aquarium for his son, each section fitted with an example of his glass. A small garage houses two vintage cars that Chihuly particularly prizes. A hallway in the Boathouse with a *Persian Ceiling* echoes what has become a signature feature of many Chihuly museum installations.

The Northwest Room (once known as the Indian Room) is one of the most famous areas of the Boathouse. It stands as a symbol of Chihuly's long interest in Native American art and its impact upon his glass. Furnished with overstuffed leather easy chairs, the room contains several key elements: a large selection of his collection of Pendleton and other trade blankets, some folded and draped along one side of the room, others stacked in piles; a wall of photographs of Native American women by Edward Curtis; and a wall containing examples from Chihuly's collection of Native American Northwest Coast baskets along with examples of his own early glass *Baskets* inspired by the simple, often slumped forms of the Native works. An Indian Twin motorcycle from 1915 and an Algonquin canoe hanging from the ceiling complete the furnishing of this intriguing space.

The Chihuly Studio, located not far from the Boathouse in the Ballard neighborhood of Seattle, is the design and administrative nerve center of Team Chihuly. This large

three-building facility serves multiple functions. It contains Chihuly's principal office, decorated with selections from his collections of soldiers, carnival chalkware figurines, movie posters, books, and other materials. The Chihuly Studio Archives, a meticulously maintained body of primary material documenting Chihuly's deeds and words, and the offices of Portland Press, Chihuly's publishing arm founded in 1992, are also located here. Conference rooms, design offices, a registrar's office, a business and financial office, the photography studio, and other support services worthy of a good-sized museum are also located in this important facility.

The Ballard Studio also contains work spaces where the larger installation pieces, such as *Chandeliers*, *Towers*, neon works, and *Persian Walls*, can be assembled, reassembled, and experimented with and tested. Although the largest examples may need to be done in two sections, the high ceilings of these mock-up spaces allow for *Chandeliers* to be shaped under Chihuly's direction, as trained staff insert hundreds, sometimes thousands, of individual glass pieces into a steel armature. Scales fitted to the support structures allow each work to be weighed, providing important information to the engineers, as they cope with the logistical issues of transporting and installing such large and heavy pieces.

Chihuly also maintains a large warehouse in his home town of Tacoma, about an hour's drive south of Seattle, which serves as the shipping and receiving facility, equipped with a loading dock, cold glass-working shop, substantial storage areas for objects and drawings, meeting rooms, a photography studio, and packing materials. All the Chihuly national and international exhibitions come and go from this well-maintained facility. A computer database similar to those used by museums allows the Studio to maintain registrarial control over the thousands of pieces in their care.

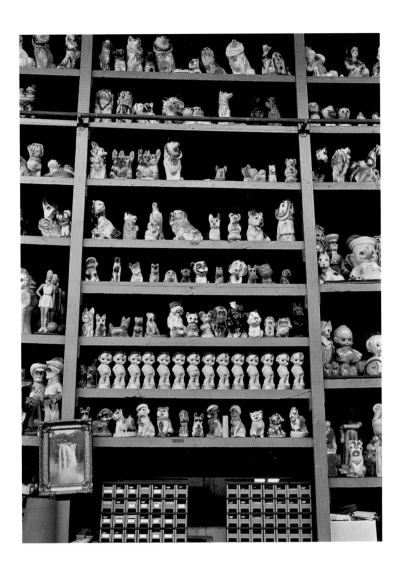

Chalkware figurines
Chihuly Studio
Tacoma, Washington, 2001

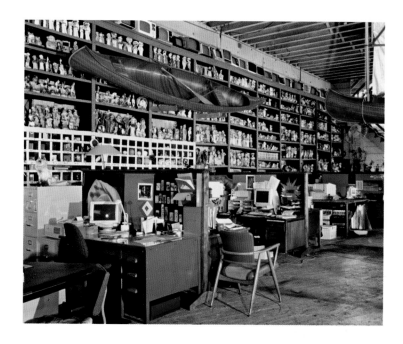

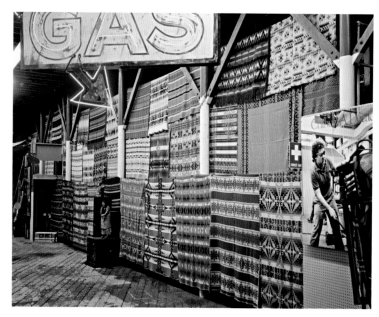

Above: Dale Chihuly's collections, Chihuly Studio, Tacoma, Washington, 1999
Below: Trade blankets, Chihuly Studio, Tacoma, Washington, 1999

Chihuly as Collector

"I don't know what it is about collecting, but I love to collect things."

To say that Chihuly loves to collect things is an understatement of epic proportions. Many objects from his various collections can be found throughout the Boathouse and the Ballard Studio. Moreover, he maintains a significant storage facility in Tacoma for his reserve holdings. This large storeroom, occupying several floors, overwhelms the visitor. A simple listing of its inventory conveys little of the sensory overload that the space imposes. One can see there hundreds of accordions; a pile of wooden tennis rackets; compartments of electrical appliances such as blenders, televisions, and toasters; a tower of "collectible" kid's metal lunch boxes; more Pendleton blankets; full-size boats hanging from the ceiling; posters arrayed along the walls. And, perhaps most daunting of all, one is stunned by serried rows of hundreds of carnival chalkware figurines, given as prizes at various carnival games and tests of skill.[23] Made from about 1910 until they were superseded by stuffed animals in the 1960s, these inexpensive figurines are the epitome of vernacular sculpture, both in terms of their simple manufacture from plaster of Paris and their depiction of animals; cartoon, movie, television, and other characters; and popular-culture shapes. Chihuly collects not only a wide range of subjects, but also has gathered multiple copies of the same figurine.

Rather than collect objects one at a time, Chihuly often prefers the method—also used by many noted collectors, such as J. P. Morgan—of acquiring whole collections assembled by others. On a recent visit to storage, a collection of mid-twentieth-century radios had arrived, not yet uncrated, as collecting continues apace. To Chihuly, as to the Victorians, "too much is not enough." As he puts it, "My phi-

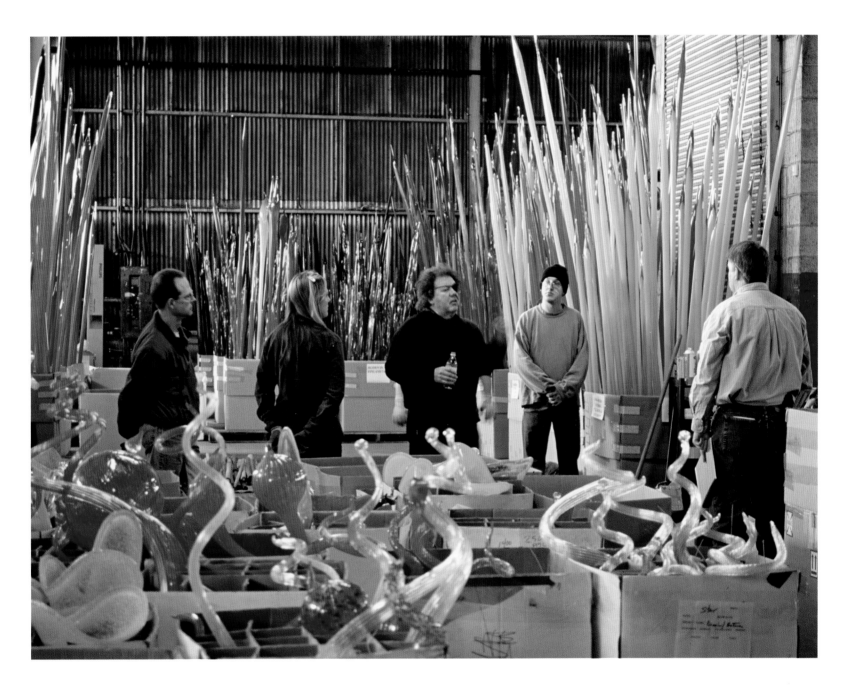

Dale Chihuly with his team at the Chihuly Studio
Tacoma, Washington, 2001

Blanket Cylinder and trade blanket
American Textile History Museum
Lowell, Massachusetts, 2000

losophy is: When one is good, a dozen is better."[24] Although he falls short of the "infinity of things" assembled by some people, such as Henry Wellcome, the British collector of medical artifacts, Chihuly is no slouch.[25] Chihuly also collects his own work, perhaps in a more decorative than analytical or comprehensive way: "I go through different phases about collecting my own work. I do collect key things from different series and put them away. And sometimes those pieces mean a lot to me and sometimes they don't." What he does like to collect are photographs of his work: "It's the 4 x 5-inch transparencies that probably, in a funny way, mean more to me than the objects themselves. I think that's because I can refer to them and look at them very easily."[26]

Chihuly's objects and their display are important to his work in several different ways. His collections have been linked to the themes of "repetition and accumulation" that personify his work in glass.[27] A *Persian Wall* or *Ceiling*, for example, can contain hundreds of examples of related forms, each essentially a repetition but with its own unique shape, that are massed together to create a majestic work. The numerous elements of a *Mille Fiori* or *Chandelier* or *Macchia Forest* similarly are based on the principles of accumulation and repetition to create an effective display.

In some other instances, as with his collections of Native American Northwest Coast baskets and Indian trade blankets made by Pendleton and other firms, there is a strong formal connection with his work, where the collected object serves as a springboard for Chihuly's designs. This intersection is clearly seen in the glass drawings on *Navajo Blanket Cylinders* and other *Cylinders*, echoing the patterns on Pendleton blankets, or the soft, slumping forms of his *Tabac Baskets*, based on the undulating forms of the older Native examples executed in fiber that over time has started to sag and shift. As Chihuly puts it, his *Cylinders* "were wear-

ing their drawings just as the Indians were wearing their blankets." His work with the *Cylinders* and *Baskets* has continued to inform several of his later series.[28] One can easily observe, for example, the influence of the earlier works on his *Cylinders* and *Soft Cylinders* in the series known as *Chihuly Black* from 2006.[29]

Any sort of specific visual connection between Chihuly's collections of many types of objects and his art seems less direct. Clearly he enjoys being surrounded by his collections; they provide comfort and pleasure to his working environment. Collecting is a social as well as intellectual activity, providing friendships (and sometimes rivalries) with fellow collectors, experts, and dealers, and enriching journeys and travels. Many of the objects in the Chihuly collections seem to strike a nostalgic chord for someone who grew up in the 1940s, 1950s, and 1960s, evoking fond memories of family and friends and early experiences. Put most directly, perhaps, they represent the hobby of someone who likes stuff, and who has the means to buy it and the space to accumulate it in quantity. And, as he acknowledges, "some of the things I collect give me ideas that I probably would not otherwise have. It's just one of those things that work well for me."[30]

Many other artists have also been dedicated collectors, notably (in this context) Andy Warhol. Warhol's activity in this regard has been called "possession obsession."[31] He, too, amassed holdings of some ten thousand objects, ranging from folk art and Native American art, from high-style art deco pieces to cookie jars, Fiesta ware, Russell Wright designs, and many other types of material culture. Chihuly has on several occasions expressed his admiration for Warhol, commenting on Warhol's myriad activities that influenced many creative people.[32] The fact that both artists are collectors is surely no coincidence. For each, the goods they collected are part of an "instrumental materialism," in which the objects serve as "an essential means for discovering and furthering goals" rather than simply being an end in themselves (what can be called "terminal materialism" and is evidenced by the phenomenon of hoarding). In some often inchoate way, his collections help Chihuly visualize the worlds that he brings forth in his work.[33]

Art or Craft

"Call it art, call it craft. I don't care what they call it. Somewhere down the line, long after I'm dead, someone will figure out what it was and how important it was. In the meantime, I get my kicks out of people seeing the work."

What is one to make of Dale Chihuly? His work has received careful consideration and often positive reviews from many critics, curators, and art historians, including Henry Geldzahler, Donald Kuspit, and Barbara Rose, to name only three of the many commentators who have interpreted Chihuly in the light of their own backgrounds and interests. Thomas Hoving was especially fulsome in his praise, stating that Chihuly "is without doubt one of the most important artists America has ever produced" and emphasizing that his art is not only beautiful, but reflects "high intellectual creativity" on a par with the work of such artists as Donald Judd and Richard Serra.[34]

In addition to such critical acclaim, Chihuly's exhibitions and installations are wildly popular with the general public, often shattering attendance records at a given institution. His glass has even been mentioned by name in a television sitcom, one of the surest signs of fame in American popular culture; he is about as close to a household name as a living artist in America can be.[35] Moreover, he receives perhaps as much commendation for his personality and generous artistic spirit as he does for his glass. His seminal role in the stu-

dio glass movement, approaching its fiftieth anniversary in 2012, is also widely recognized, as are his many contributions as a teacher, including the cofounding of the Pilchuck Glass School.[36]

Not everyone, of course, is necessarily smitten with Chihuly. Such fame and popularity as he has achieved inevitably creates a degree of what some people perceive as overexposure and also provokes tinges of envy. Some critics are troubled by the financial success, showmanship, and seemingly ubiquitous presence of Team Chihuly and its "products" in many institutions throughout the world. Chihuly also raises issues for those concerned with the making of boundaries and the careful definition of terms. Is he an artist or a designer? Is he an artist or a craftsman? Does he create art or craft? Can anything so popular actually be any good? Can things produced in large quantities really be anything but mass-produced commodities and therefore somewhat beyond the pale? Is Chihuly still practicing the "workmanship of risk," in which judgment, skill, and dexterity prevail, or has he slipped over to the "workmanship of certainty," in which the result is essentially predetermined and uniform (to borrow David Pye's terms)?[37]

The craft community, broadly conceived, seems particularly troubled by these issues. In one recent survey of the modern craft movement, Chihuly is mentioned but largely dismissed as a "prolific showman."[38] In another, he receives even more derisive commentary, largely based on the thought that his work lacks conceptual content.[39] A more careful analysis illuminates the taxonomical and other issues that Chihuly presents. Janet Koplos and Bruce Metcalf note that Chihuly's work, "as art . . .has been formalist in a period preoccupied with social message and precious when junk materials or intangibles are more often employed."[40] He is thus an imperfect fit in the contempo-

rary art world, largely standing outside the modes, content, style, and paradigms that many artists utilize and operate within.

Koplos and Metcalf also acknowledge that Chihuly presents a quandary for the field of contemporary craft; in fact, it is "impossible," they argue, to judge his work as either art or craft. Rather, his exhibitions have become instead "an accessible popular entertainment" and Chihuly himself "an impresario." While acknowledging that the beauty of his work has "never faltered," in their opinion Chihuly makes so much of it that it has become "impersonal" and stretches "the philosophical limits of craft scale" and therefore raises the evil specter of "mass production." Such comments suggest, among other things, an adherence to a modern romantic view of craftsmanship, divorced from its historical antecedents, and derived from John Ruskin and other theorists of the Arts and Crafts movement. In the eighteenth century and earlier, the best craftsman was the man who could make the best and most objects in the shortest amount of time with the benefit of whatever tools and methods and assistants were available. Making a living was the point of being a craftsman.

Nevertheless, such questions about how to evaluate Chihuly raise valid points, and the answers are of concern to those who pose them, if perhaps not of universal interest. They do not seem to be of particular concern to Chihuly himself, who on many occasions has indicated that he enjoys doing what he does and that he is content to let it all get sorted out by others and, eventually, by the judgment of history. He is comfortable being judged as both an artist and a craftsman.[41] His goal is to bring joy and beauty to the eye of the beholder. He does so through his refreshing, pre-twentieth-century Ruskinian view of the meaning and purpose of art, without the baggage of overt, polemi-

cal agendas and content. In this, he benefits from, and probably is partly responsible for, a renewed interest in glass and a "resurrection" of the very concept of beauty starting in the 1990s.[42]

Chihuly's thorough understanding of the importance of teamwork in glassblowing and his mastery of his materials have also lifted him to the pantheon of contemporary artists. He has the ability to operate a substantial enterprise from the creation of works of art through their exhibition, sale, and publication, using interpersonal skills in tandem with modern marketing tools to great effect. It is not his fault that he has risen to prominence in a country where celebrity seems to be one of the most highly valued attributes a person can achieve.

"Chihuly: Through the Looking Glass" is but the most recent demonstration of Dale Chihuly's ability to create an unforgettable experience for the museum visitor. And what is next for Chihuly? "Who knows what's next? You know, when people say, 'What are you going to do next?' I always say, 'If I knew what I was going to do next, I'd be doing it.'"[43] What is certain is that this installation is unlikely to be his last. As he notes, "I don't think much about the past. I think more about the future."[44]

Chandelier Drawing
1999
106.7 x 76.2 cm (42 x 30 in.)

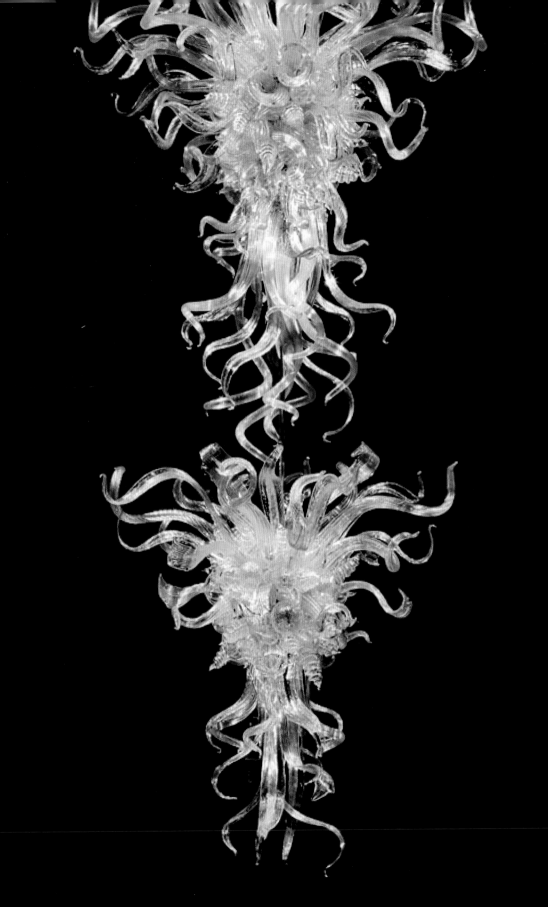

CHIHULY
AT THE MUSEUM OF FINE ARTS, BOSTON

"Give the people something to see in a museum and they will come."

"Chihuly: Through the Looking Glass" is the most recent of a long series of Chihuly exhibitions in art museums across the world. Like several of these exhibitions in recent years, the MFA installation includes much new work from this energetic and always-evolving artist, but also presents an overview of Chihuly's creations during his long career, with galleries devoted to fresh displays and new versions of some of his more famous and powerful series and environments. As is always the case, Chihuly and his team have selected works that are well suited to the site. A *Lime Green Icicle Tower* soars into space under the high ceilings of the glass-enclosed Ruth and Carl J. Shapiro Family Courtyard. Such *Towers* (and their hanging counterparts, the *Chandeliers*) have become a signature of Chihuly's work in many institutions. At the MFA, the *Tower* is joined by a long, colorful neon work, a modern version of Chihuly's longstanding interest in the effects made possible by gaseous elements in glass. Other areas with small, landscaped alcoves draw on Chihuly's experiences with botanical gardens and conservatories; for these he selected and installed glass *Cattails* that are compatible with the sculptures and vegetation that normally occupy those spaces. For the main exhibition in the Ann and Graham Gund Gallery, Chihuly and his team have created a mystical environment that progresses through room after room. Each of those spaces is devoted to a specific type of installation.

Persians

Developed in the mid-1980s, Chihuly's *Persian* series has evolved into one of his most effective components for installation art. Over time, *Persians* have been mounted vertically in wall displays, displayed similarly in window displays, used as the components of *Chandeliers*, and used to create *Persian Ceilings*, where visitors pass through a tunnel-like space with hundreds of thousands of *Persians* above them. Occasionally Chihuly has also used them underwater, perhaps most notably in the Lap Pool in his Seattle Boathouse.[1]

Although scholars have noted the visual relationships between the *Persian* series and Islamic art and other historical prototypes, the connection is perhaps more apparent than real. In the artist's mind, "Persian" was merely an evocative term that provided a

< *Silvered Chrysalis Tiered Chandelier*, Museum of Fine Arts, Boston, 2011
3.7 x 1.7 x 1.5 m (12 x 5½ x 5 ft.)

sense of exoticism to his new series, which in its richness and size created a taxonomical problem: "The *Persians*— that's one of the most difficult series to describe. It started off that they were geometric shapes, I think. It was a search for new forms. We worked for a year doing only experimental *Persians*—at least a thousand or more. Sometimes the *Persians* became very *Seaform*-like [an earlier Chihuly series], or they became very geometric." Eventually, the form known as a rondel became the most distinctive type of *Persian*, distinguished by its large size and wavy, irregular edges.

Chihuly first displayed *Persians* in 1986. He soon progressed to using them in multiples in private residences (mounted over a fireplace, for example), corporate buildings, and public installations, such as the *Malina Window* (1993) at the corporate headquarters of Little Caesar Enterprises in Detroit, the *Monarch Window* (1994) at the remodeled Union Station in Tacoma, and in a window at the University of Puget Sound, also in Tacoma. *Persian Chandeliers* have been used effectively in Chihuly's botanical garden installations, such as those in the Royal Botanic Gardens, Kew, in England (2005) and at the Phipps Conservatory and Botanical Gardens in Pittsburgh (2007).[2]

Persian Ceilings have long been a part of Chihuly exhibitions. Perhaps Chihuly's most well-known installation featuring *Persians* is the *Fiori di Como* (1997–98) at the Bellagio resort in Las Vegas, Nevada. This massive and complex installation of some two thousand pieces, as Chihuly noted, required a team of more than one hundred people, and "took about 10,000 pounds [4,536 kilograms] of steel for the armature and some 40,000 pounds [18,144 kilograms] of handblown glass," suspended at heights ranging from fifteen to twenty-five feet [4.6 to 7.6 meters] from the supporting framework.[3]

Venetians and Ikebana

Begun in 1988, Chihuly's *Venetian* series was not only an homage to Venice, one of his favorite cities and seat of the venerable Italian glassblowing tradition; it also marked his collaboration with Lino Tagliapietra, a foremost Italian glass artist, and a return to the vessel form (broadly conceived). As Chihuly has also noted, "One of the big differences between the *Venetian* series and my earlier work is that in these pieces the form is made and then things are added to it. I never made additions before this, nor had any of my crew." Moreover, as Davira Taragin points out, "Because of the very direct nature of Chihuly's working relationship with Tagliapietra, the *Venetians* are unique within Chihuly's oeuvre for their one-to-one correspondence between [Chihuly's] drawings and the glass object."[4] For that reason, Chihuly's exhibitions often display *Venetian* objects and *Venetian* drawings together, with numerous examples of both objects and drawings arranged on walls in rows.[5]

As with all of the Chihuly series, the *Venetians* have evolved over time. Early works are often large in scale, as Chihuly pushed the limits of the material. The large vessels of various forms were notable for their applied excrescences of scrolls, prunts, handles, flowers and leaves, curls, ribbons, or even birds and fish. Working with several gaffers, Chihuly has developed related series, including the *Putti* series in collaboration with Tagliapietra and another outstanding Italian glass artist, Pino Signoretti, and other variations in different sizes and color palettes.[6] Tagliapietra's association with the *Venetians* ended in the mid-1990s. Since then, Richard Royal, James Mongrain, and Dante Marioni have continued to work with Chihuly on additional expressions of the series.[7]

The *Ikebana* series, started in 1989, makes reference to the Japanese art of flower arranging in its title and reflects

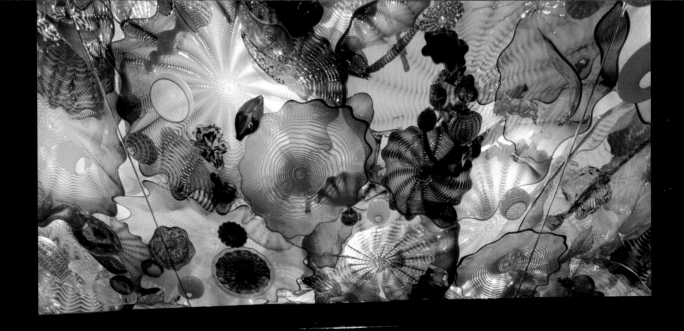

Persian Ceiling
de Young Museum
San Francisco, Calif
2008
4.6 x 8.5 m (15 x 28

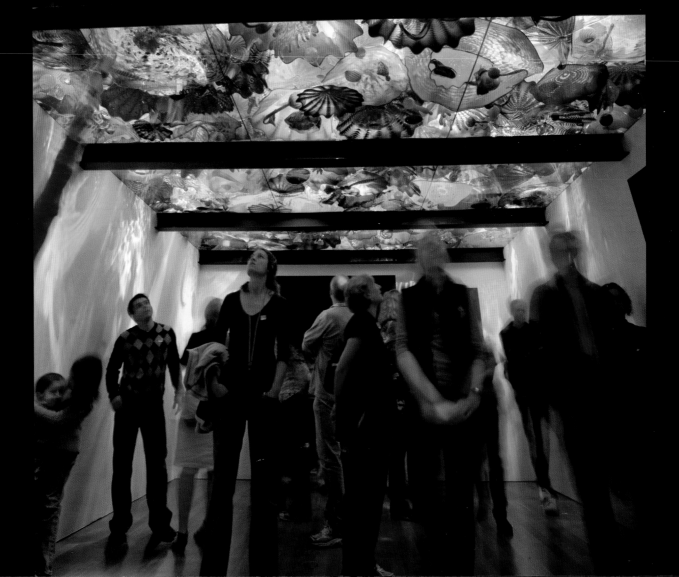

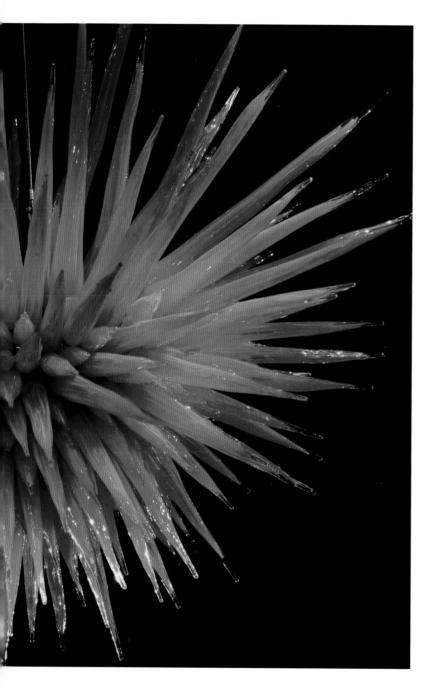

Scarlet Icicle Chandelier (detail), Museum of Fine Arts, Boston, 2011,
1.8 x 2.3 x 1.8 m (6 x 7 ½ x 6 ft.)

Chihuly's lifelong interest in plants and the natural world. The series developed organically from the *Venetian* series, similarly indebted to the skills and visions of Lino Tagliapietra. *Ikebana*, however, could be even larger, ranging to as much as 1.8 meters (6 feet) tall. Like all of the Chihuly series, the *Ikebana* have evolved over time, as new gaffers and artists have become involved. The initial vessels were ordinarily vaselike in form, with leaves, stems, and other stylized floral devices emanating from their mouths. Within a few years, long *Ikebana* tendrils were fashioned and formed into large compositions, as with the circular *Lackawanna Ikebana* installed at Union Station in Tacoma in 1994, some 5.5 meters (18 feet) in diameter, and in several botanical garden exhibitions.[8]

Chandeliers and Towers

Inspired by an epiphany at a Barcelona restaurant, Chihuly made his first *Chandelier* in 1992 for an exhibition at the Seattle Art Museum.[9] Just a few years later, he installed his first outdoor example, the *Icicle Creek Chandelier* mounted atop a granite boulder in Leavenworth, Washington.[10] *Chandeliers* were the focal point of what many consider to be Chihuly's "break-out" exhibition, "Chihuly Over Venice," in 1996. Chihuly organized a display of fourteen *Chandeliers* throughout the Italian city, drawing upon Irish, Finnish, Mexican, and American glassblowers to create these unique works that established him as a significant international presence in the contemporary art world.[11] *Chandeliers* (which hang down like stalactites) and *Towers* (which rise up from the ground like stalagmites) are among the largest and most visually compelling objects created by Chihuly, and have become an integral part of many installations in museums, botanical gardens, and elsewhere. A *Red Icicle Chandelier* greets visitors as they enter the main gallery in the MFA exhibition.

Joey DeCamp has been the lead gaffer for the *Towers* and *Chandeliers* since 1995. As the series has progressed, the forms have gotten larger and the armatures more complex, and the shapes of the numerous individual components have evolved from rounded, gourdlike shapes to more angular, wavelike forms that have been given their own descriptive terminology, such as "hornet," "stinger," and "twisted horn." The *Lime Green Icicle Tower* installed at the MFA stands 12.6 meters (41.5 feet) tall and weighs in excess of 4,080 kilograms (9,000 pounds); other examples have been more than 16.8 meters (55 feet) high.

Chihuly has commented on his *Chandeliers* frequently. He has observed, for example, that "The *Chandeliers* [I have made] range from three to thirty feet [one to nine meters] in length and can be made up of as many as a thousand elements attached to a stainless steel armature. The parts can be bulbous, long and twisted, short and spiraled, or even frog-toed. Hung together, the many pieces that make up each *Chandelier* create a unified, though complex, composition." Any given *Chandelier*, which "doesn't really symbolize anything," achieves its quality through "the massing of color. If you take a thousand blown pieces of one color, put them together, and then shoot light through them, now that's going to be something to look at." They are, according to Davira Taragin, Chihuly's "most significant contribution to installation art of the late twentieth century."[12] The exhibition at the MFA contains a gallery with six *Chandeliers* and *Towers*, more than Chihuly has included in any previous museum exhibition.

Reeds

The glass forms known as *Reeds* (or sometimes as *Water Reeds* or *Spears*) consist of tall glass rods, often inserted into birch logs or the ground, occasionally crisscrossed in tipi fashion, sometimes left leaning against a structure, or at

Lime Green Icicle Tower (detail), Museum of Fine Arts, Boston, 2011
12.6 m (41½ ft.)

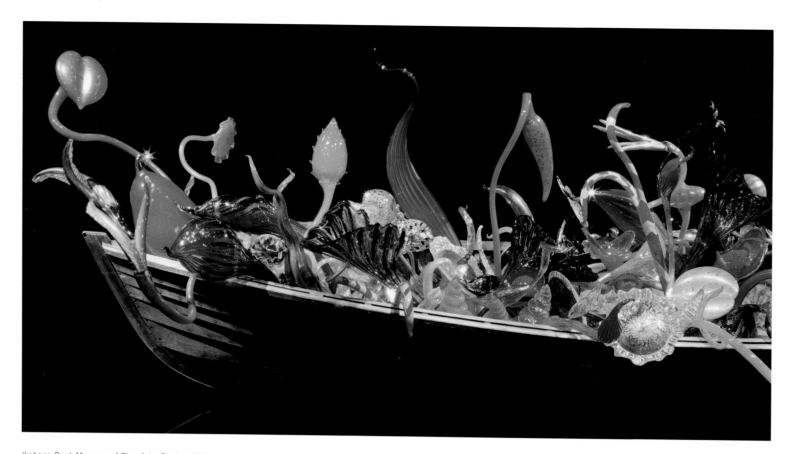

Ikebana Boat, Museum of Fine Arts, Boston, 2011
1.5 x 5.2 x 2.1 m (5 x 17 x 7 ft.)

other times placed over steel rods in the water or even hung in trees. They have been a feature of Chihuly installations for the last fifteen years, and are made in various colors— such as red, yellow, turquoise blue, or the Chihuly version of bright blue/lavender known as neodymium. Since their inception, Chihuly has kept making *Reeds*, in his characteristic fashion, "longer and longer and longer."[13] They were used to particularly dramatic effect as a part of the "Chihuly in the Light of Jerusalem 2000" project, where examples of *Spears* made in France joined those made in Finland, along with related *Green Grass* forms fashioned in the Czech

Republic.[14] Most of Chihuly's *Reeds* are made in Finland, although he has also had them made in a glasshouse in Bullseye, Oregon, that had ceilings high enough and ovens long enough to allow for the creation of the objects. Thomas Hoving described the "mysterious and poetic" appearance of *Reeds* at an exhibition in 2008: "a romantic image of a primeval forest bathed in blue moonlight. Dozens of faintly threatening, spearlike, azure, and cerulean *Reeds* were planted into five immense birch logs whose pale white and speckled bark contrasted splendidly with the stark and shimmering blues of the *Reeds*."[15]

Mille Fiori

The *Fiori* series dates to 2003, when Chihuly assembled his first such installation at the Tacoma Art Museum, measuring 7.6 by 8.5 by 17 meters (25 by 28 by 56 feet). Ultimately derived from a life-long fascination with flowers, *Mille Fiori* developed more immediately out of Chihuly's experience in seeing his work displayed amidst the natural botanical forms of glasshouse conservatories. The *Mille Fiori* assemblages draw upon much of Chihuly's earlier work; they include examples from many of his series from the 1980s and 1990s, as well as more recent work, even including *Chandeliers*. The arrangements have varied from dense to spare, and blend vertical with horizontal elements. The gardenlike installation at the MFA is more than 18.3 meters (60 feet) in length, the largest *Mille Fiori* to date.[16]

Boats

Like many of his installations, the *Boats* developed organically and spontaneously from an earlier project. While in Finland in 1995, preparing for "Chihuly Over Venice," Chihuly got the idea to toss some of his spheres and other forms into the local river. "A group of teenage boys in wooden boats started to retrieve the pieces, and Chihuly was struck by the energy between the old boats and his weird array of contemporary glass forms." This observation led to the creation of installations featuring small wooden boats placed on a reflective glass surface. A boat might be "jammed to the gunwales" with *Niijima Floats* or contain many types of objects, as in an *Ikebana Boat*.[17]

Northwest Room

One of the most distinctive spaces in Chihuly's Seattle Boathouse is a room devoted to the unified, coordinated display of his collections and his objects connected with Native American art and design. This Northwest Room (sometimes referred to in the past as the Indian Room) has been replicated recently by Chihuly for museum exhibitions. In a review of one such installation, Hoving observed somewhat remarkably that the display "was, to [him], one of the most striking, effective, and memorable galleries ever created in any museum show in America virtually since museum shows began." He continued: "The delicacy of the forms and the colors—tinges of brown, beige, and the occasional spark of rust—of Chihuly's *Tabac Baskets* were downright miraculous. If he had invented only the *Tabac Baskets,* his career would have made the history books."[18]

Neon

Boathouse Neon II is a lengthy and colorful work that spans the width of the Ruth and Carl J. Shapiro Family Courtyard. Using inert gases in glass tubing provides Chihuly with another means of working with color. Neon (red to orange) and argon (whitish blue) generate their own specific hues, while the glass tubing can itself be colored or coated with fluorescent powder to achieve additional color variations. In this site-specific work, Chihuly takes advantage of niches in the exterior wall of the Museum's original 1909 building, which adjoins the glass-enclosed courtyard opened in 2010, creating syncopated patterns of light and color and bringing old and new together.

• • • • •

"Chihuly: Through the Looking Glass" thus provides a thorough reprise of the artist's oeuvre, revealing his ability to transform specific spaces into his own alternate realities. The emphasis in each area is on beauty. While each individual viewer's reaction varies, some theorists might suggest that Chihuly's glass is popular because it is pleasing to the eye in terms of its colors, patterns, and frequent evocation of familiar, natural shapes. Moreover, it is also a type of virtuoso performance that gives people pleasure through the contemplation of the process of its clearly complicated creation.[19] That is quite a lot for a humble mixture of sand and ash to achieve.

A lot of the work I do is inspired by nature or looks as if it might come from nature, but I don't look at something specific in nature to make a piece. I just sort of have a natural feeling for using glass—trying to take advantage of the color and transparency that glass offers. Also, I'm making use of the ability to take this ancient material, which is blown with human breath—this magical material—to some new place.

Japanese Bridge Chandelier
Missouri Botanical Garden
St. Louis, Missouri, 2006
1.4 x 2.4 x 2.1 m (4½ x 8 x 7 ft.)

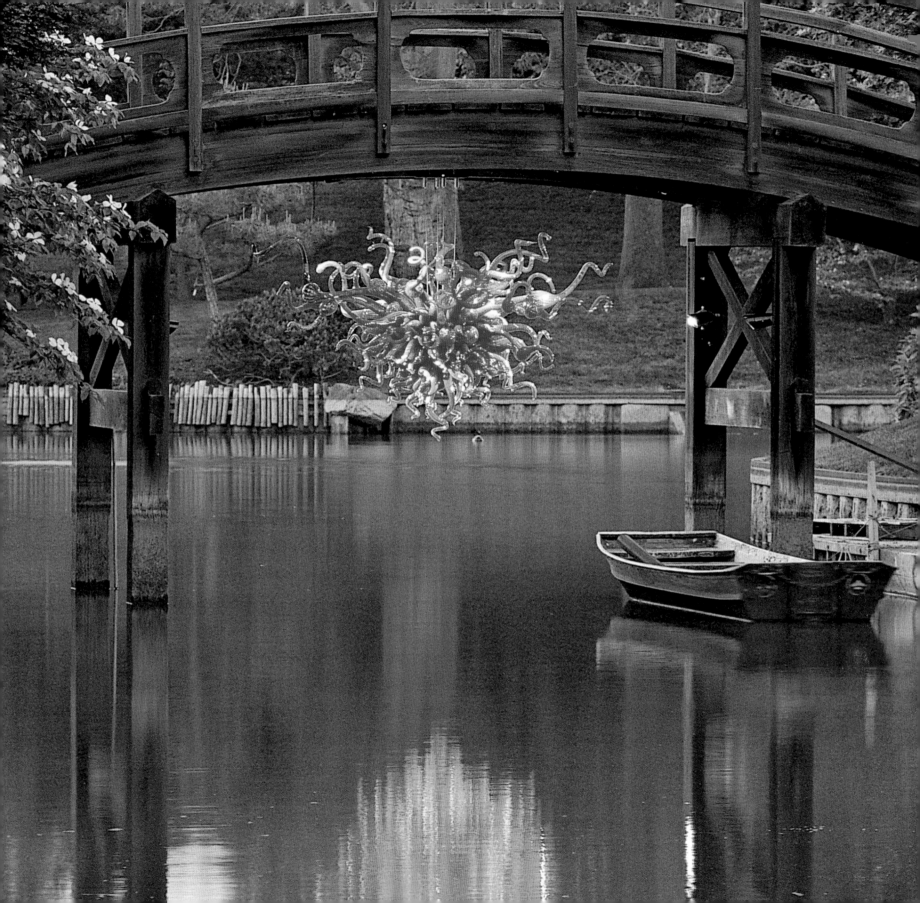

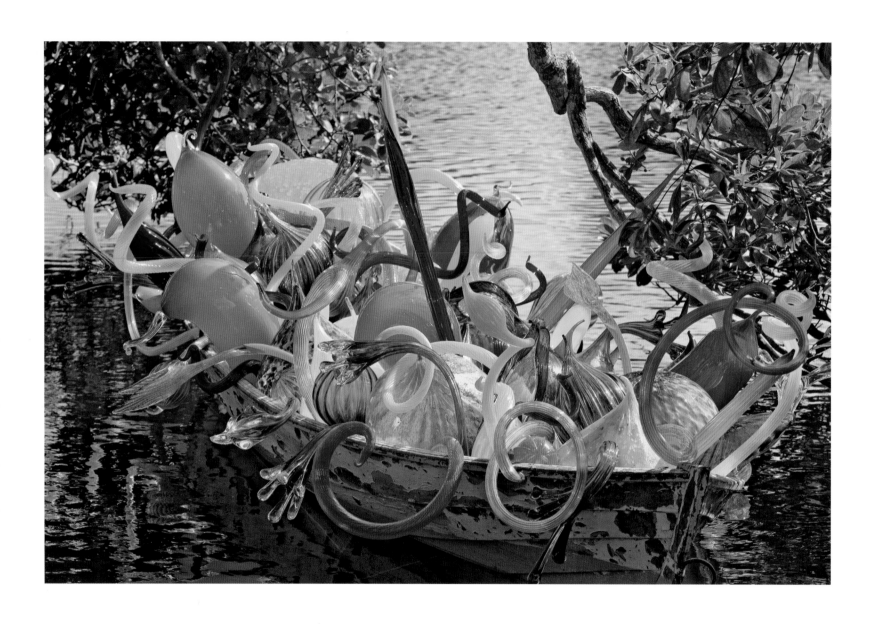

Carnival Boat
Fairchild Tropical Botanic Garden
Coral Gables, Florida, 2005
1.2 x 4.6 x 1.5 m (4 x 15 x 5 ft.)

> *Isola di San Giacomo in*
Palude Chandelier
Venice, Italy, 1996
2.6 x 2.1 m (8½ x 7 ft.)

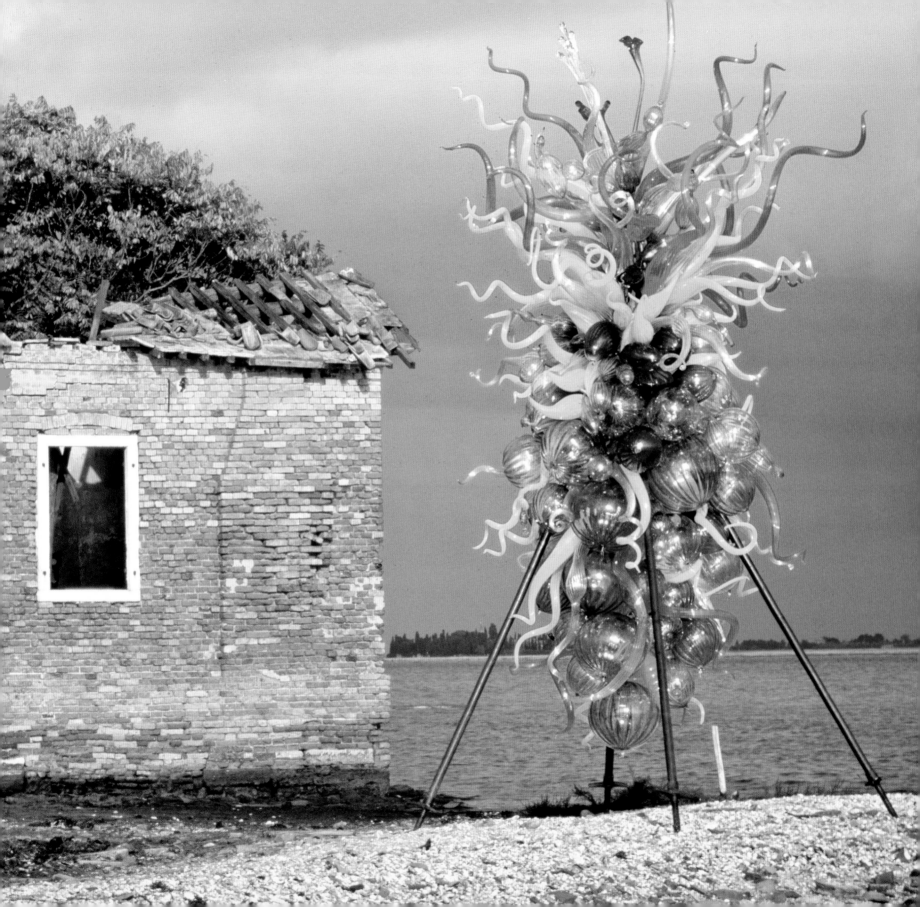

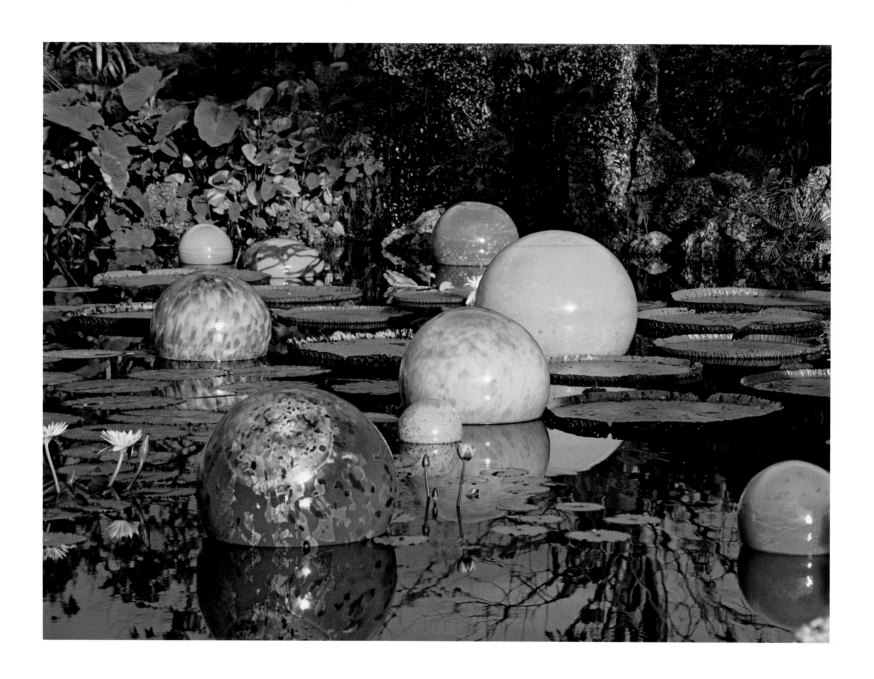

Niijima Floats
Fairchild Tropical Botanic Garden
Coral Gables, Florida, 2005

Niijima Floats
Palm Springs, California, 1999

(following pages)
Niijima Tower
Niijima, Japan, 1997
2.4 x 0.9 m (8 x 3 ft.)

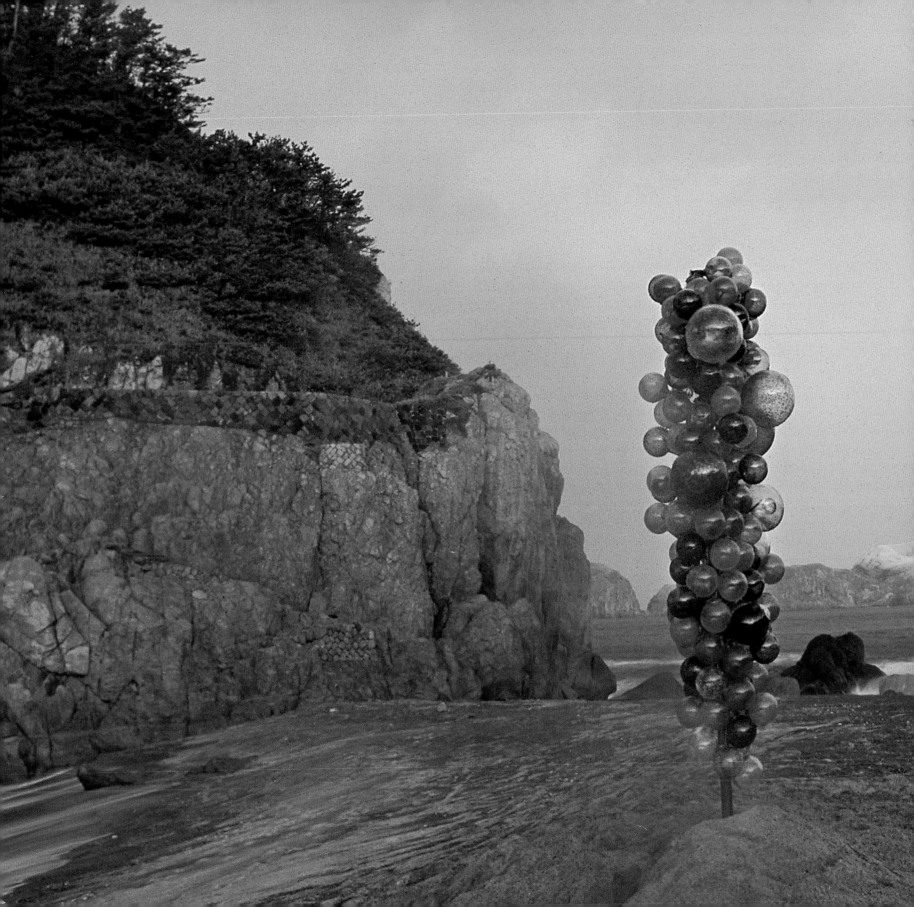

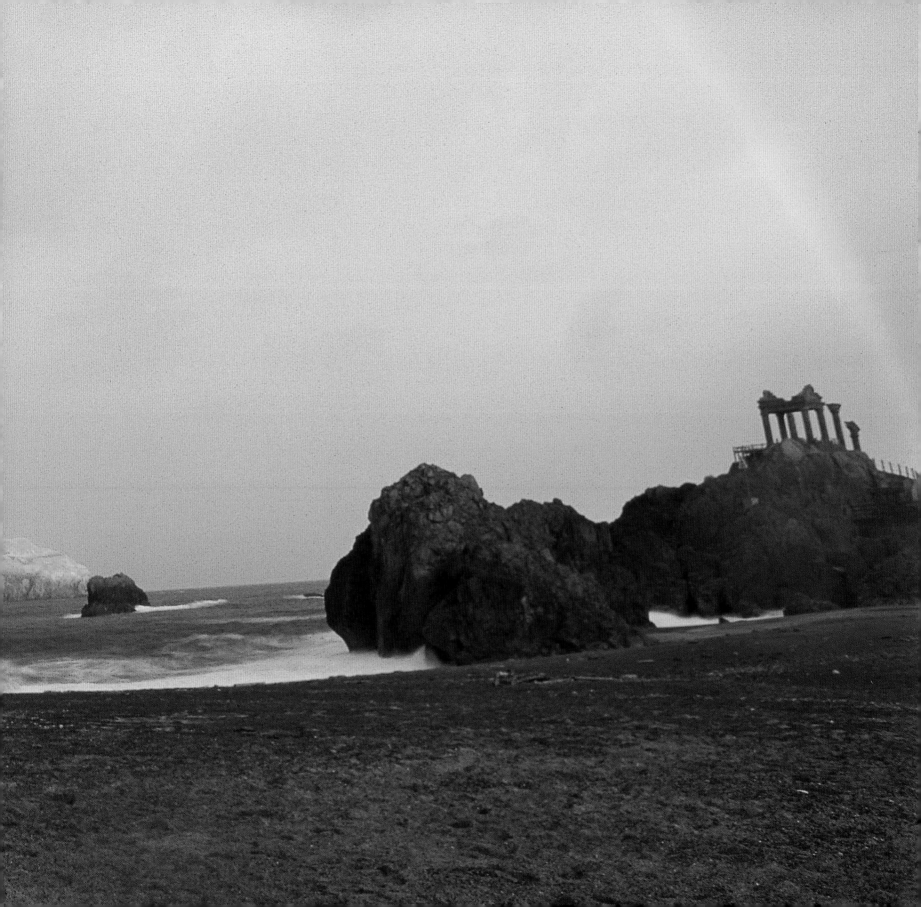

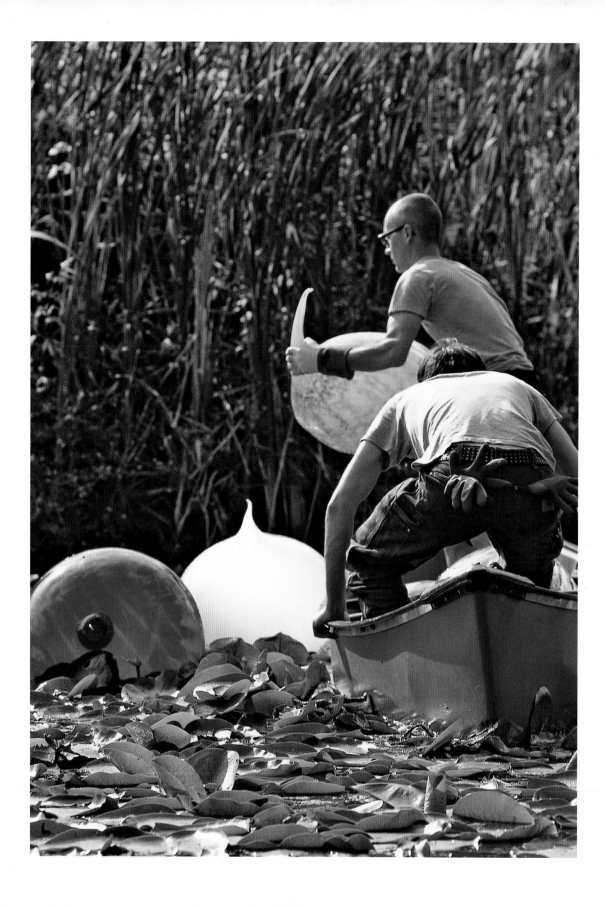

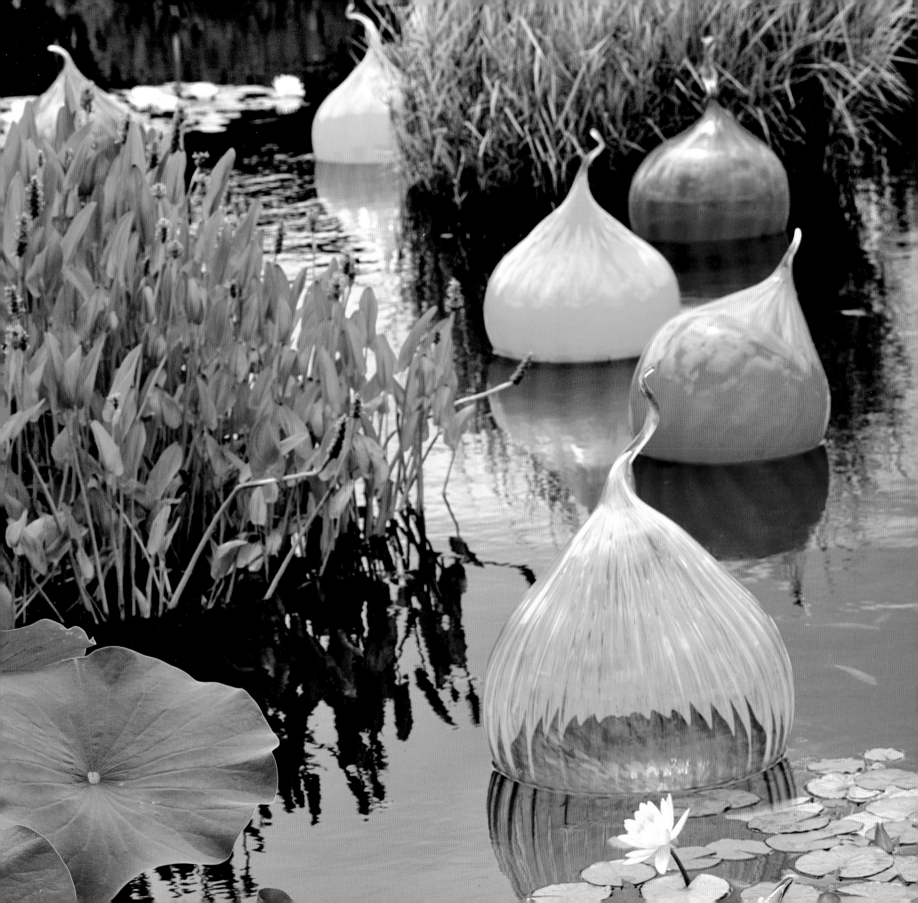

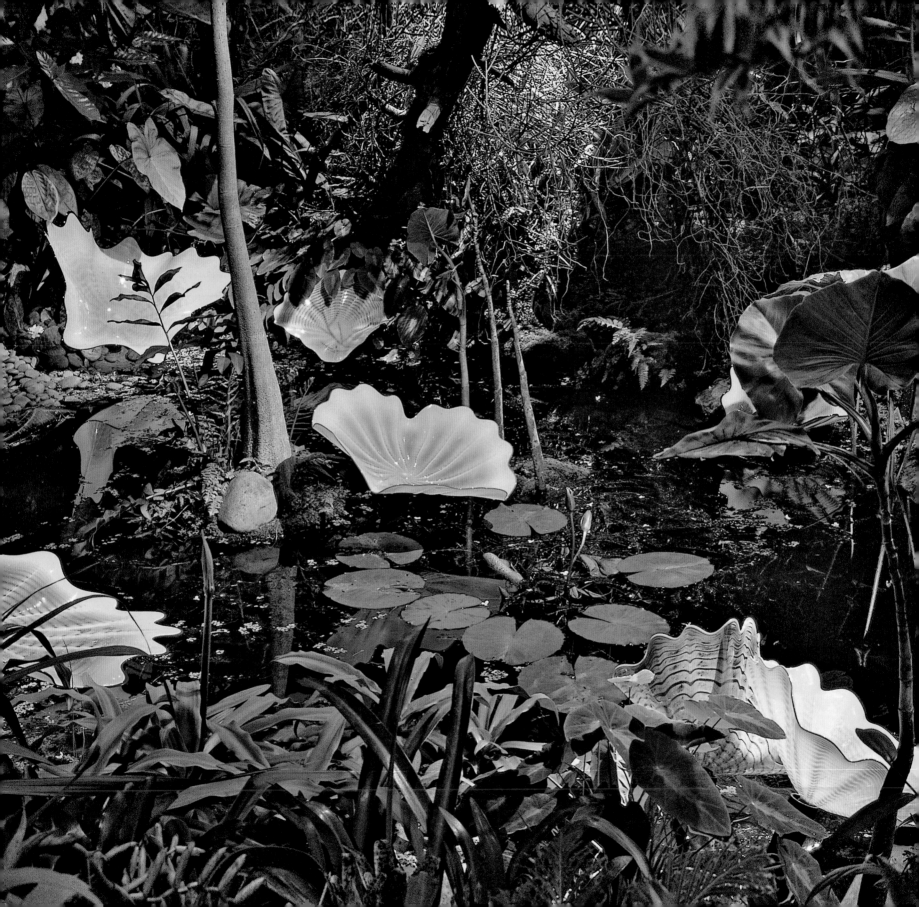

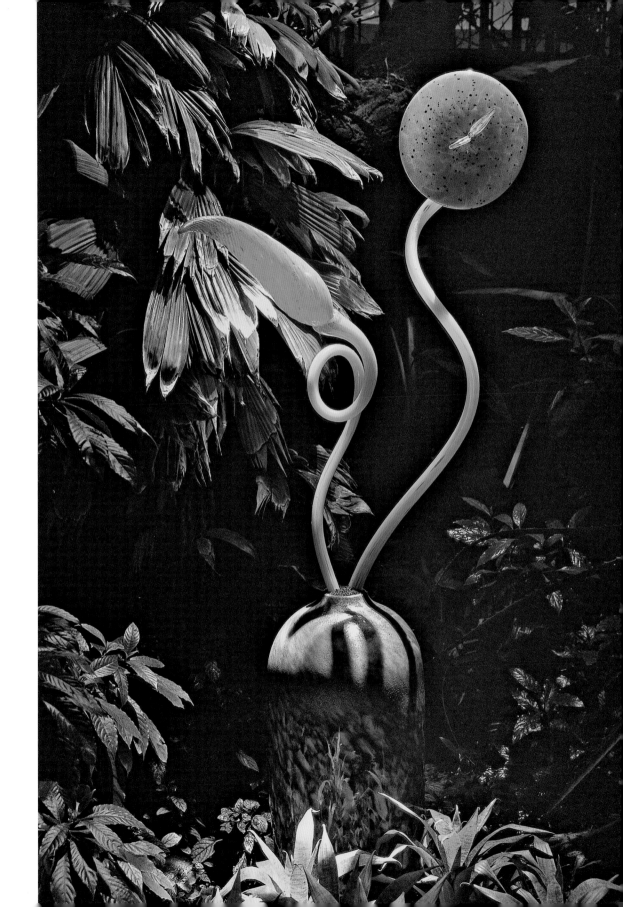

< *Persian Pond*
Atlanta Botanical Garden
Atlanta, Georgia, 2004

> *Mottled Bronze Ikebana with
Apricot and Chartreuse Stems*
Missouri Botanical Garden
St. Louis, Missouri, 2006
172 x 71.1 x 35.6 cm (68 x 28 x 14 in.)

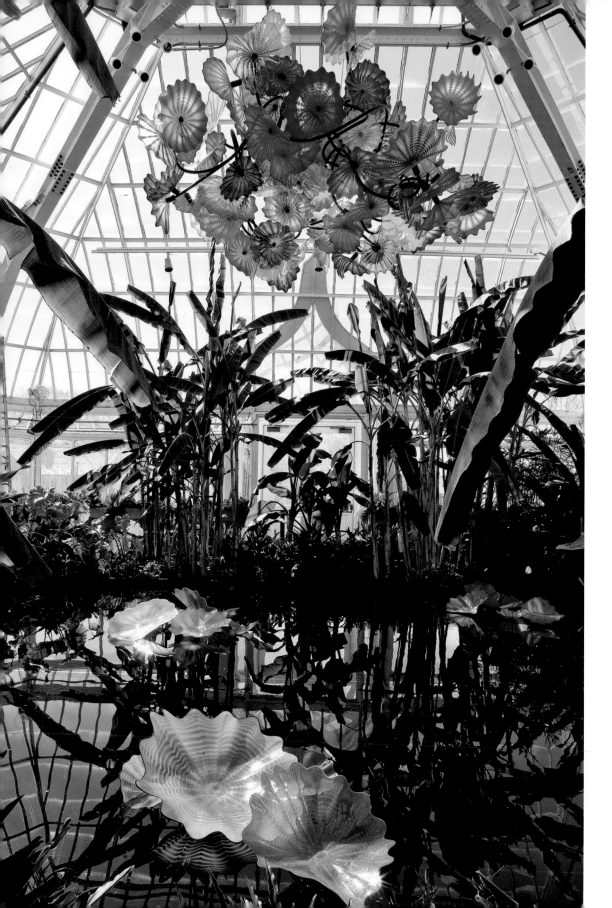

Persian Chandelier
Phipps Conservatory and
Botanical Gardens
Pittsburgh, Pennsylvania, 2007
2.4 x 3 x 2.7 m (8 x 10 x 9 ft.)

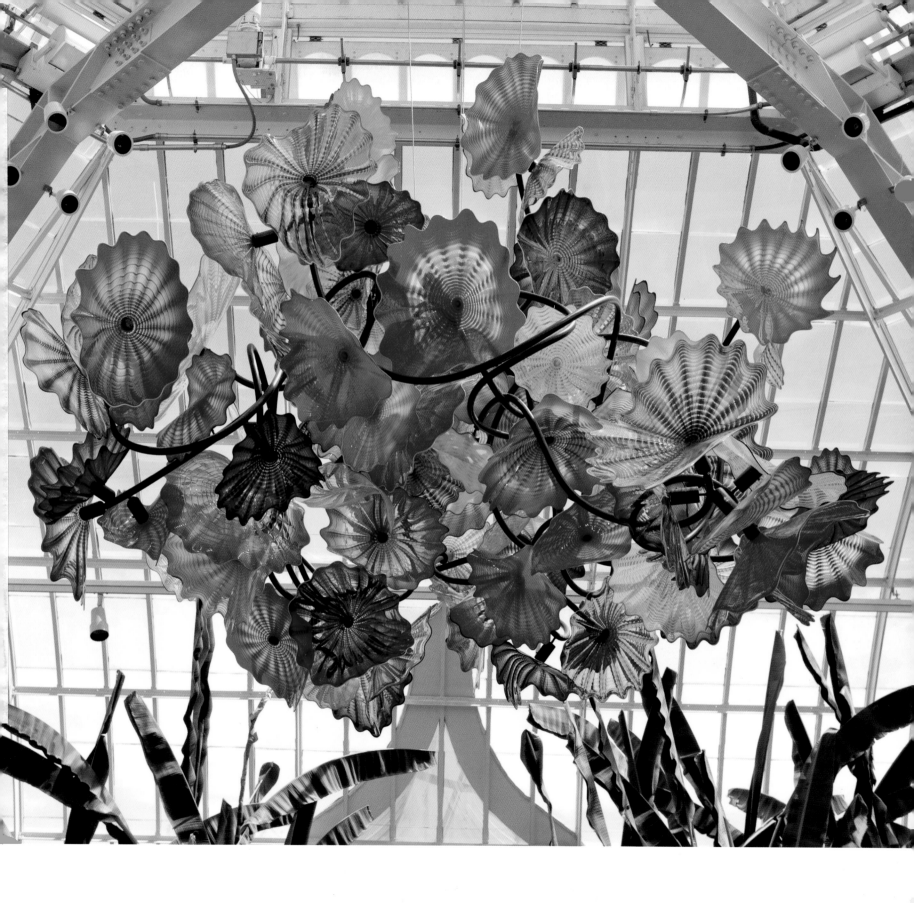

Dale Chihuly with *Red Spears*
Vianne, France, 1997

> *Japanese Garden Red Reeds*
Portland, Oregon, 1997

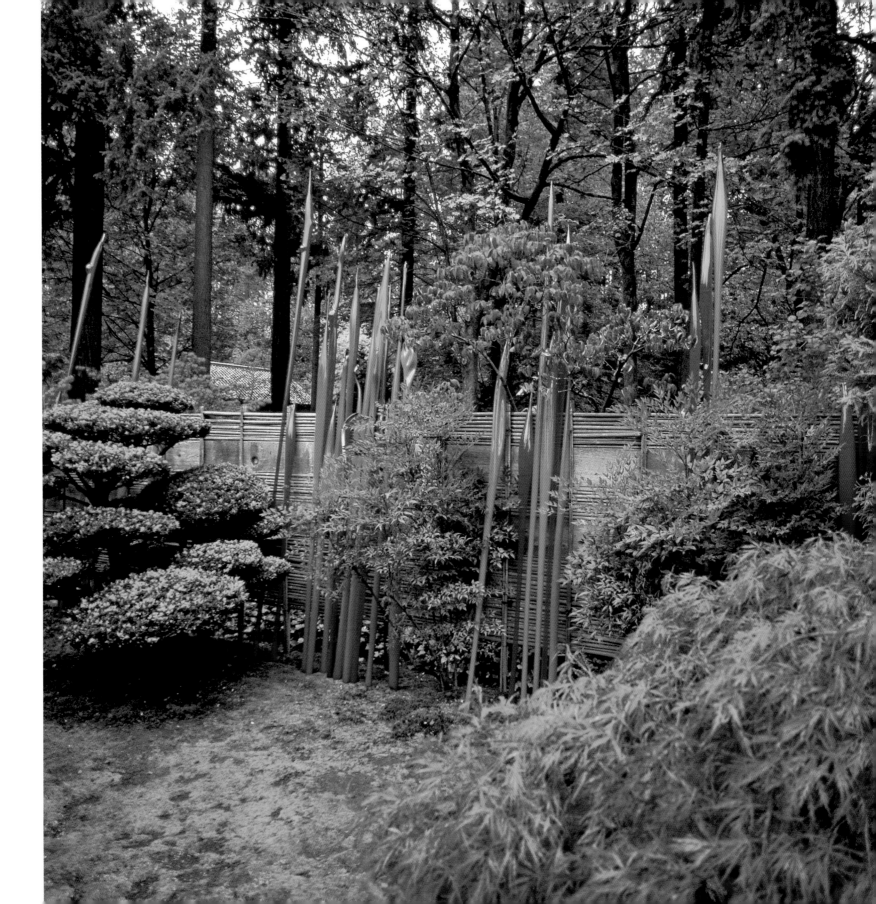

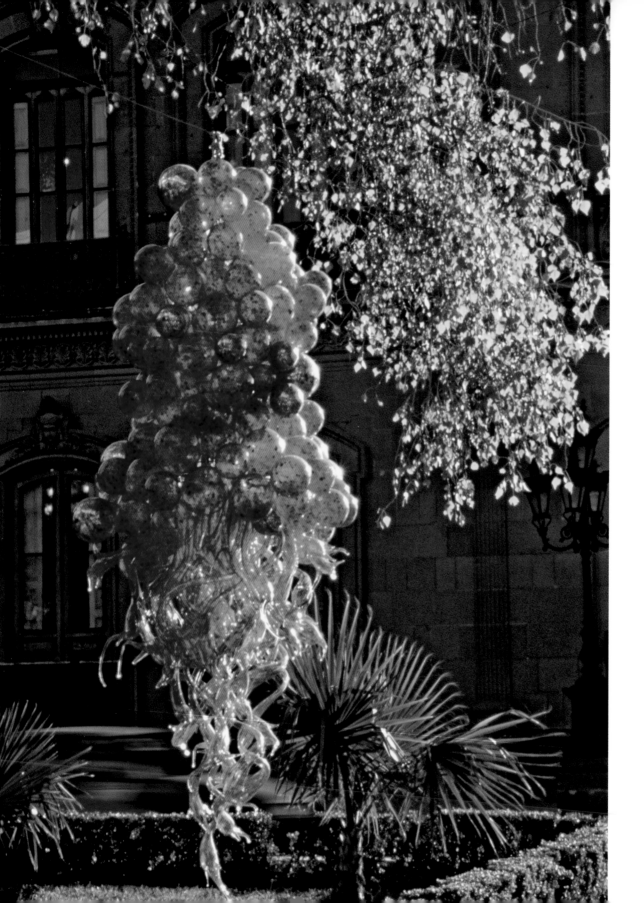

Mexican Plaza Chandelier
Monterrey, Mexico, 1996
3 x 1.5 m (10 x 5 ft.)

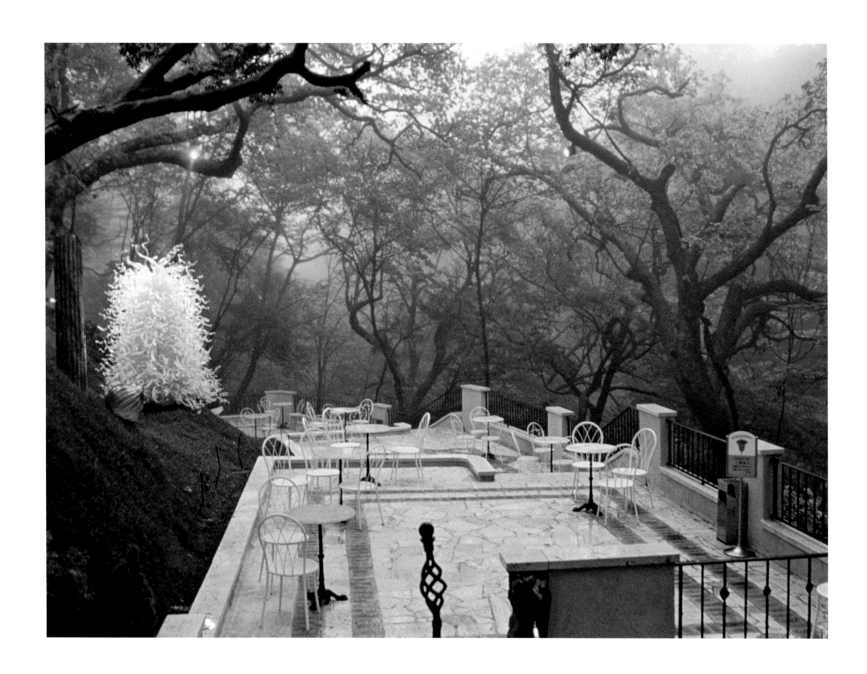

Palazzo Ducale Chandelier
Hakone Glass Forest, Ukai Museum
Hakone, Japan, 1997
2.7 x 1.8 x 1.8 m (9 x 6 x 6 ft.)

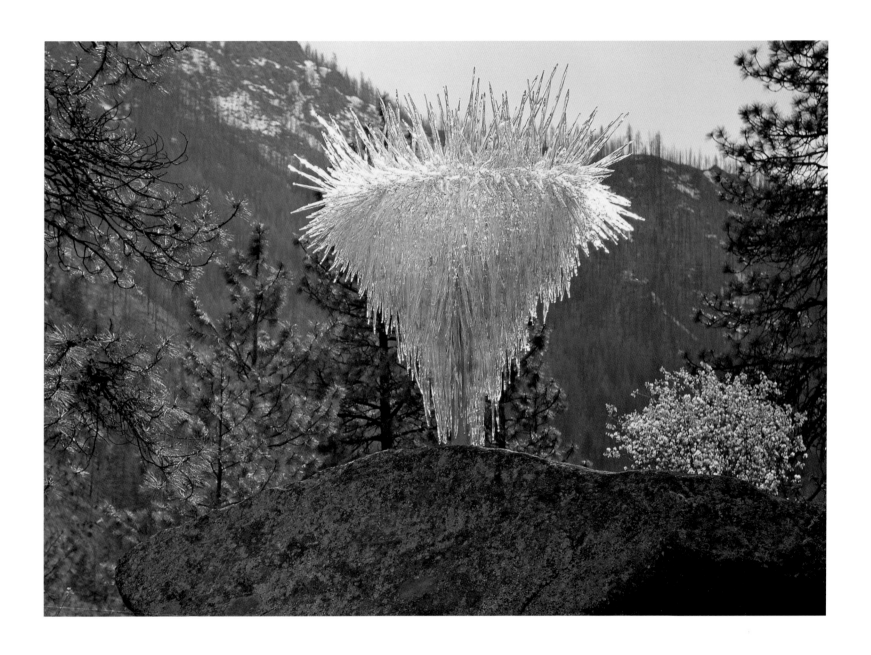

Icicle Creek Chandelier
Leavenworth, Washington, 1996
3.7 x 2.7 x 1.8 m (12 x 9 x 6 ft.)

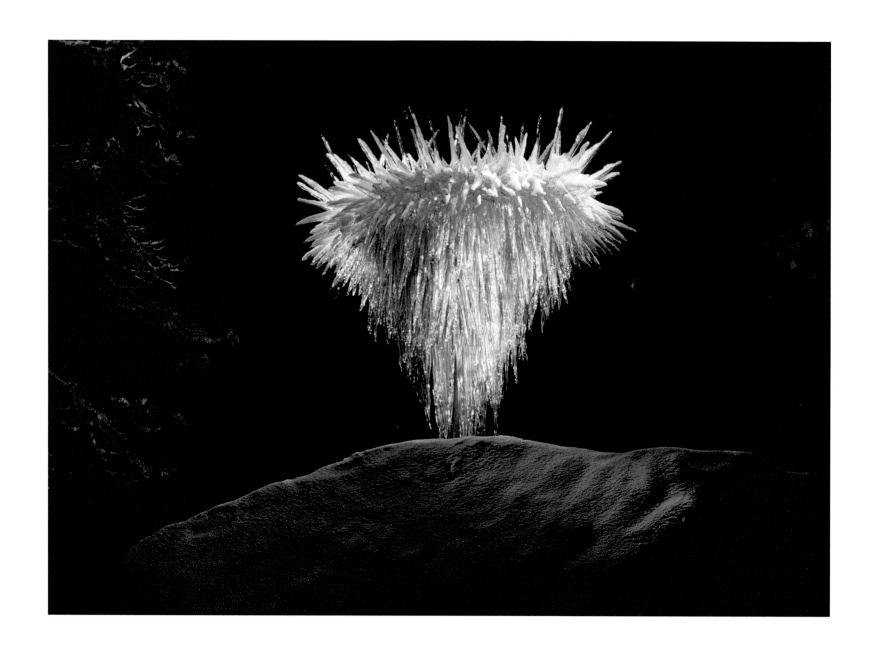

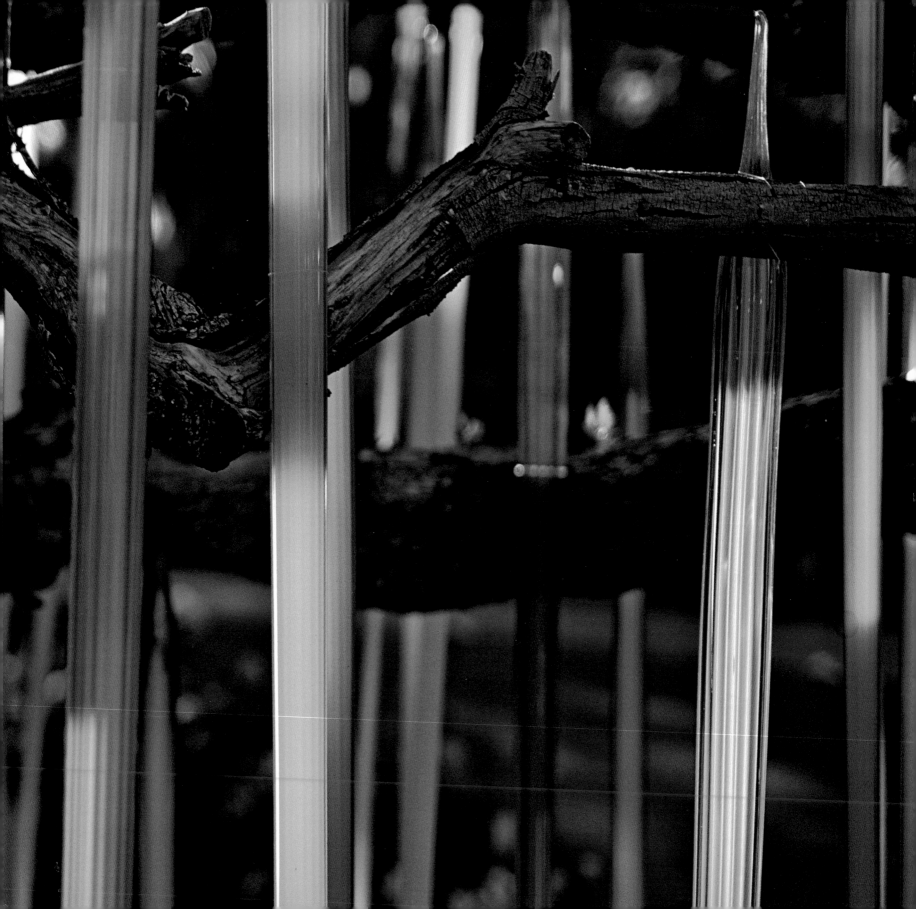

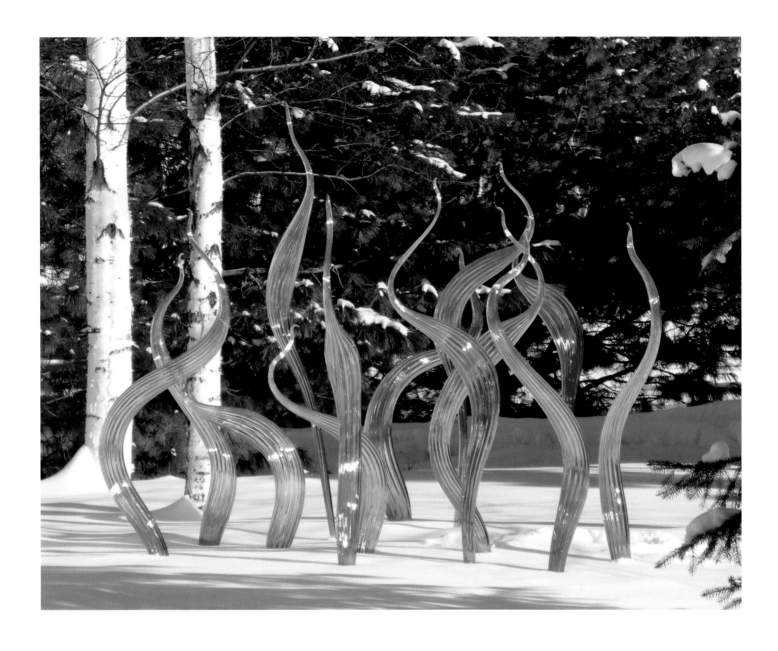

< Purple Reeds (detail)
Palm Springs, California, 2000

Herons
Nuutajärvi, Finland, 2010

Public installations are my favorites because so many people get to see the work and I'm lucky that my work appeals to such a wide cross section of people... I want people to be overwhelmed with light and color in some way they've never experienced.

Ponti Duodo e Barbarigo
Chandelier
Venice, Italy, 1996
3.4 x 1.2 m (11 x 4 ft.)

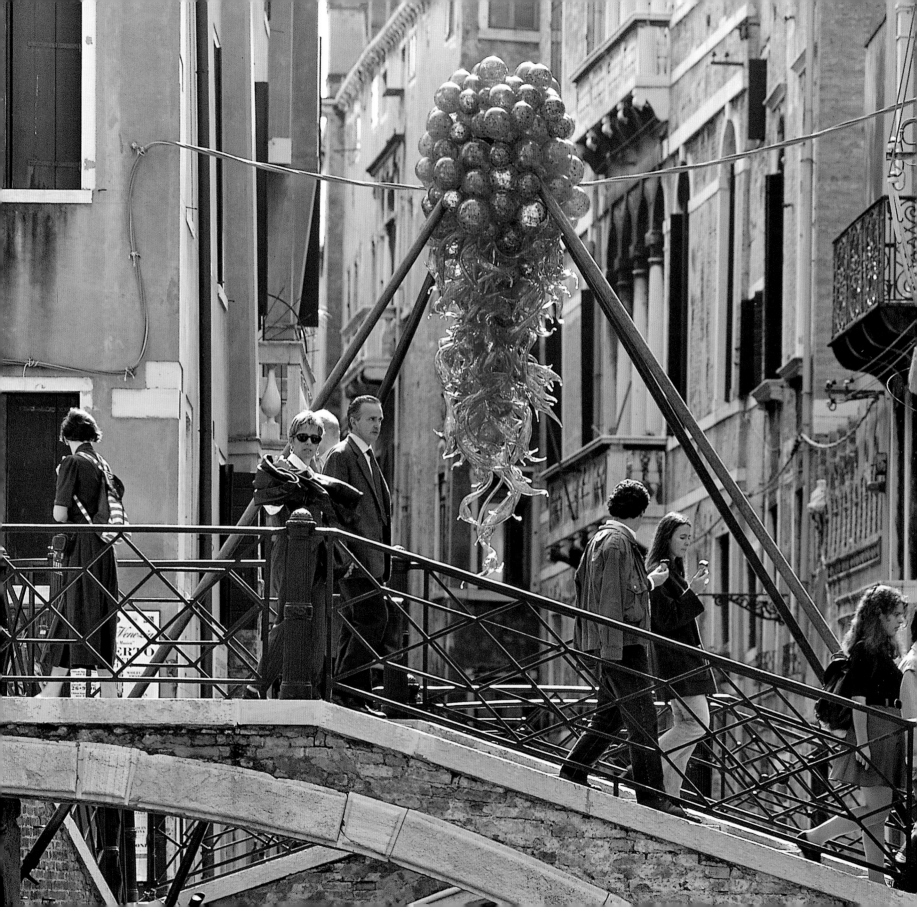

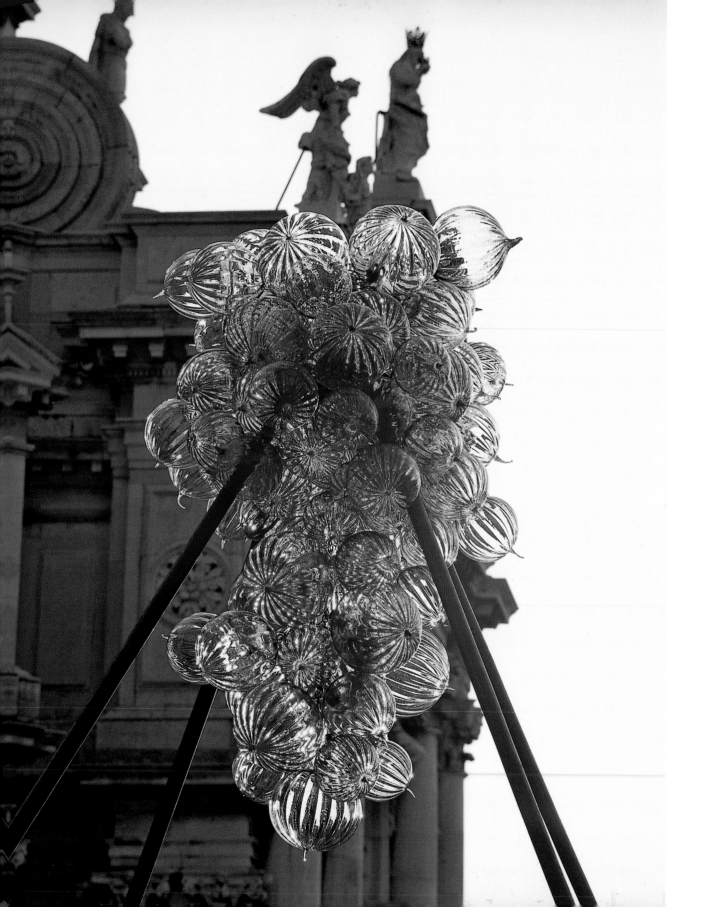

Campo della Salute Chandelier
Venice, Italy, 1996
4.3 x 1.8 m (14 x 6 ft.)

Campiello Remer Chandelier
Venice, Italy, 1996
3.8 x 1.7 m (12½ x 5½ ft.)

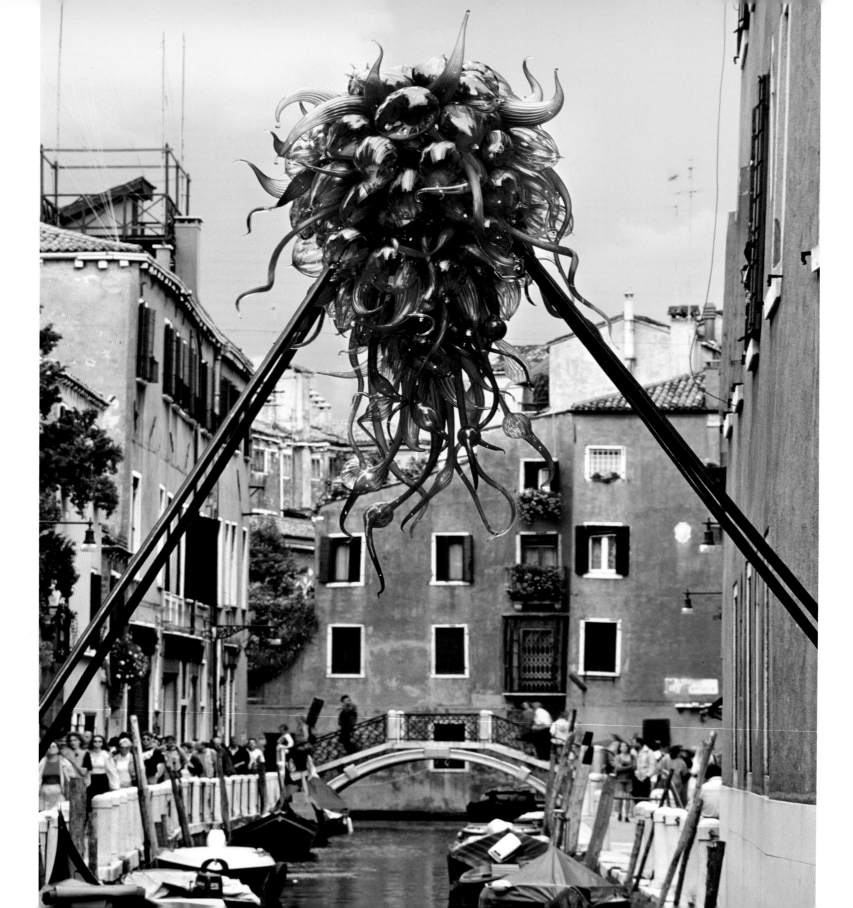

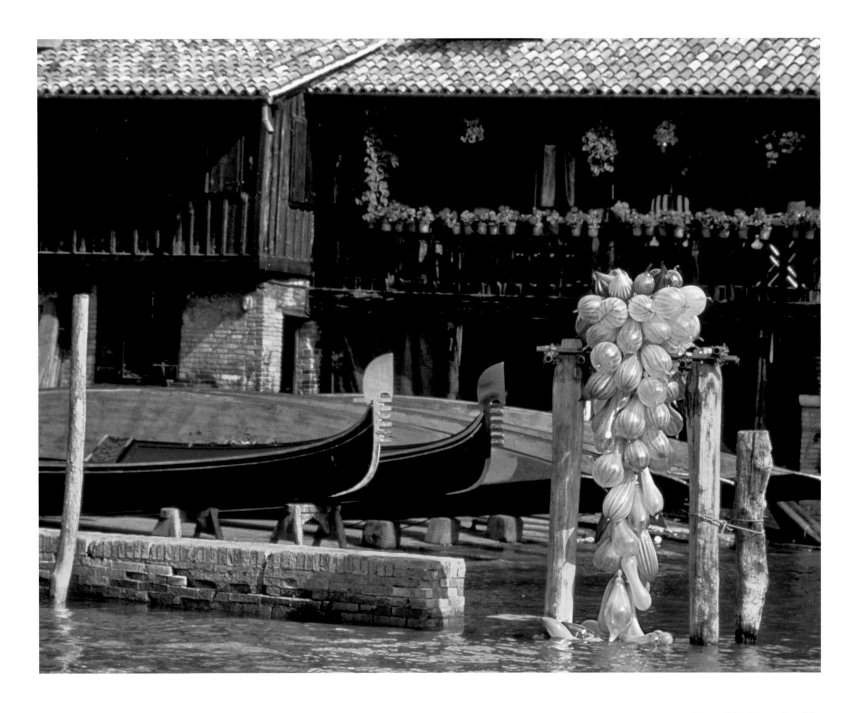

< *Rio delle Torreselle Chandelier*
Venice, Italy, 1996
2.1 x 2.4 m (7 x 8 ft.)

Squero di San Trovaso Chandelier
Venice, Italy, 1996
3 x 1.2 m (10 x 4 ft.)

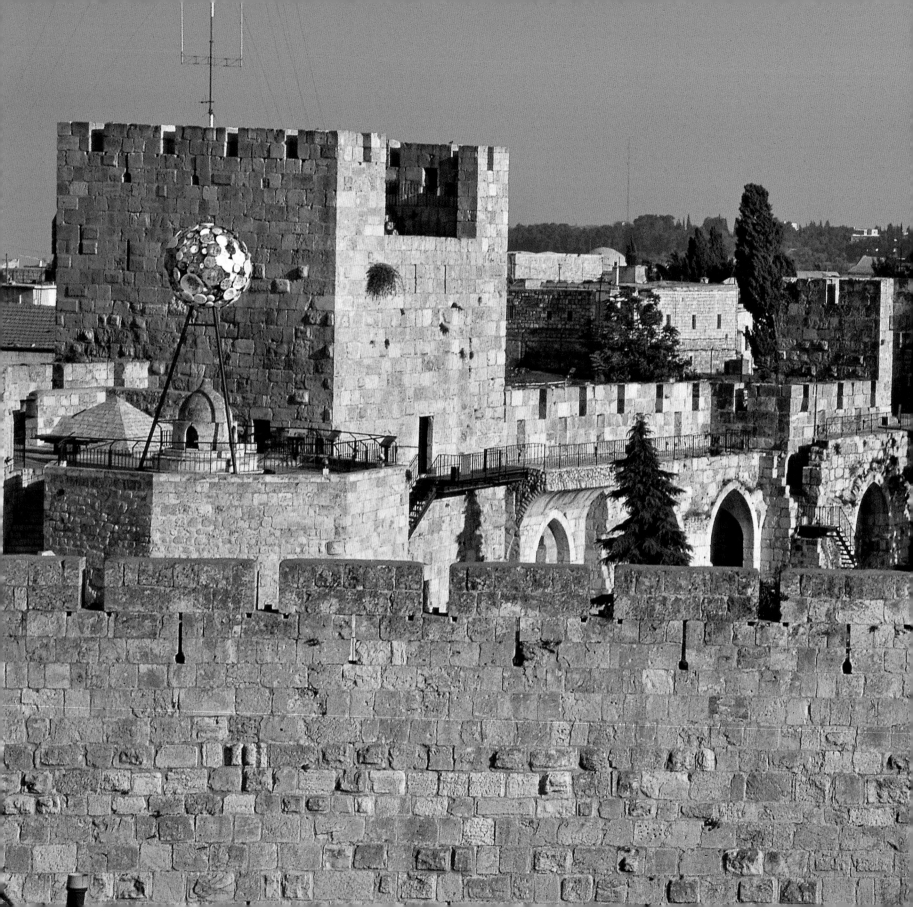

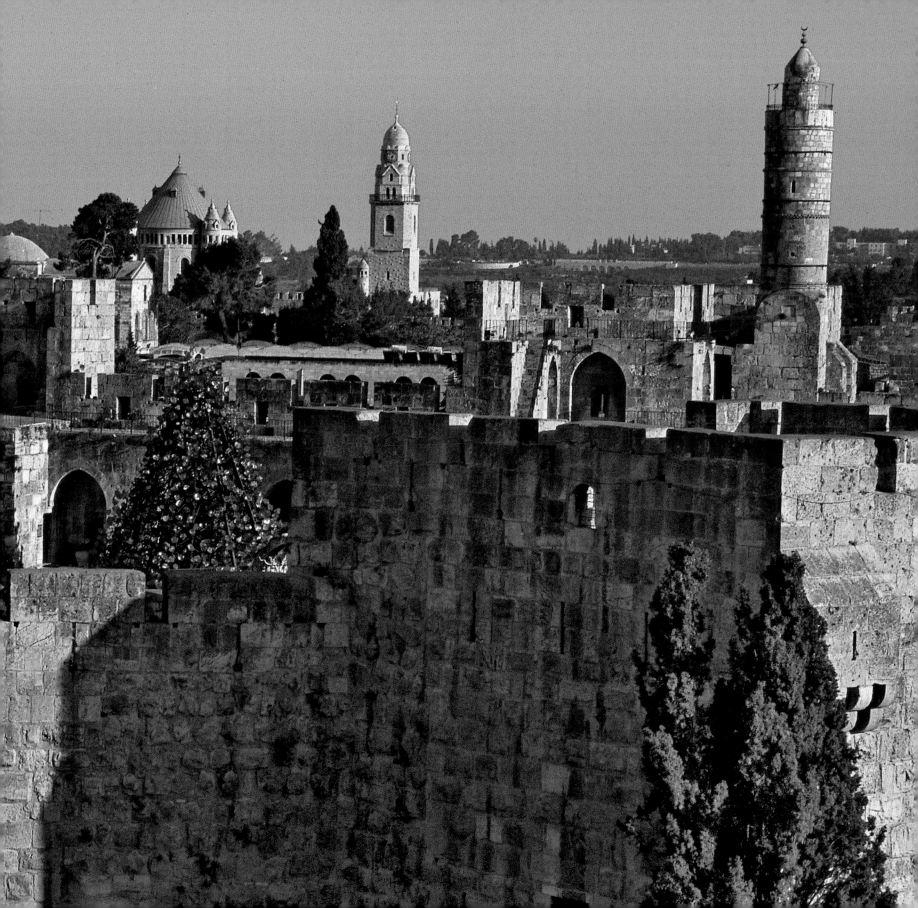

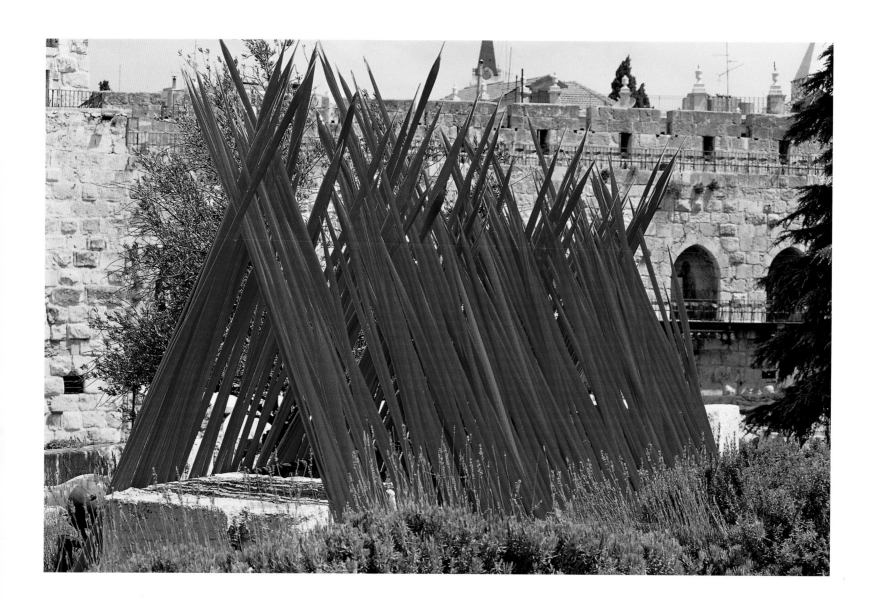

(previous pages)
Crystal Mountain and Moon
Tower of David Museum of the
History of Jerusalem
Jerusalem, Israel, 1999

Red Spears
Tower of David Museum of the
History of Jerusalem
Jerusalem, Israel, 1999

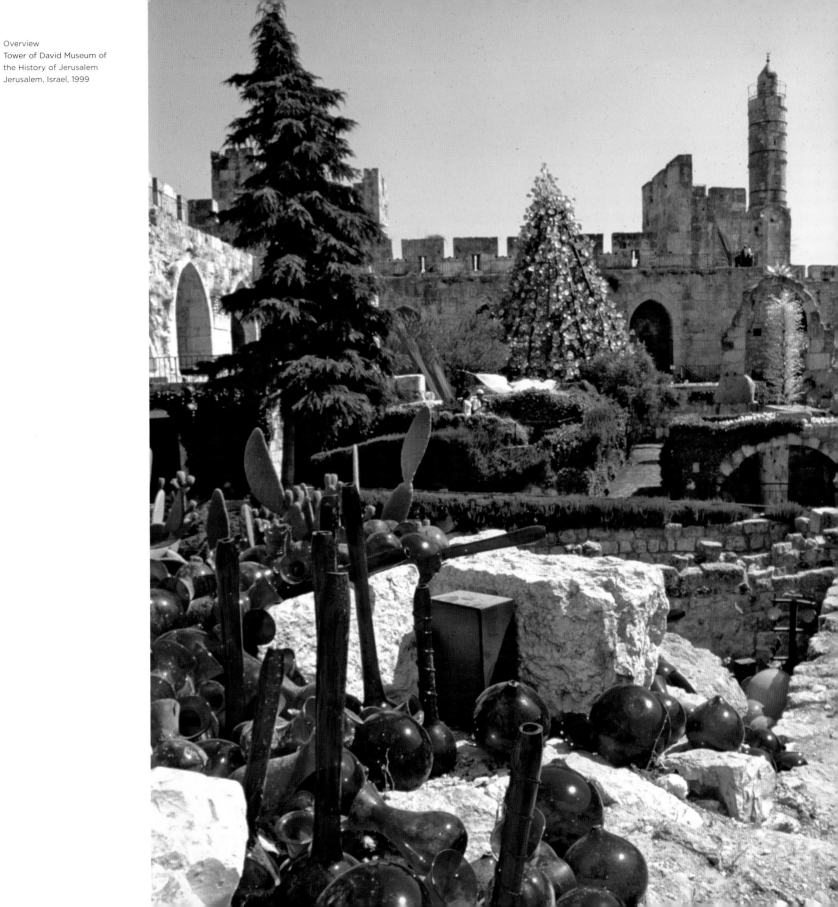

Overview
Tower of David Museum of
the History of Jerusalem
Jerusalem, Israel, 1999

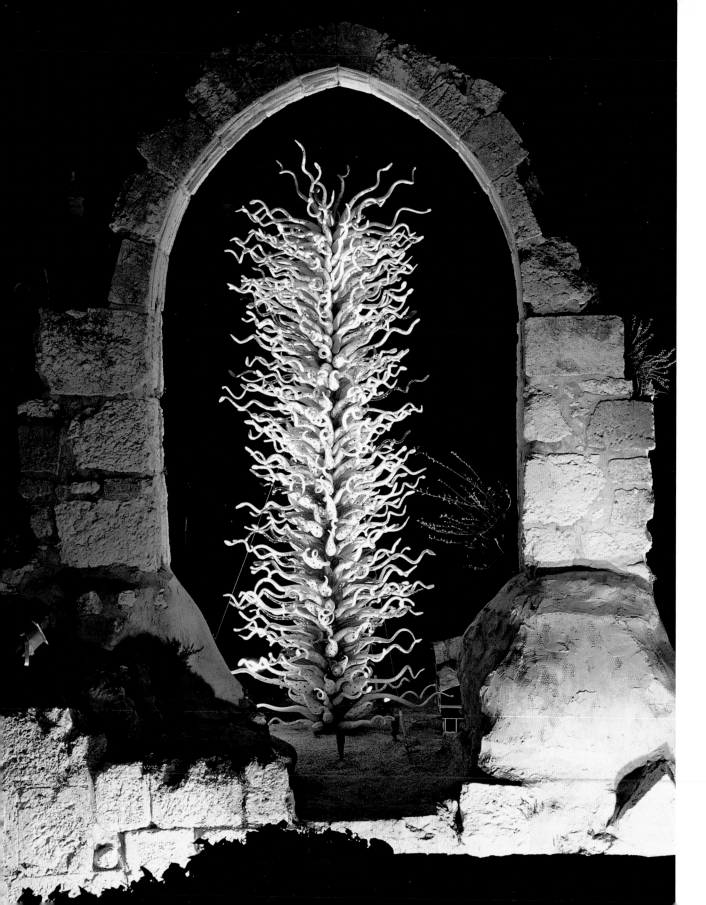

< *White Tower*
Tower of David Museum of
the History of Jerusalem
Jerusalem, Israel, 1999
2.3 x 1.8 x 1.8 m (7½ x 6 x 6 ft.)

> *Niijima Floats*
Tower of David Museum of
the History of Jerusalem
Jerusalem, Israel, 1999
5.9 x 11.9 m (19½ x 39 ft.)

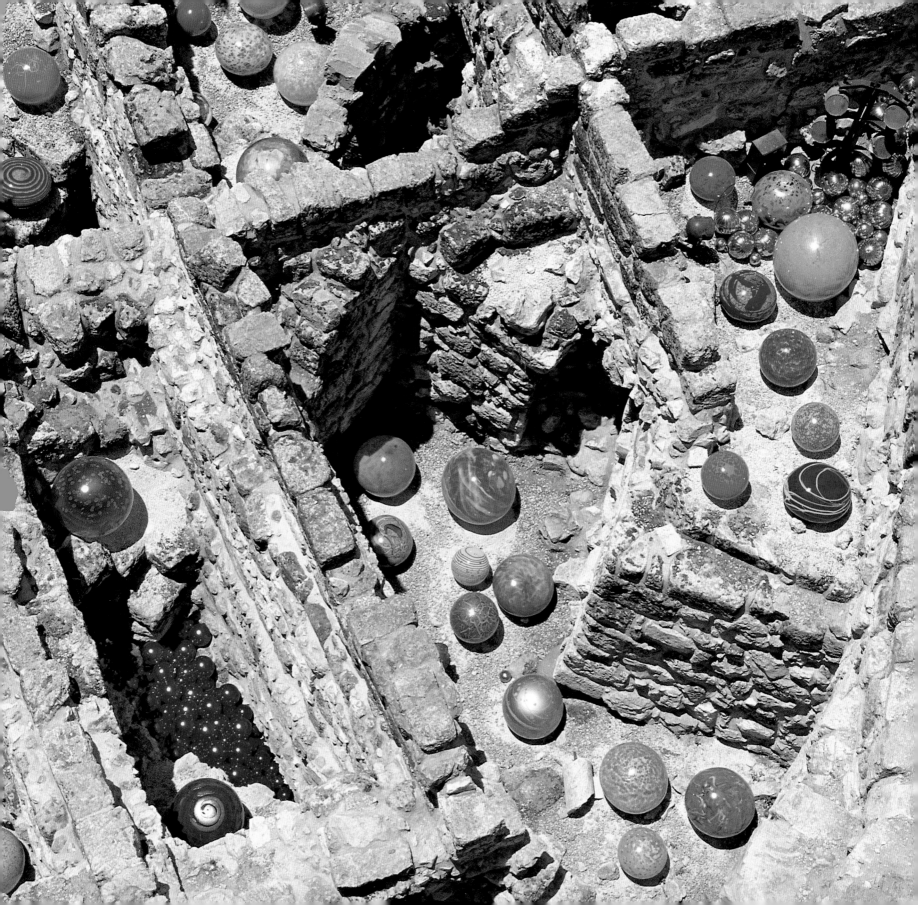

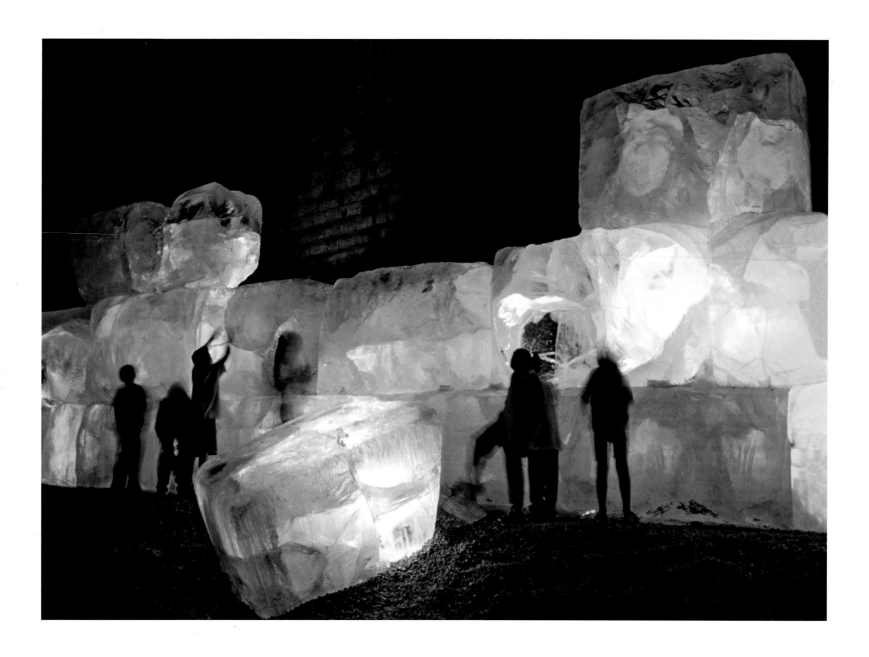

Jerusalem Wall of Ice
Tower of David Museum of the
History of Jerusalem
Jerusalem, Israel, 1999

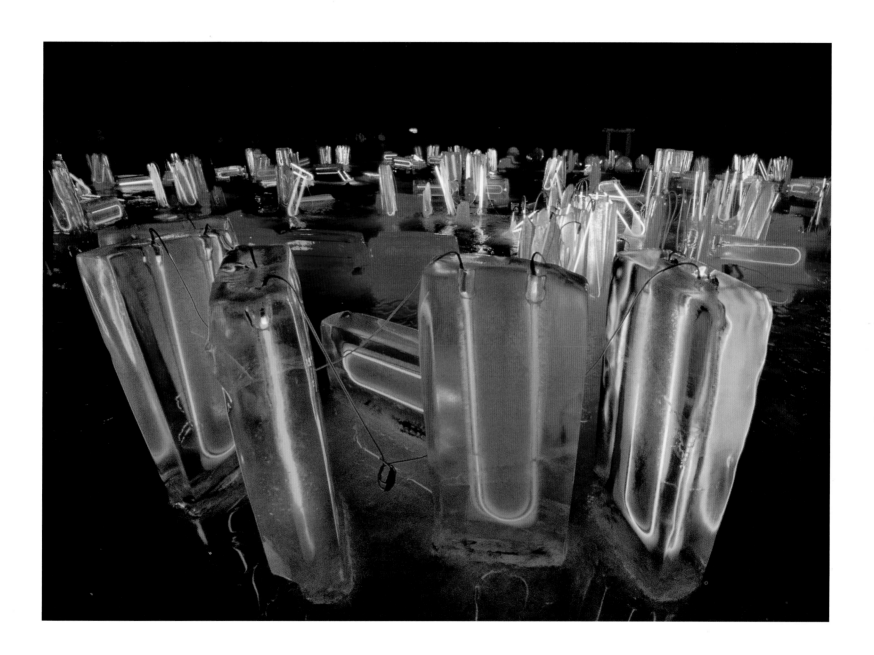

100,000 Pounds of Ice and Neon
Tacoma Dome
Tacoma, Washington, 1993

(following pages)
Neon installation
The Boathouse
Seattle, Washington, 1993

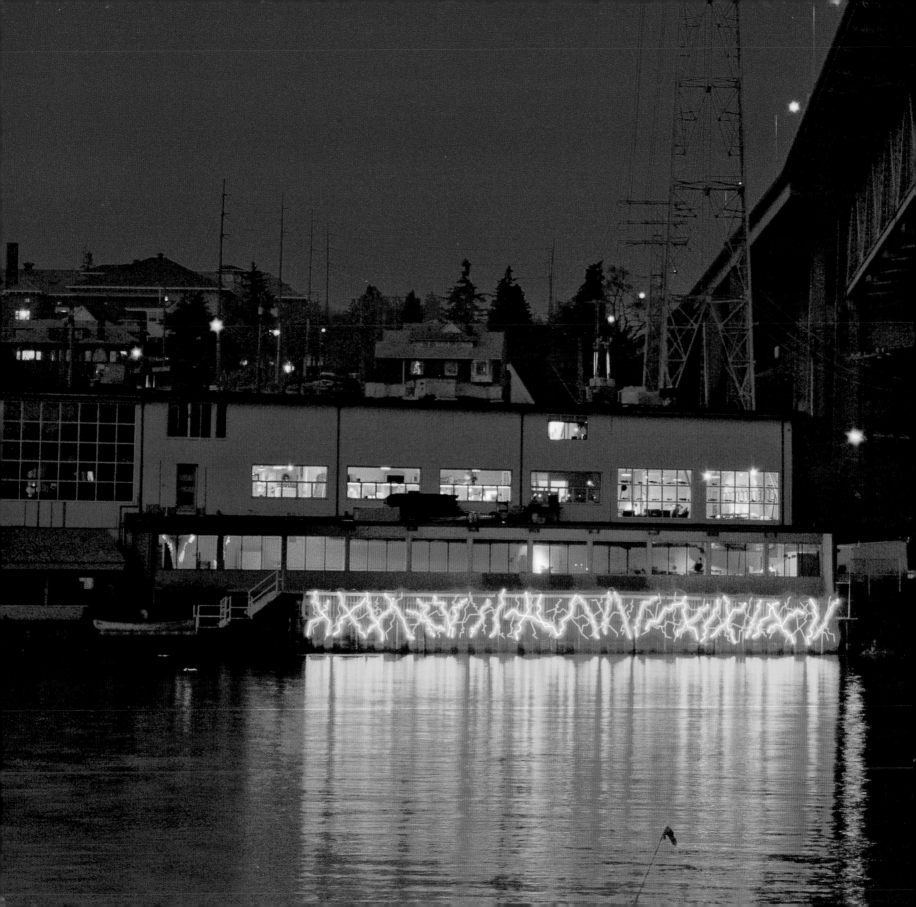

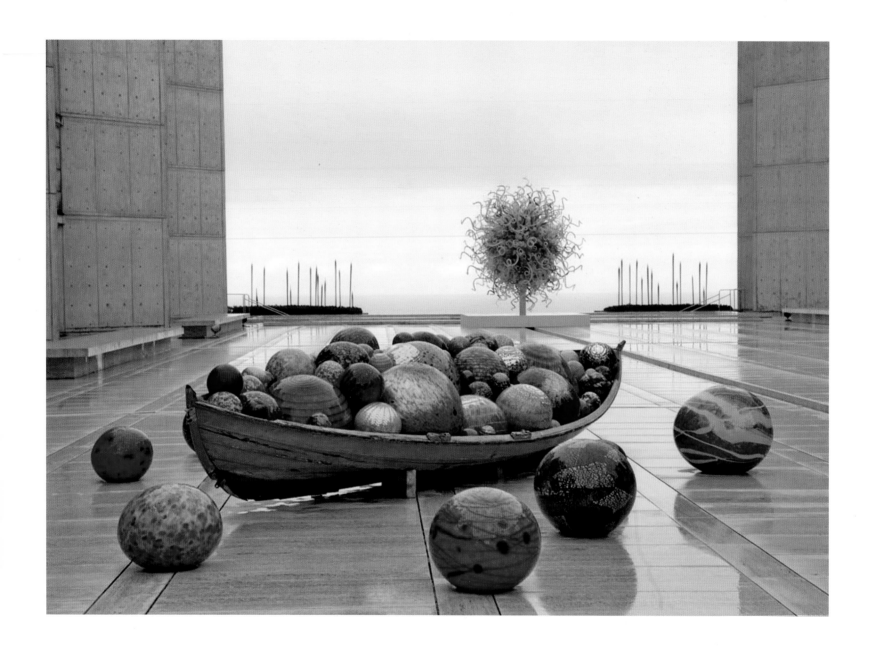

Float Boat, *The Sun*, and *Red Reeds*
Salk Institute for Biological Studies
La Jolla, California, 2010

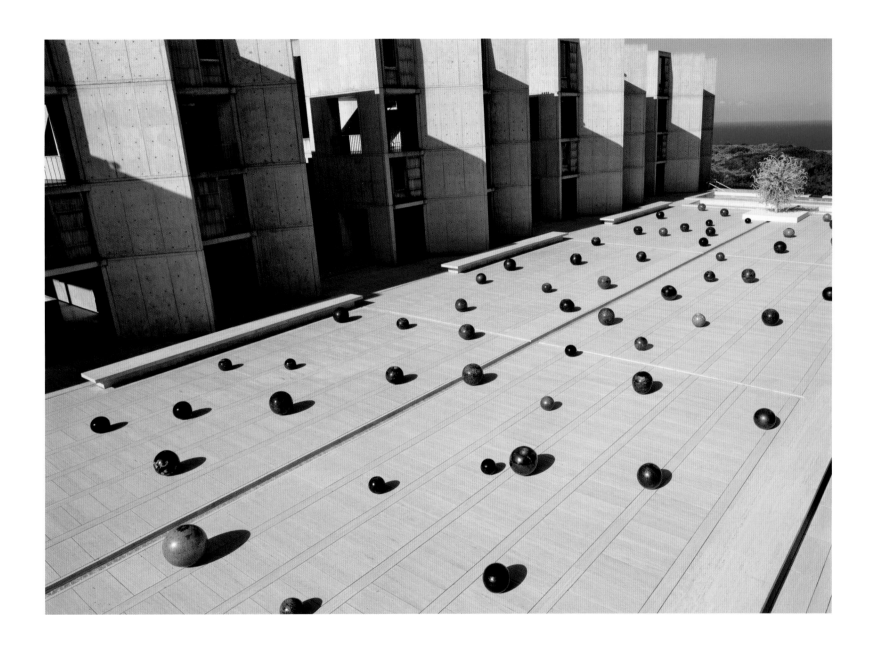

Black Niijima Floats and *The Sun*
Salk Institute for Biological Studies
La Jolla, California, 2010

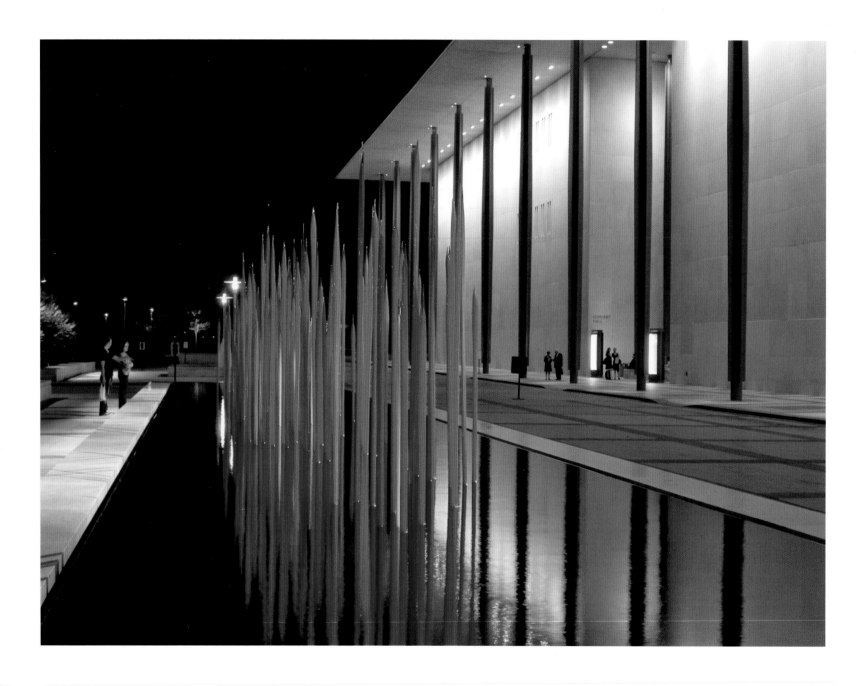

Red Reeds
The John F. Kennedy Center for
the Performing Arts
Washington, D.C., 2010

> *Sunset Boat*
United States Botanic Garden
Washington, D.C., 2007

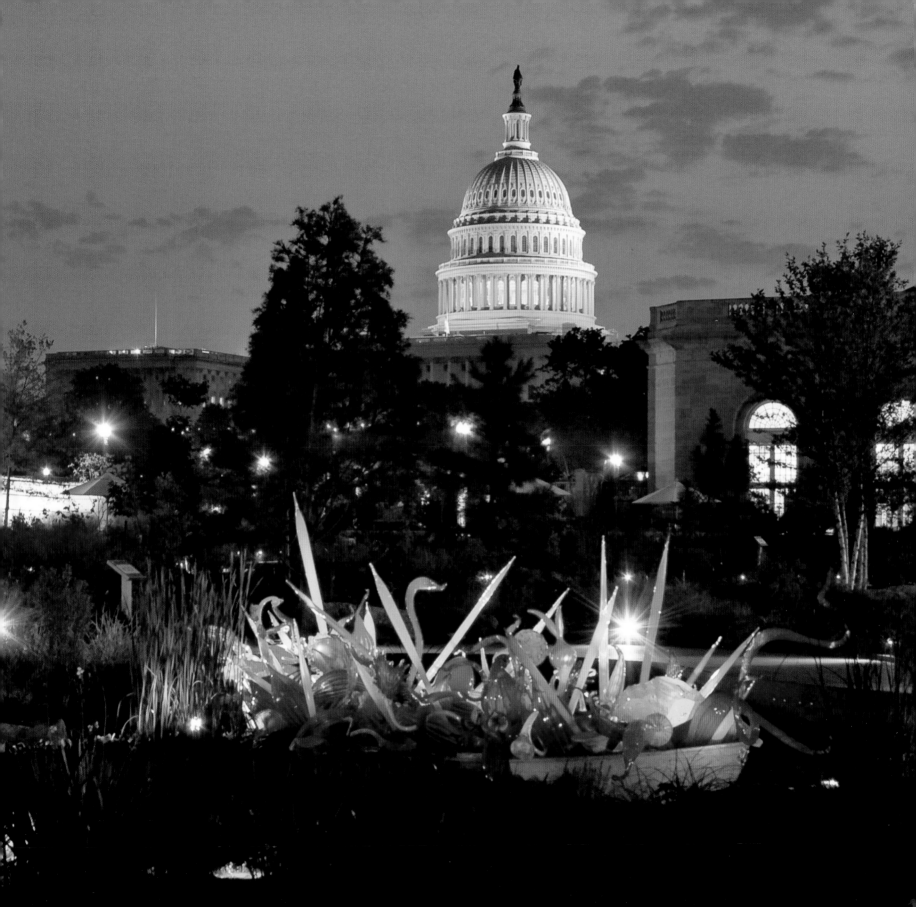

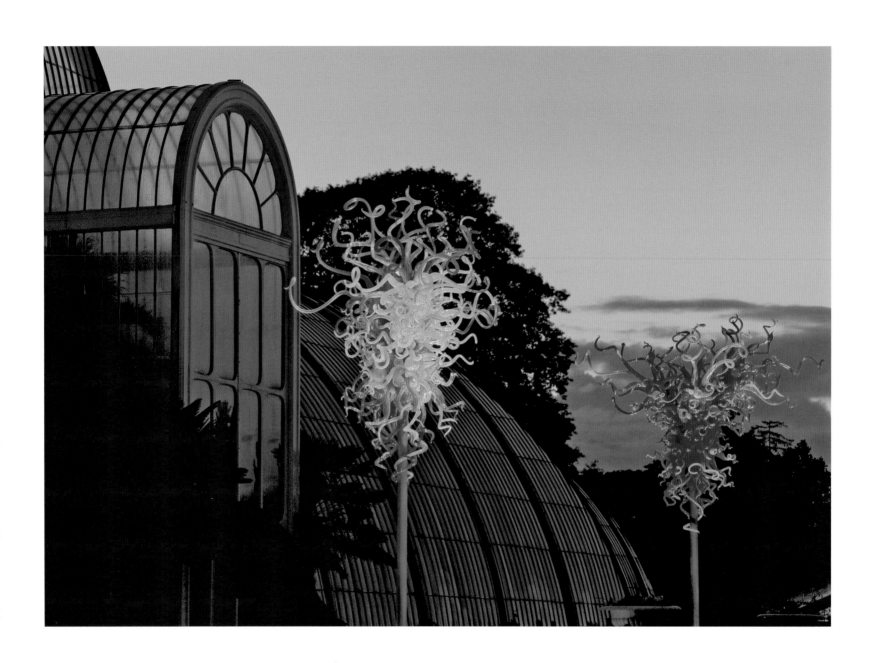

Asymmetrical Towers
Royal Botanic Gardens, Kew
Richmond, Surrey, England, 2005

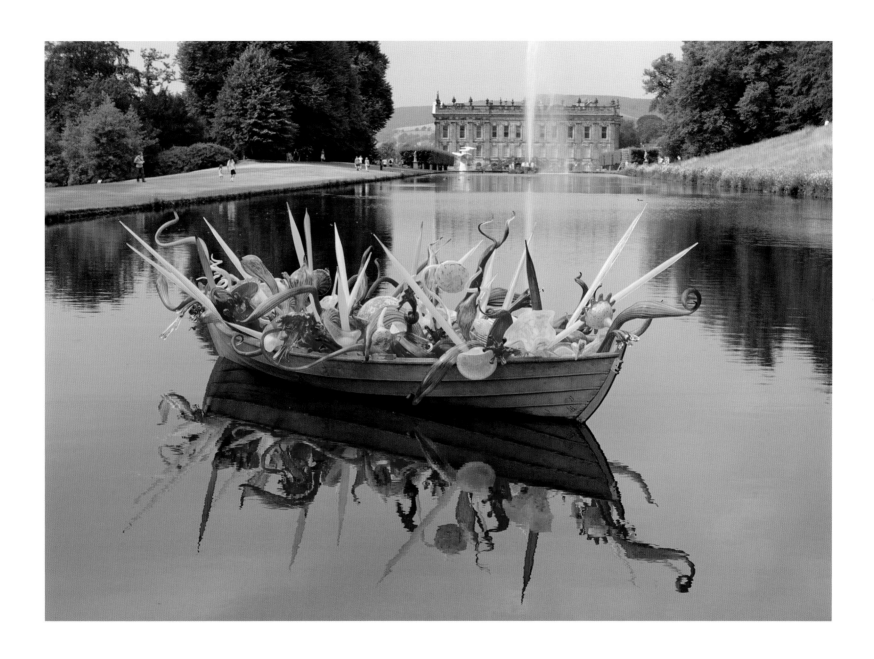

Sunset Boat
Chatsworth
Bakewell, Derbyshire, England, 2006
2 x 7 x 2.9 m (6½ x 23 x 9½ ft.)
Reproduced by permission of
Chatsworth House Trust

ilove working in architectural spaces. In this case it's basically the entire ceiling of a large lobby. It requires a totally different type of thinking. We're not talking about a single object here; we're talking about a couple of thousand pieces of glass being used to create one object.

Cobalt Blue Chandelier
Union Station
Tacoma, Washington, 1994
6.1 x 2.7 x 0.9 m (20 x 9 x 3 ft.)

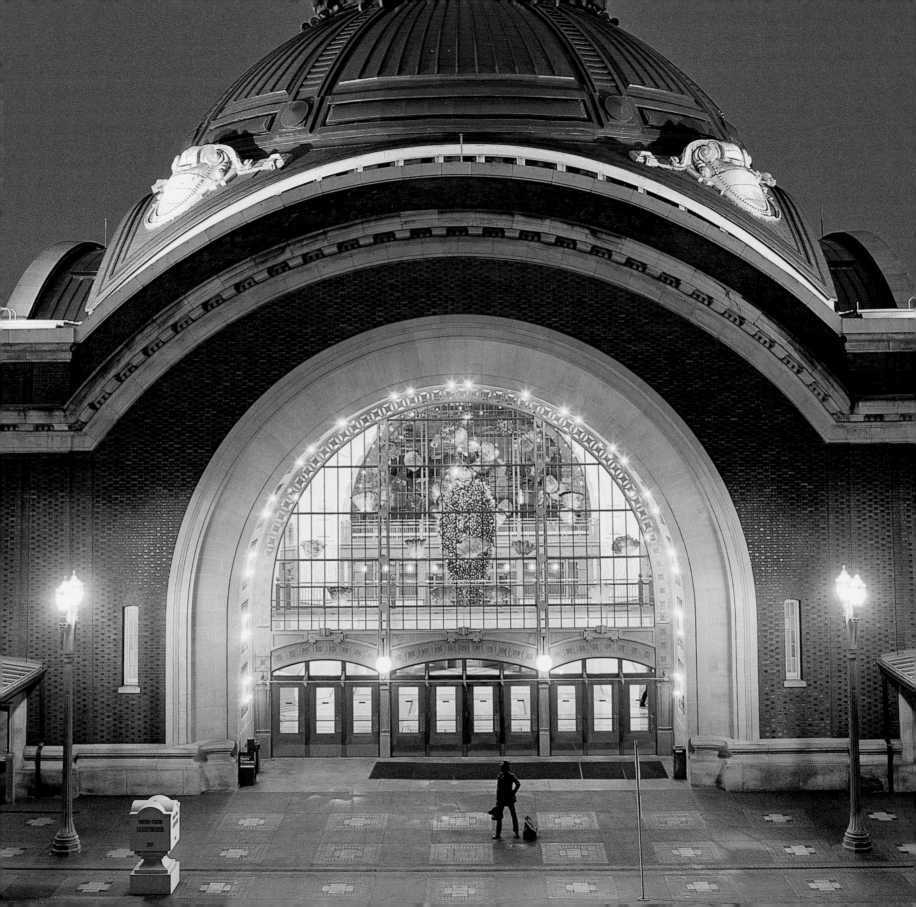

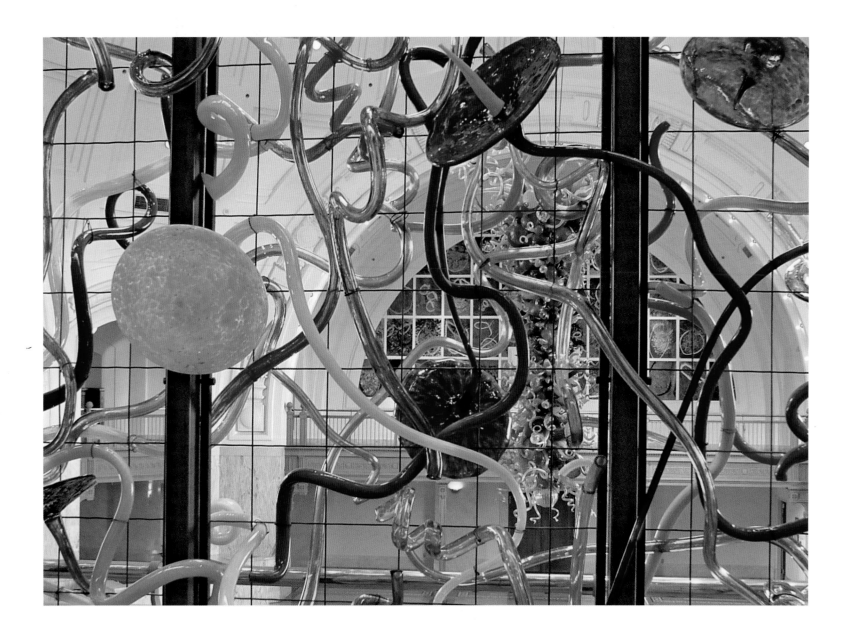

> *Cobalt Blue Chandelier* and *Monarch Window*
Union Station
Tacoma, Washington, 1994

(following pages)
Monarch Window
Union Station
Tacoma, Washington, 1994
6.7 x 12.2 x 0.9 m (22 x 40 x 3 ft.)

Lackawanna Ikebana installation (detail)
Union Station
Tacoma, Washington, 1994
Diam. 5.5 m (18 ft.)

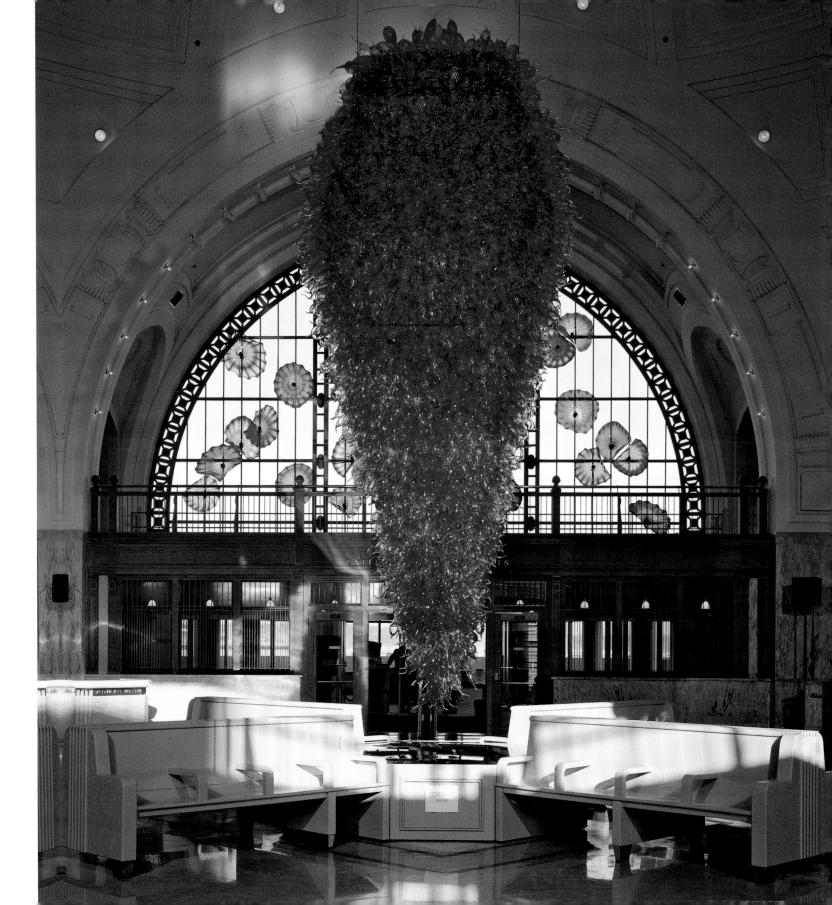

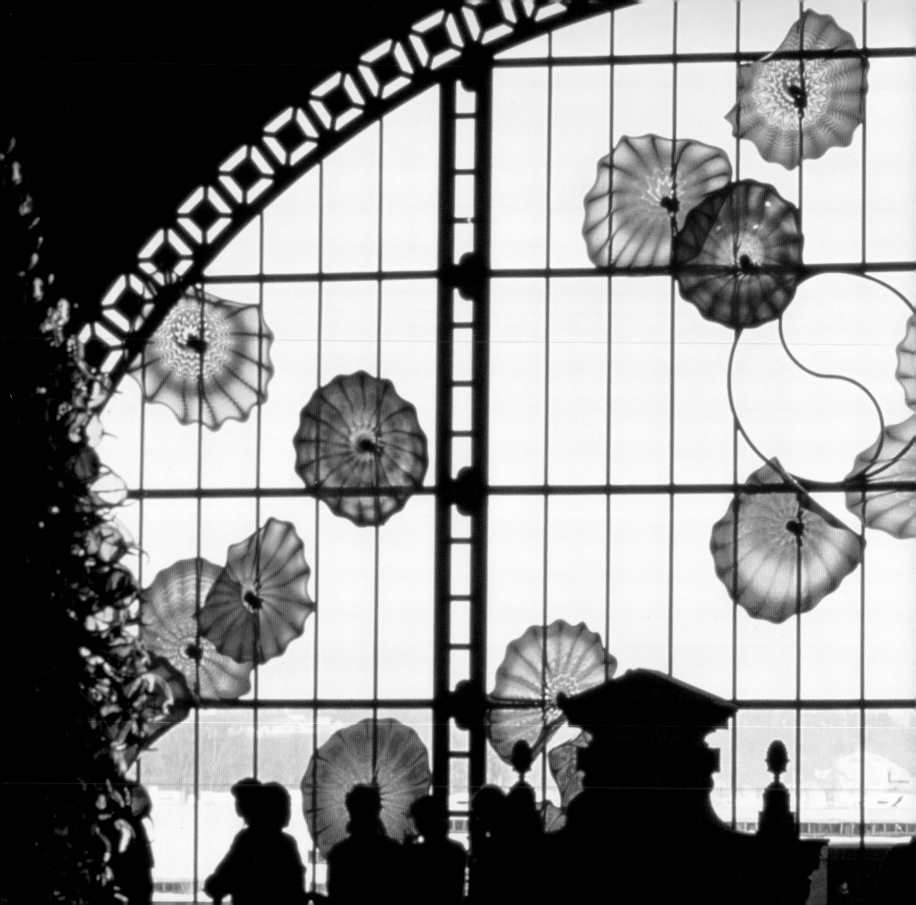

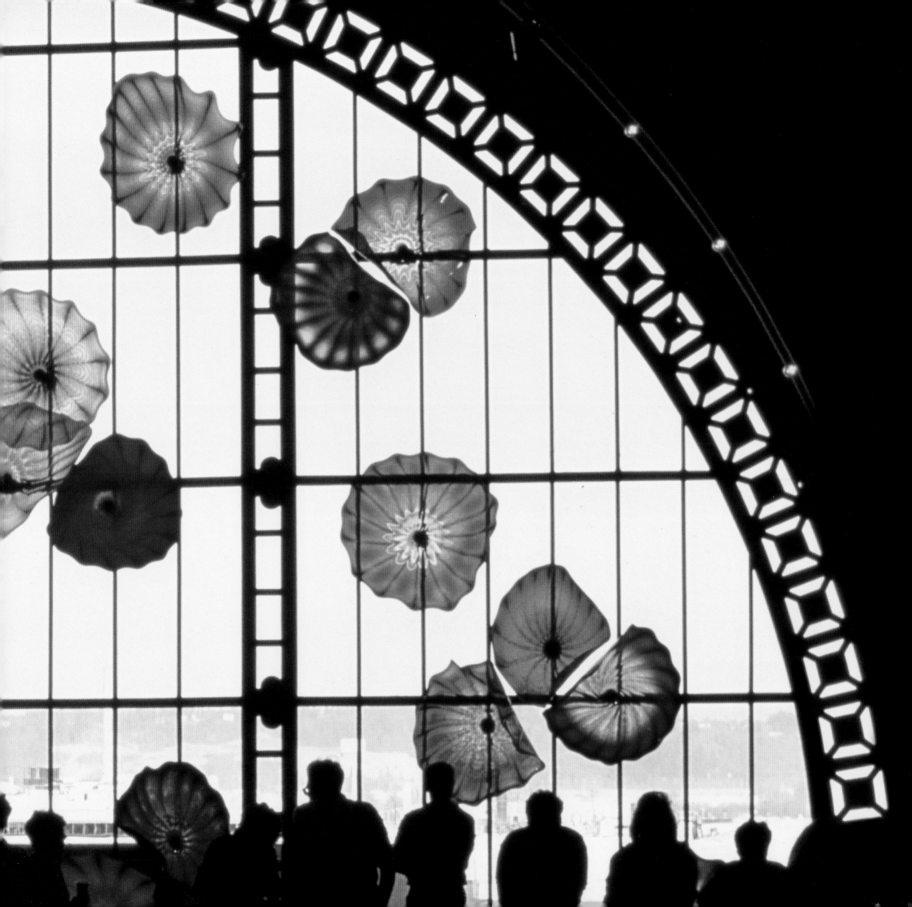

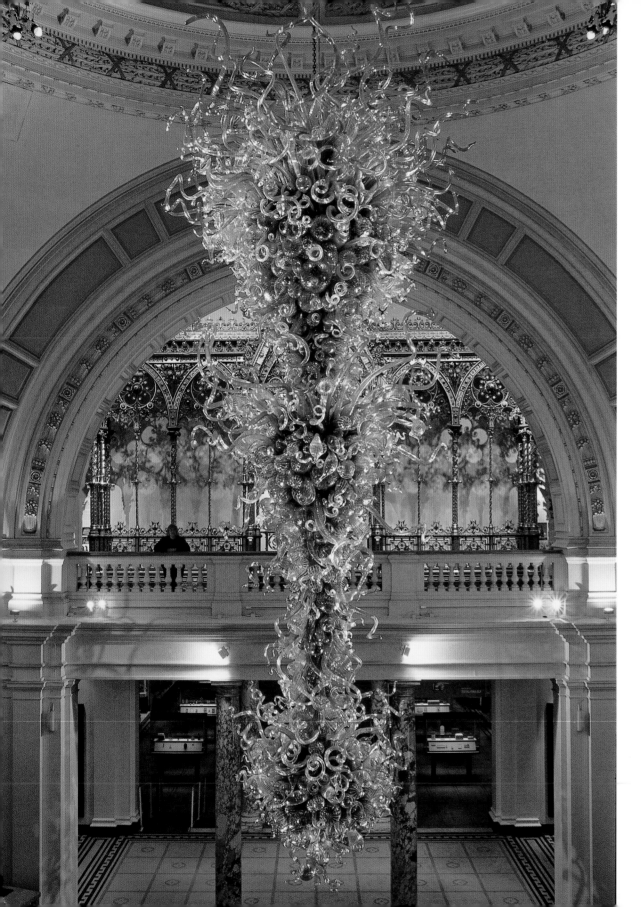

V&A Chandelier
Victoria and Albert Museum
London, England, 2001
8.2 x 3.8 m (27 x 12½ ft.)

(following pages)
Fiori di Como
Bellagio Resort
Las Vegas, Nevada, 1998

Fiori di Como (detail)
Bellagio Resort
Las Vegas, Nevada, 1998

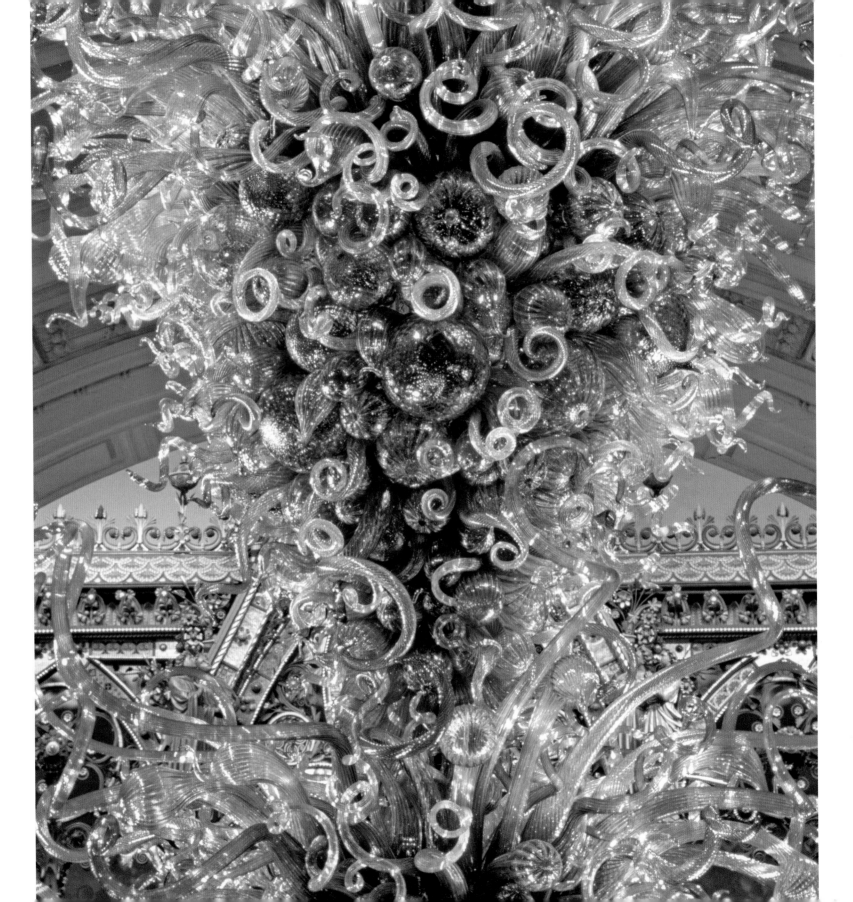

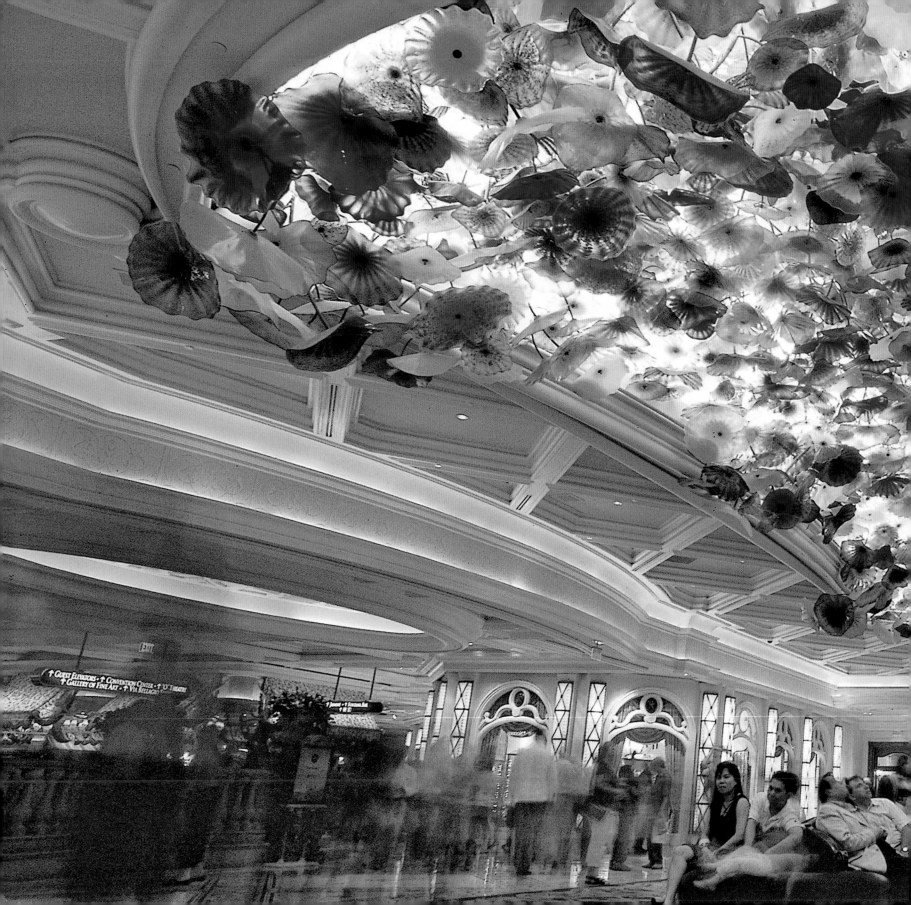

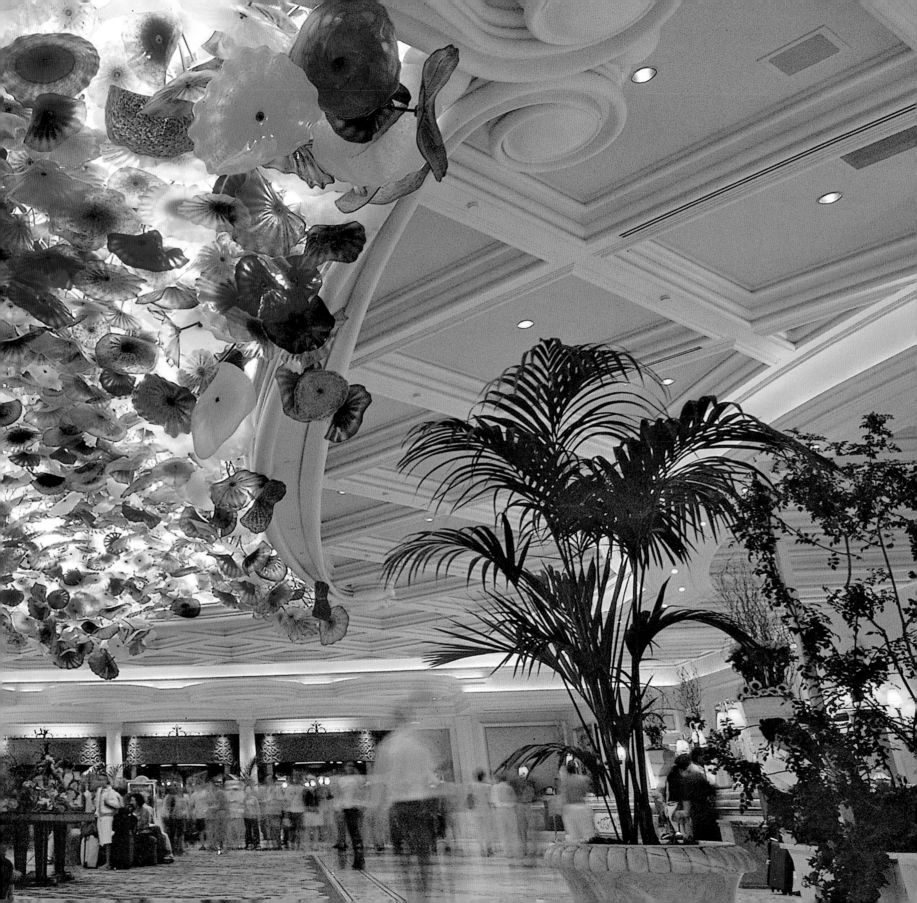

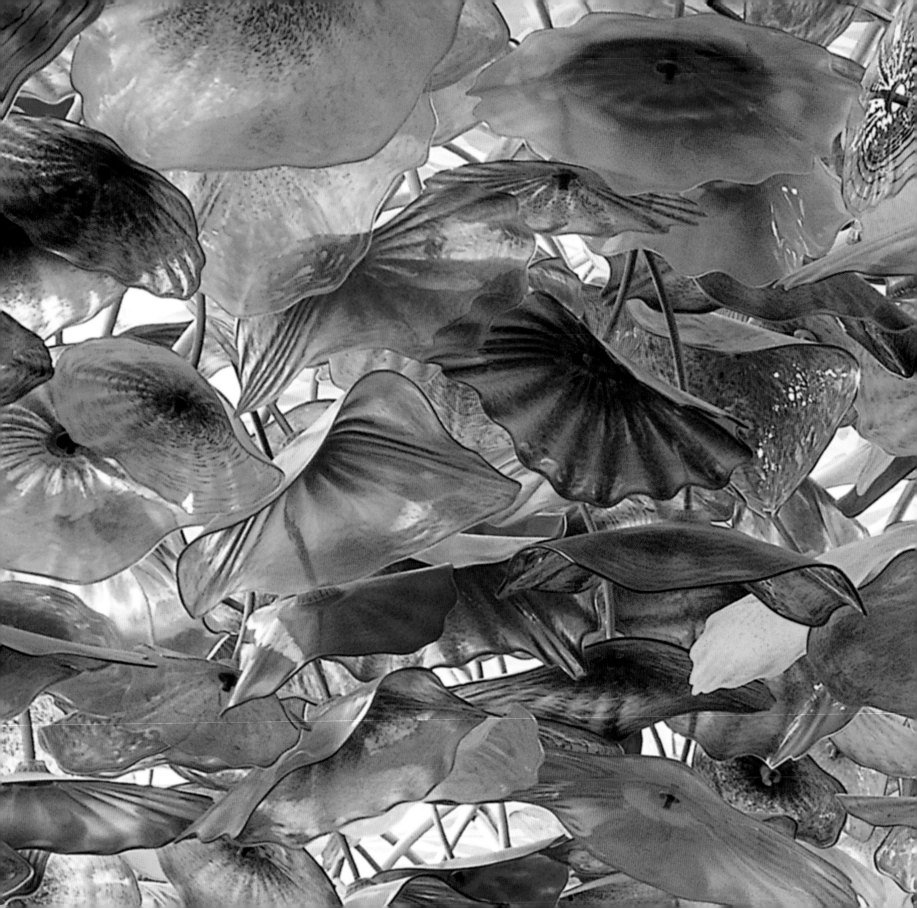

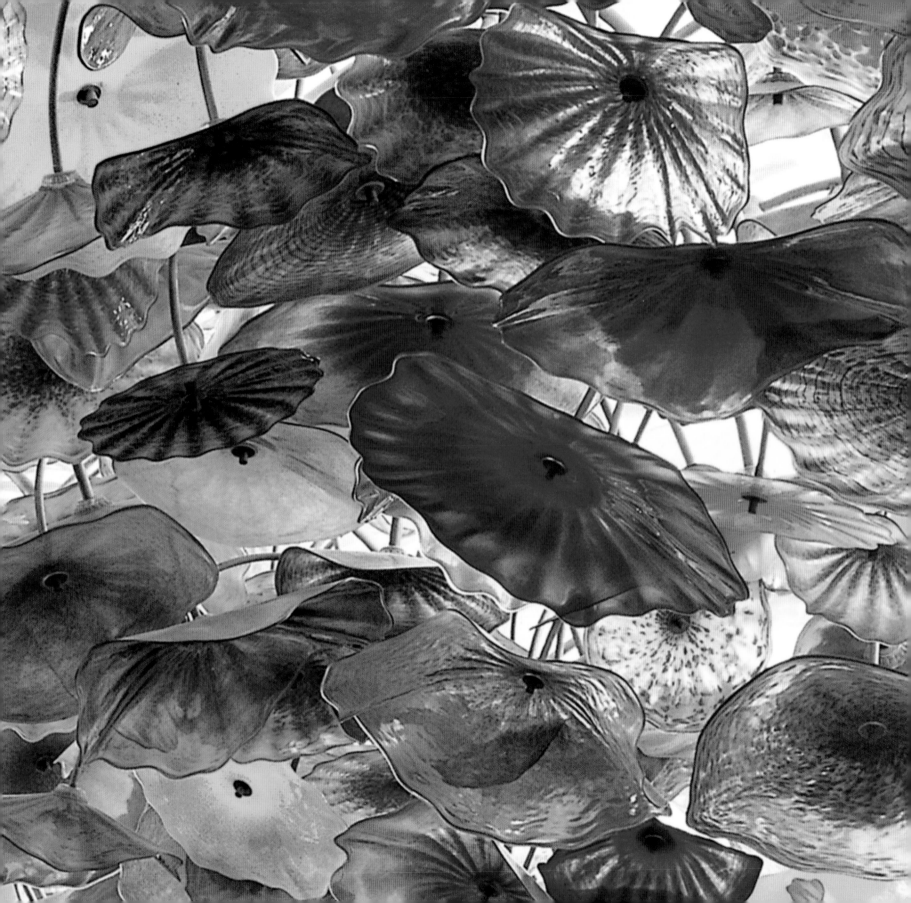

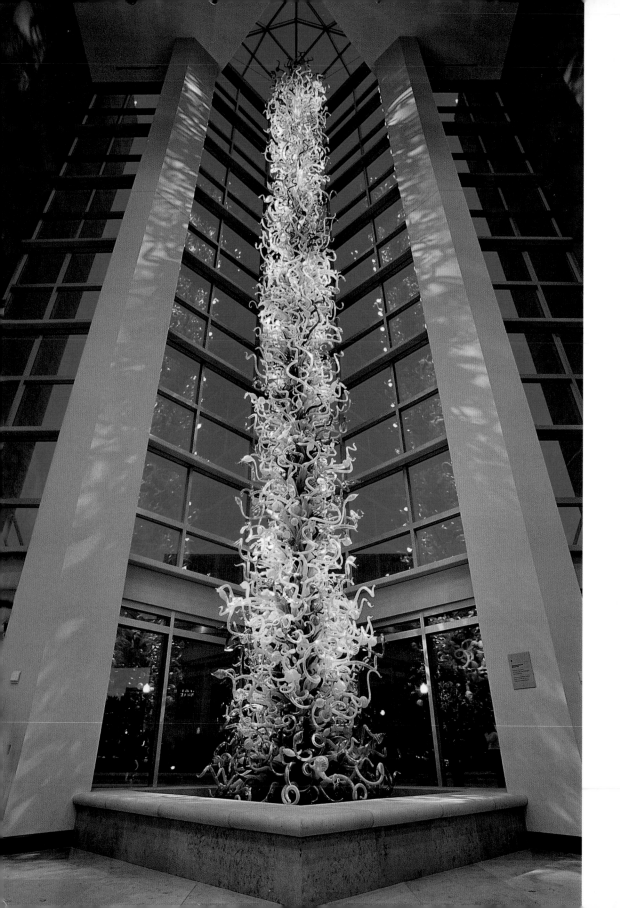

Eleanor Blake Kirkpatrick
Memorial Tower
Oklahoma City Museum of Art
Oklahoma City, Oklahoma, 2002
16.8 x 2.4 m (55 x 8 ft.)

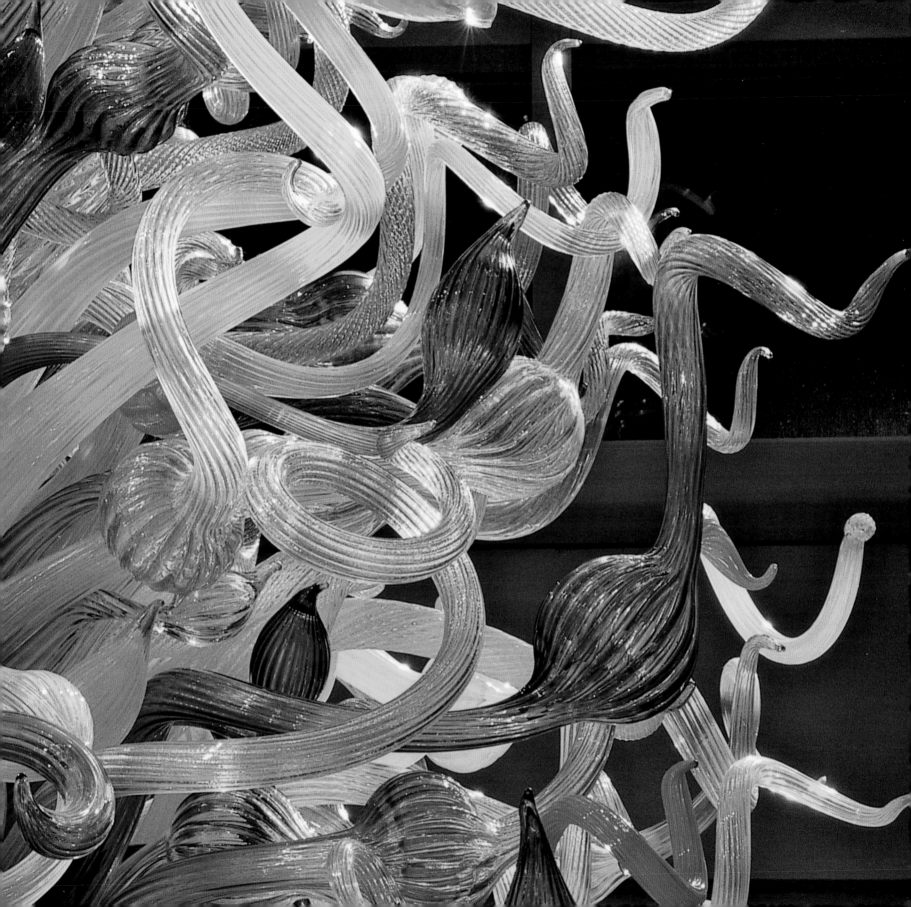

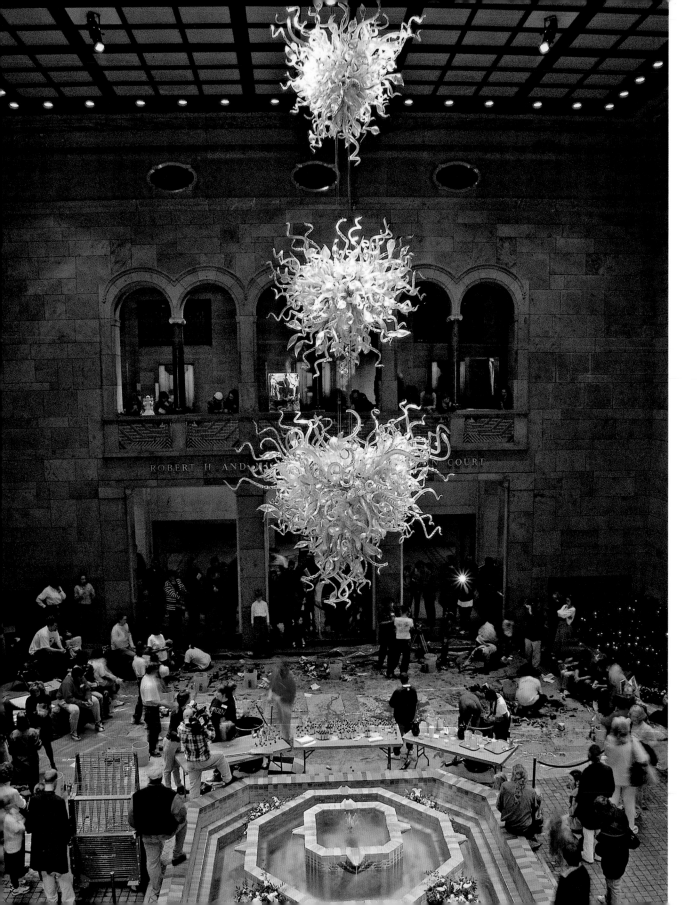

Gilded Silver and Aquamarine
Chandelier
Joslyn Art Museum
Omaha, Nebraska, 2000
7.5 x 3 m (24½ x 10 ft.)

Crystal Gate
Atlantis
Paradise Island, Bahamas,
1998
5.2 x 3 m (17 x 10 ft.)

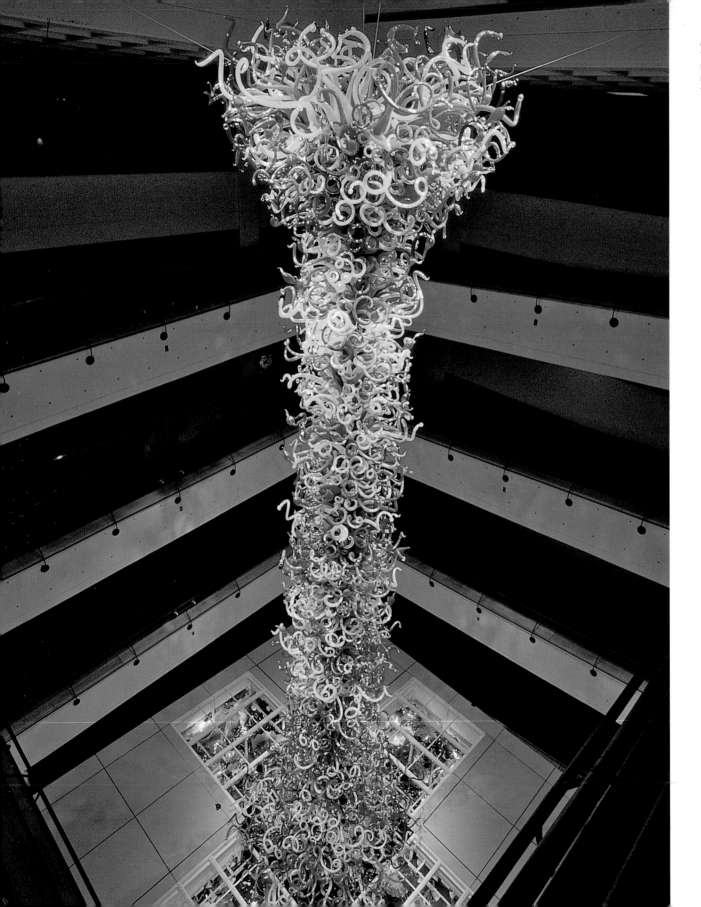

Fireworks of Glass
The Children's Museum of
Indianapolis
Indianapolis, Indiana, 2006
13.3 x 4 x 4 m (43½ x 13 x 13 ft.)

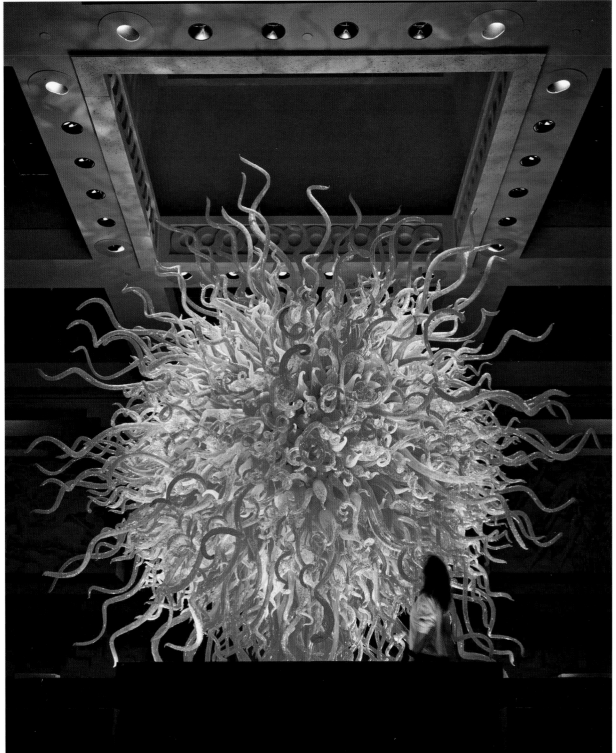

Temple of the Sun
Atlantis
Paradise Island, Bahamas,
1998
Diam. 5.2 m (17 ft.)

When people go into a museum, it's the perfect environment. They already feel they're in a special place looking at special things. If the lighting's just right, the situation's just right, it can be very powerful. When people go into a museum, it's a sacred place. Museums are almost like the cathedrals of our time in some respects.

Chandelier Room
Mock-up for the de Young Museum
2008

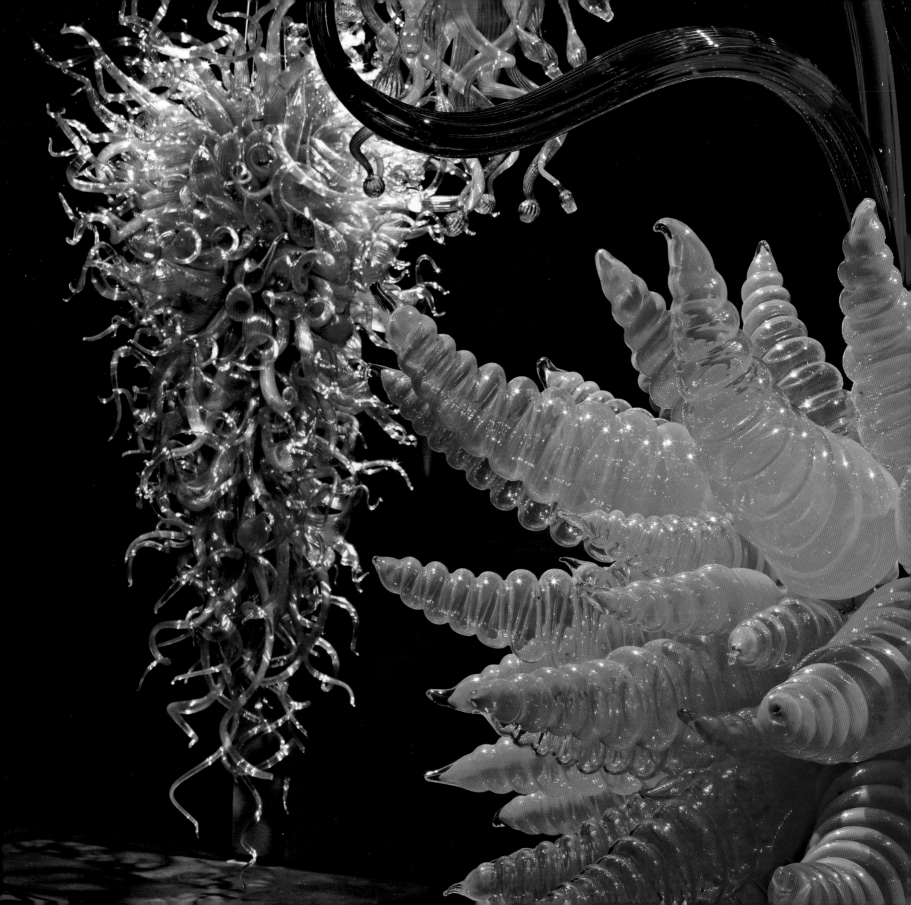

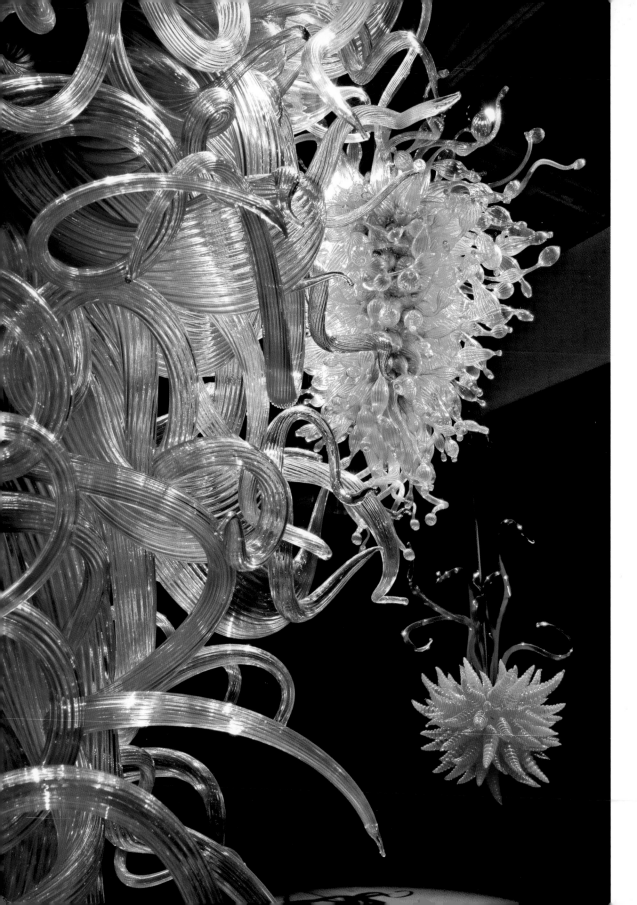

Chandelier Room
Mock-up for the de Young Museum
2008
(also following pages)

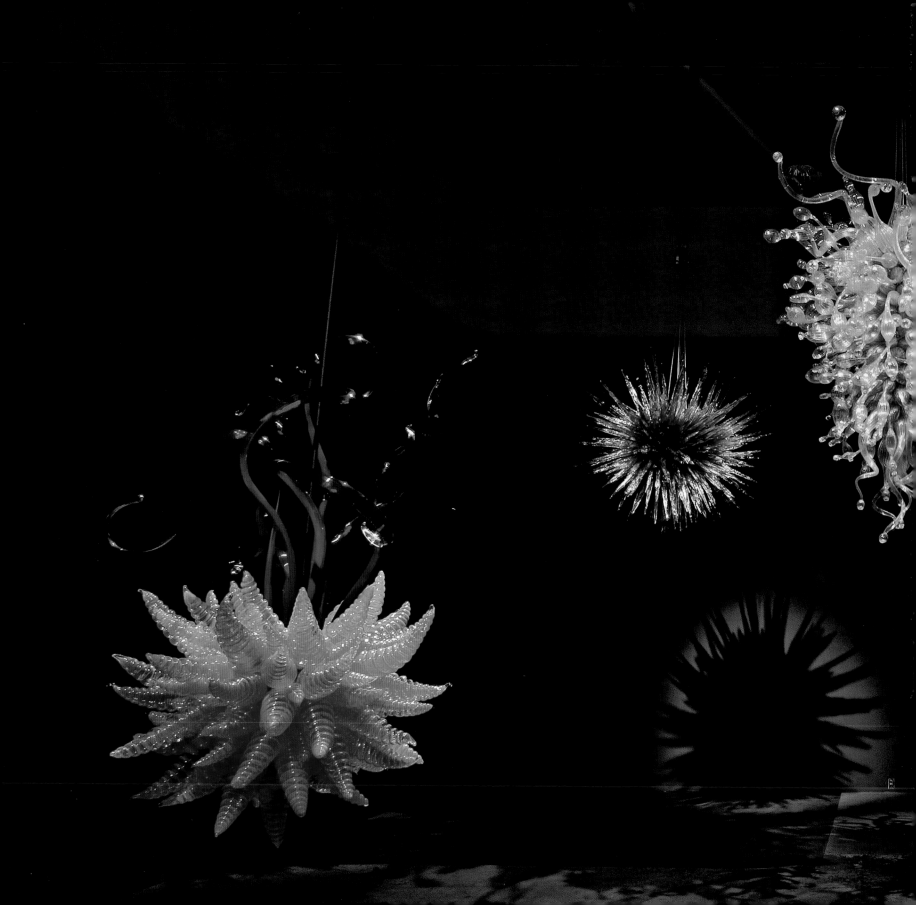

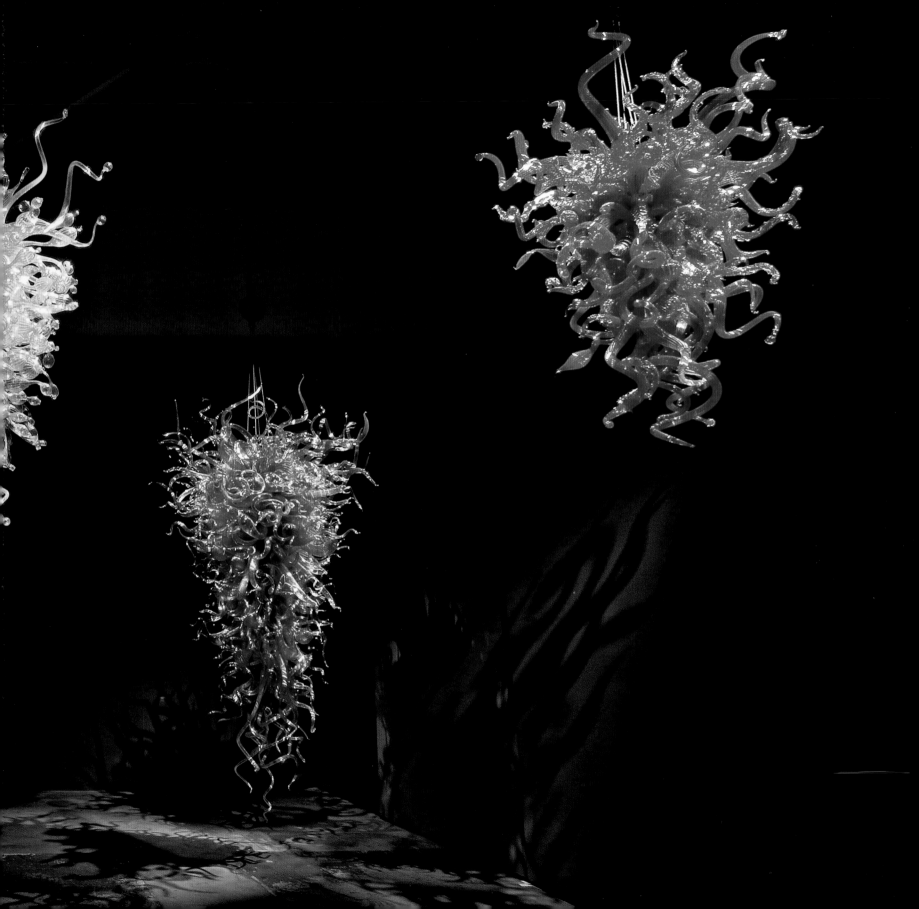

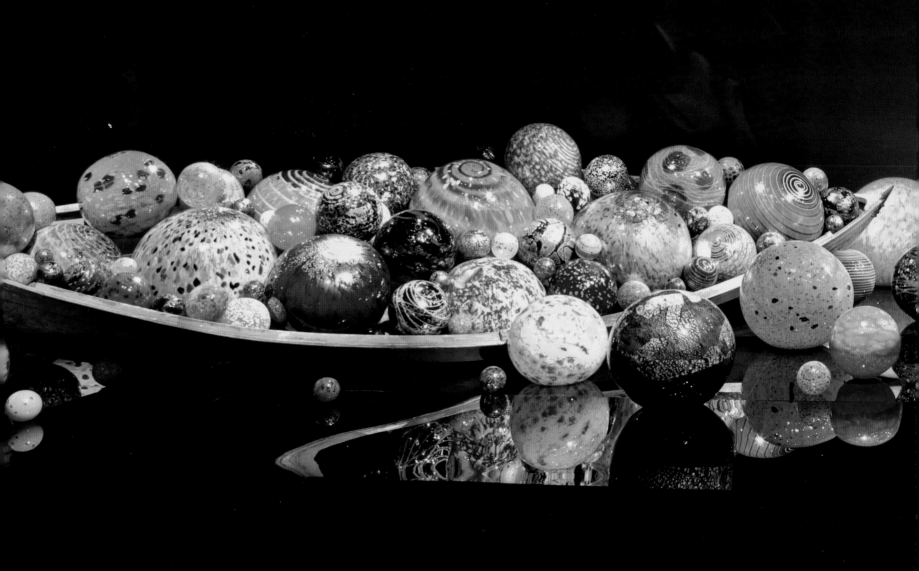

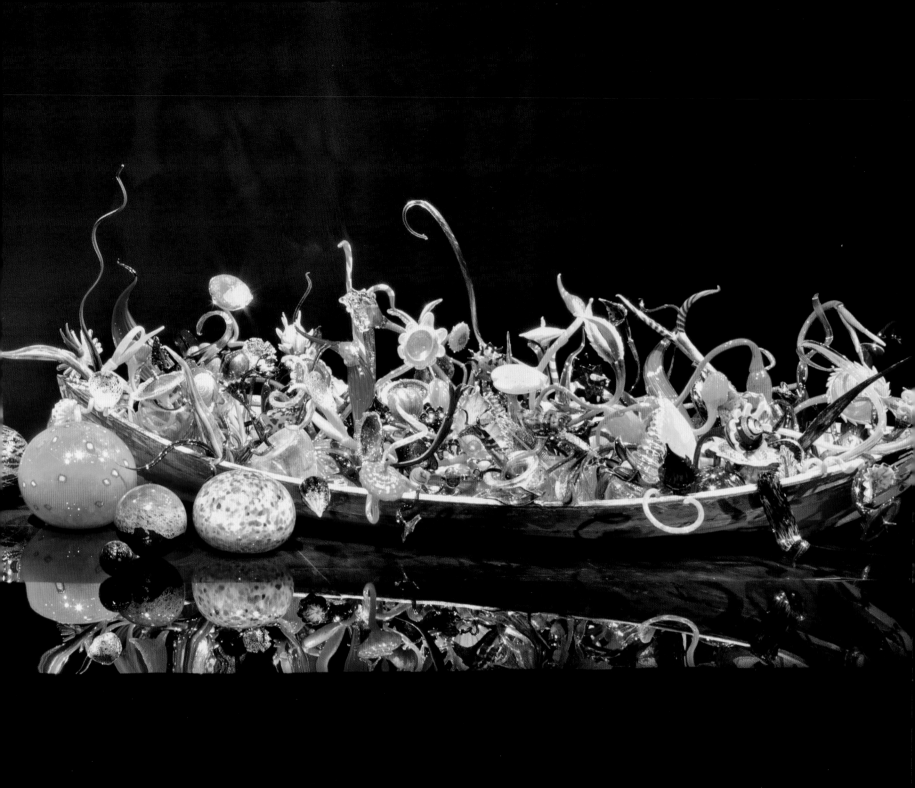

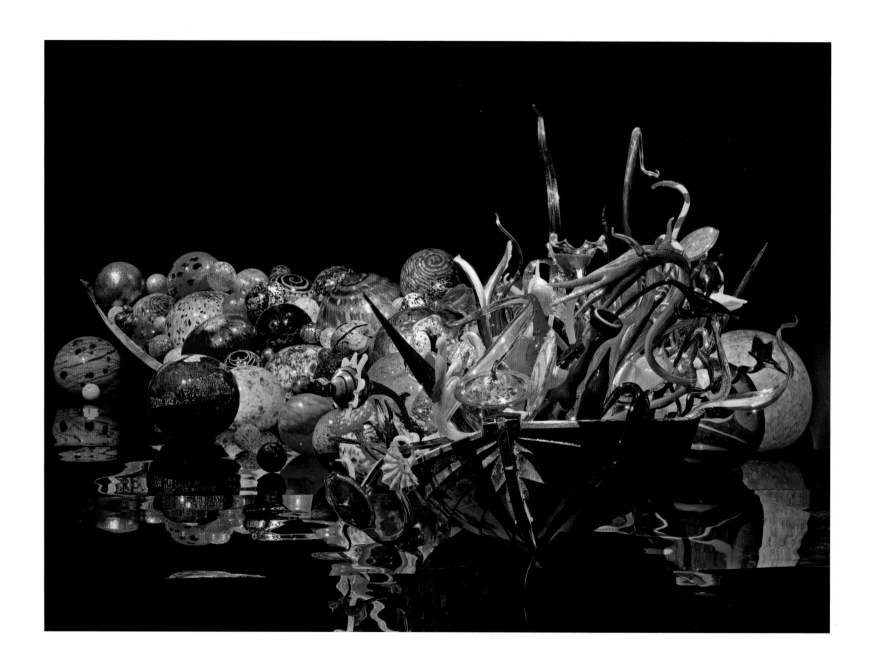

Float Boat and *Ikebana Boat*
Mock-up for the de Young Museum
2008
(also previous pages)

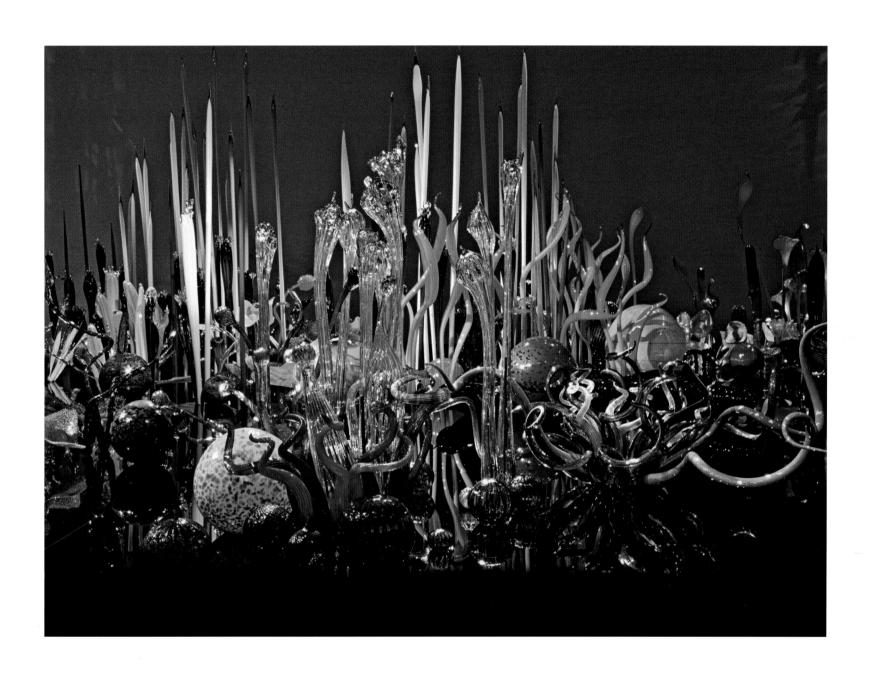

Mille Fiori
Tacoma Art Museum
Tacoma, Washington, 2003
7.6 x 8.5 x 17.1 m (25 x 28 x 56 ft.)

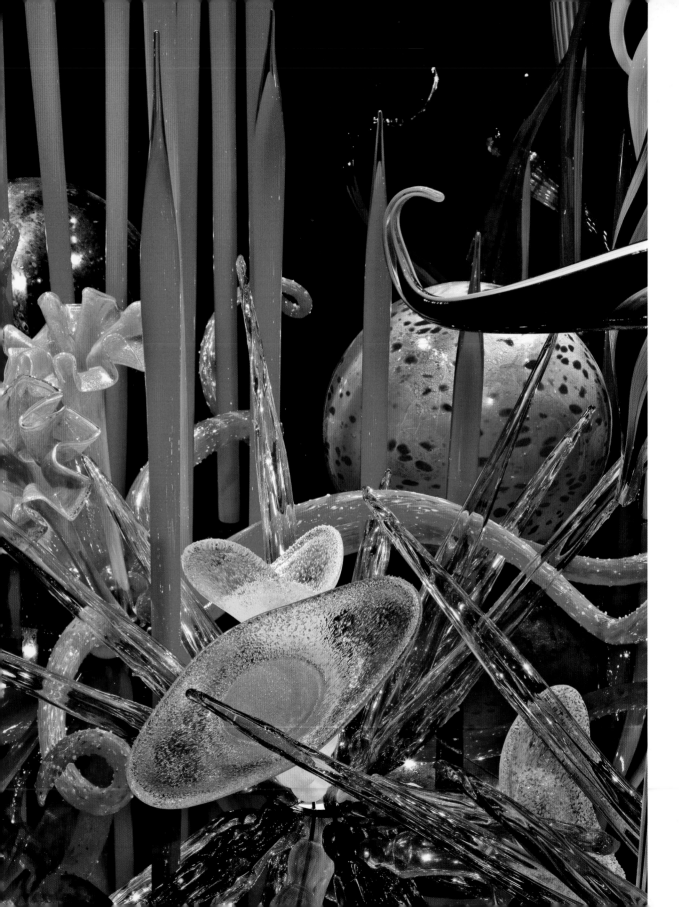

Mille Fiori
Mock-up for the de Young Museum
2008
2.9 x 17.1 x 3.7 m (9½ x 56 x 12 ft.)

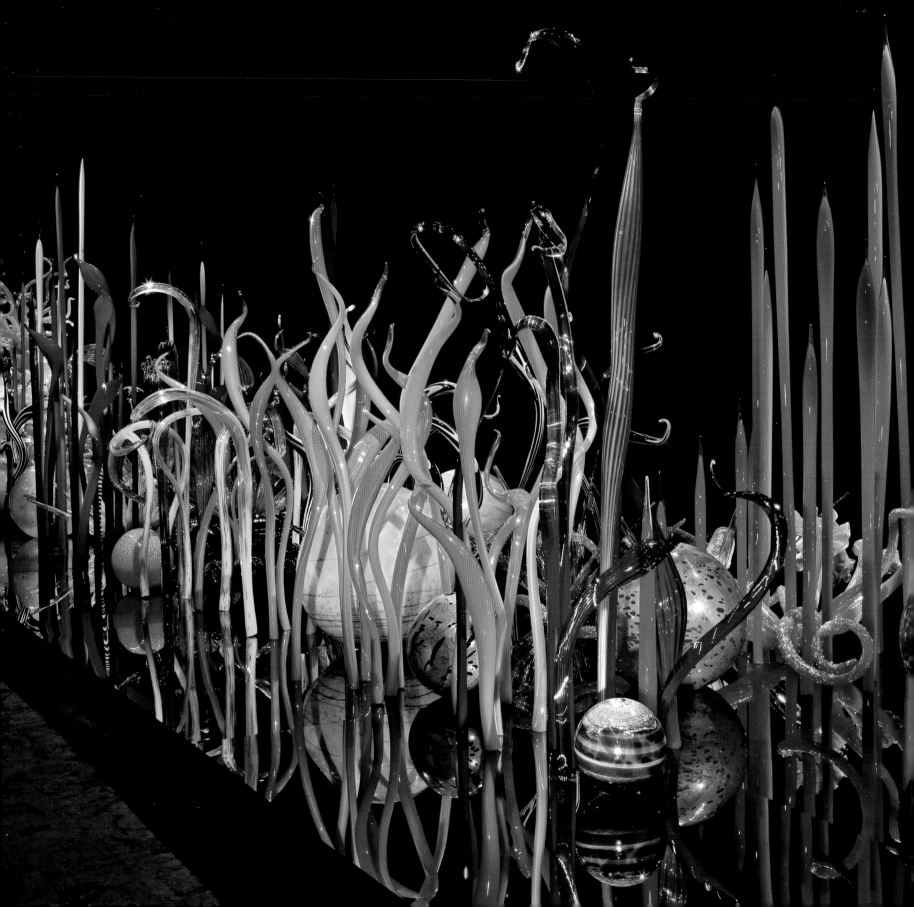

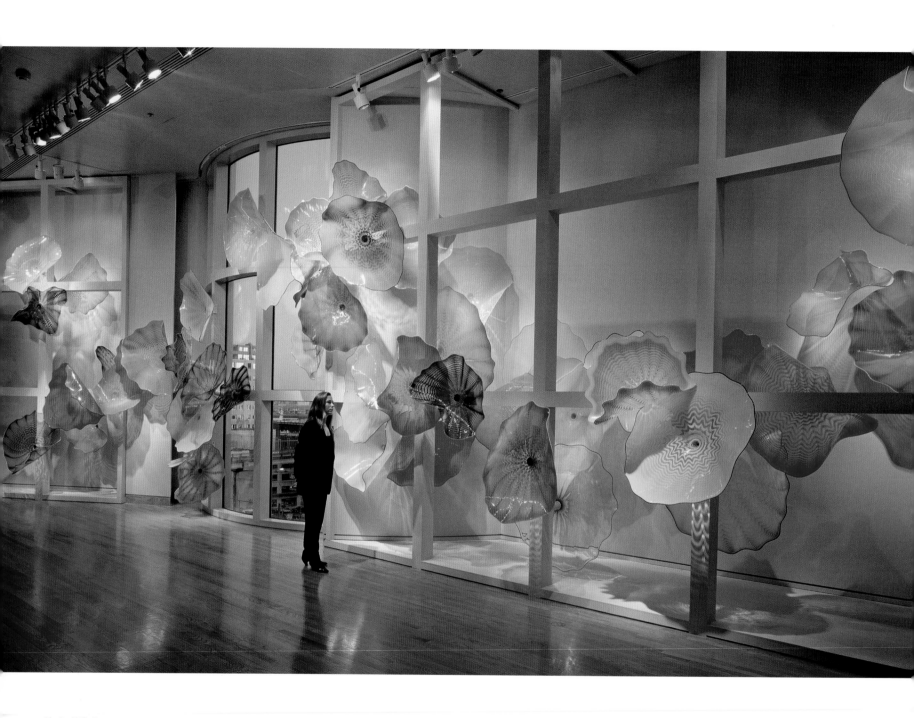

Venturi Window
Seattle Art Museum
Seattle, Washington, 1992
14.6 x 4.9 x 2.1 m (48 x 16 x 7 ft.)

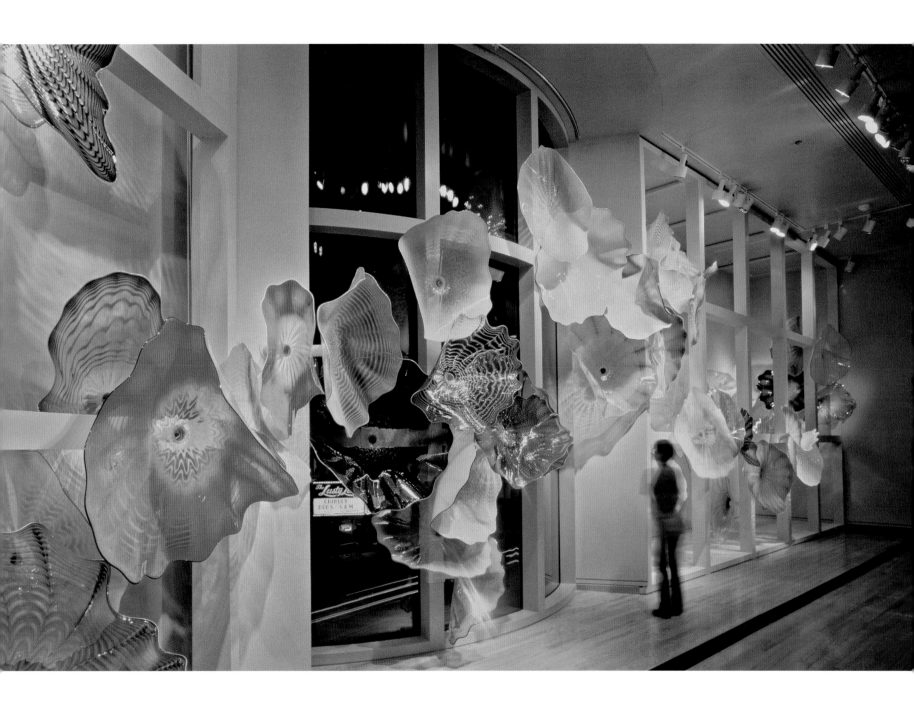

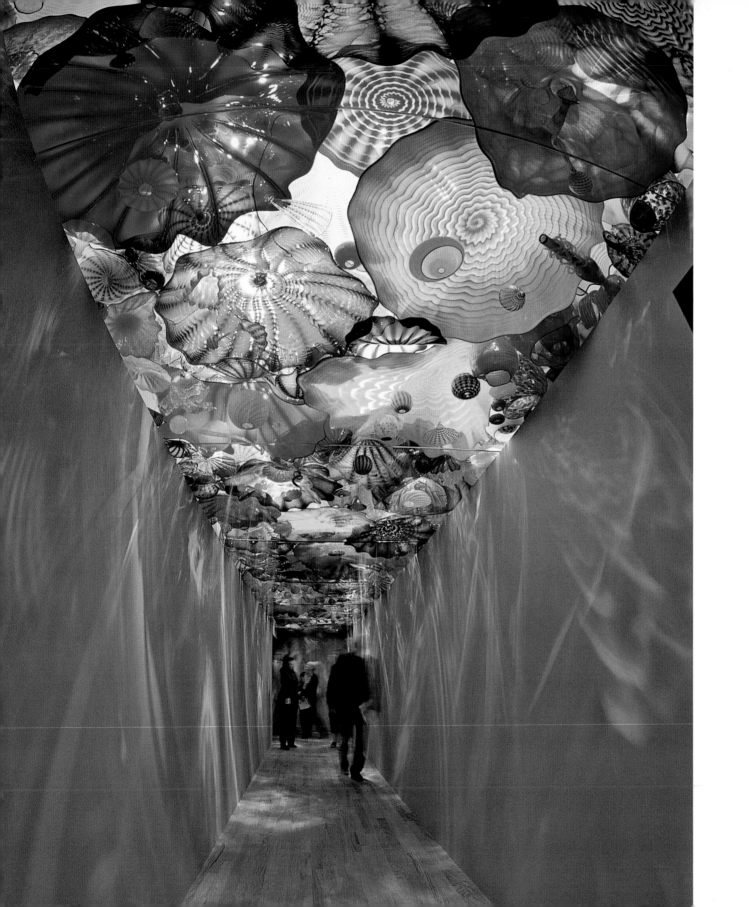

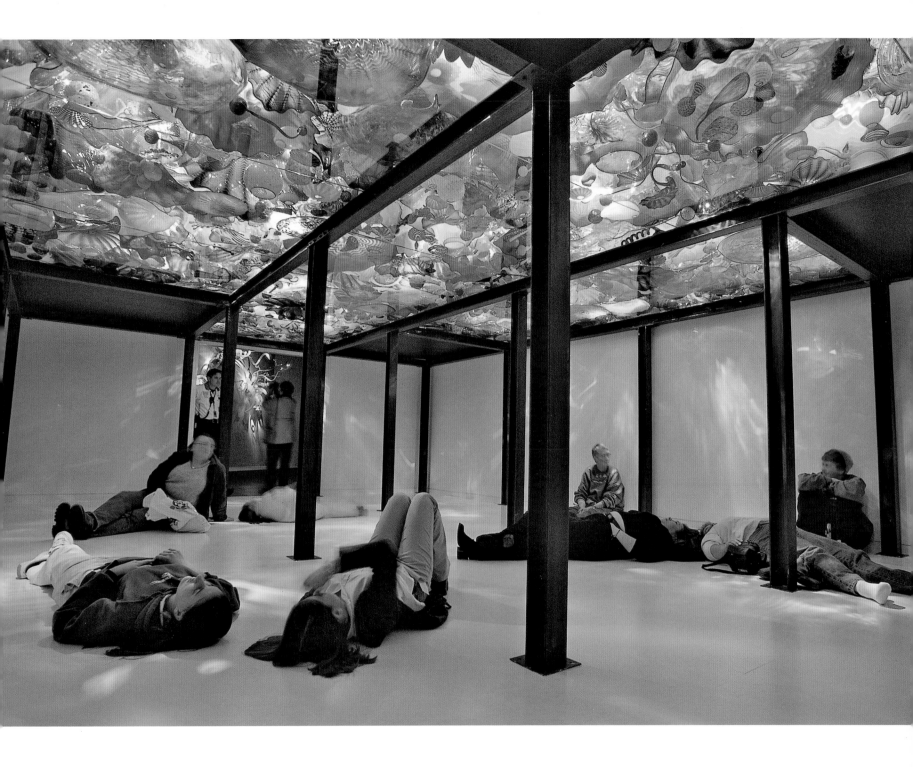

< Persian Ceiling
Oklahoma City Museum of Art
Oklahoma City, Oklahoma, 2002
12.2 x 1.8 m (40 x 6 ft.)

Persian Pergola
Olympic Arts Festival
Salt Lake City, Utah, 2002

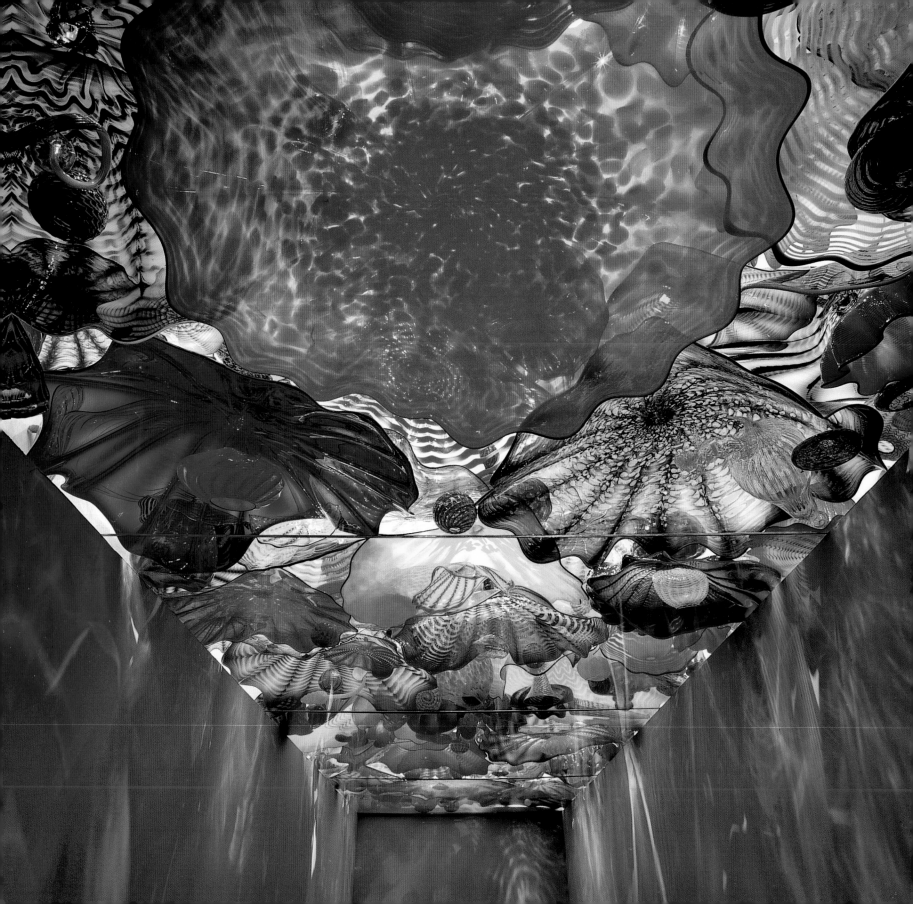

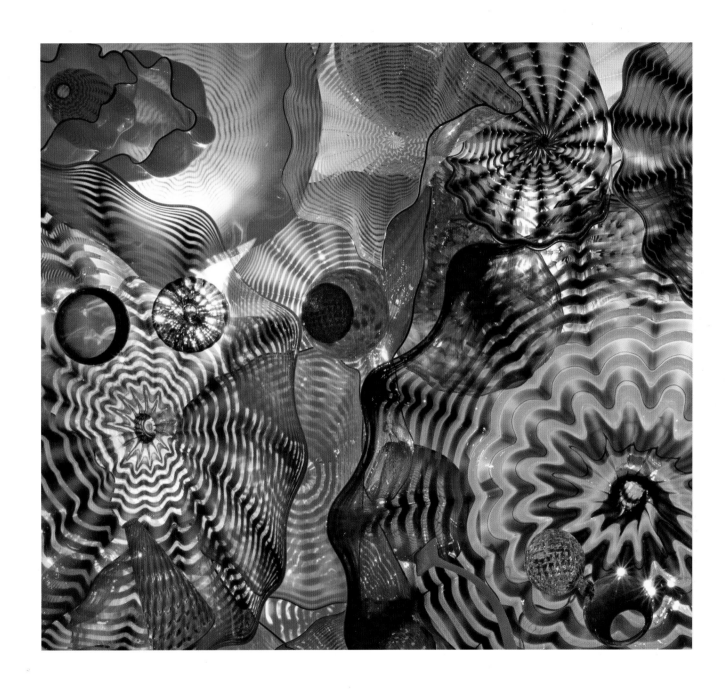

Persian Ceiling
Oklahoma City Museum of Art
Oklahoma City, Oklahoma, 2002
12.2 x 1.8 m (40 x 6 ft.)

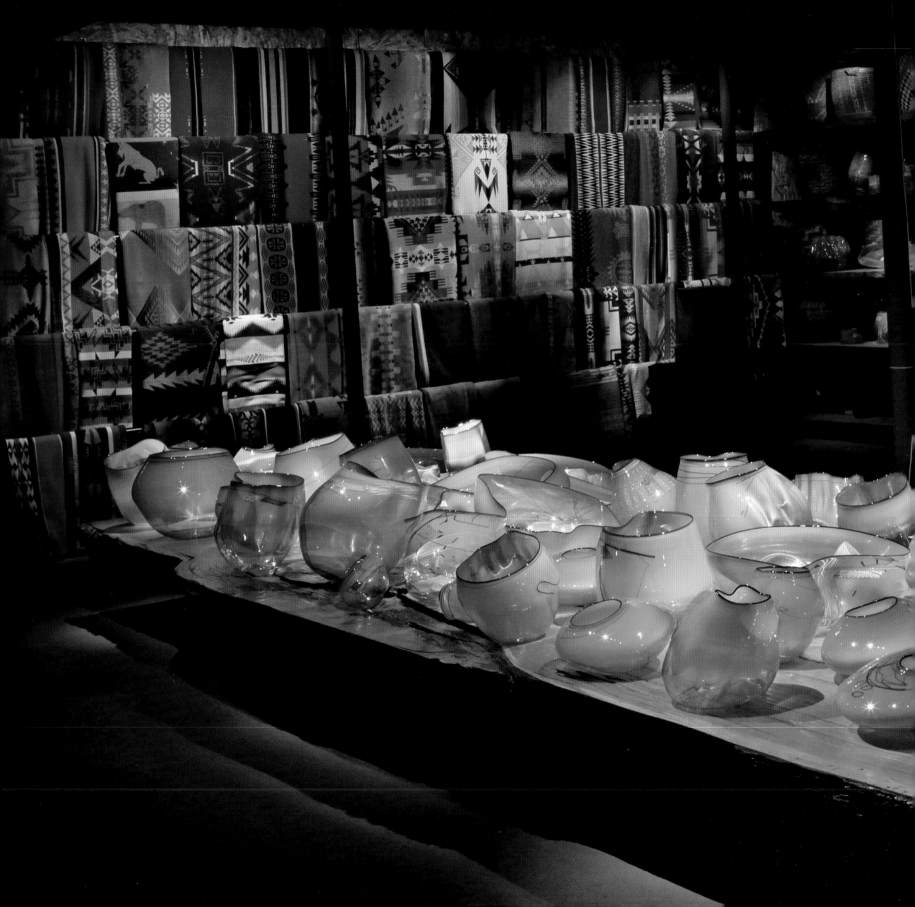

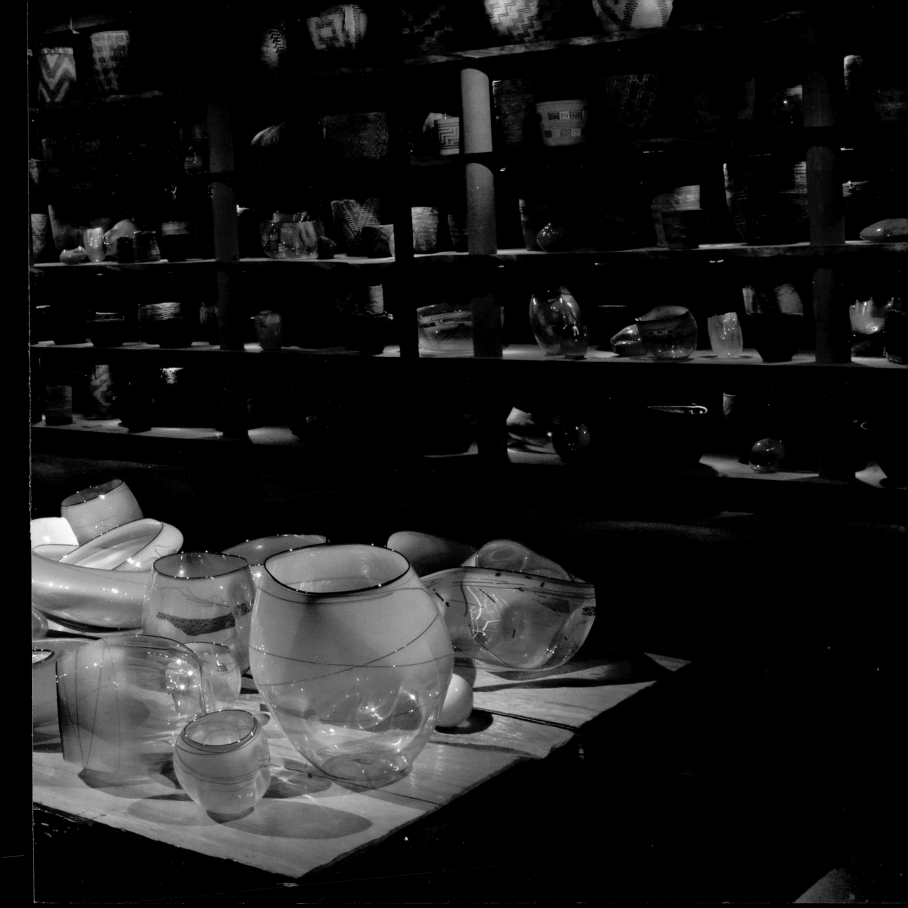

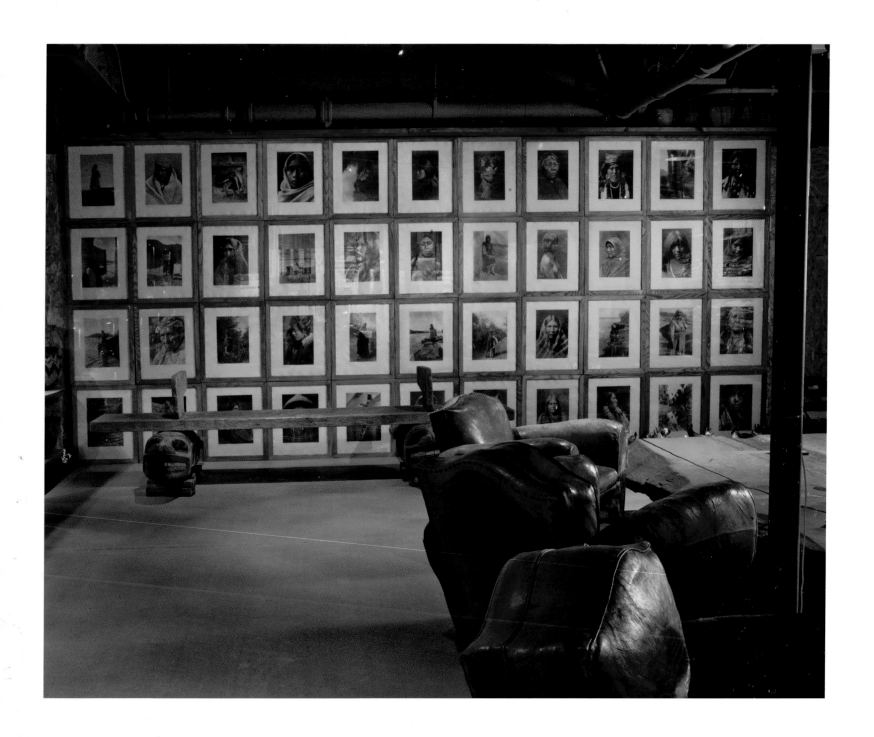

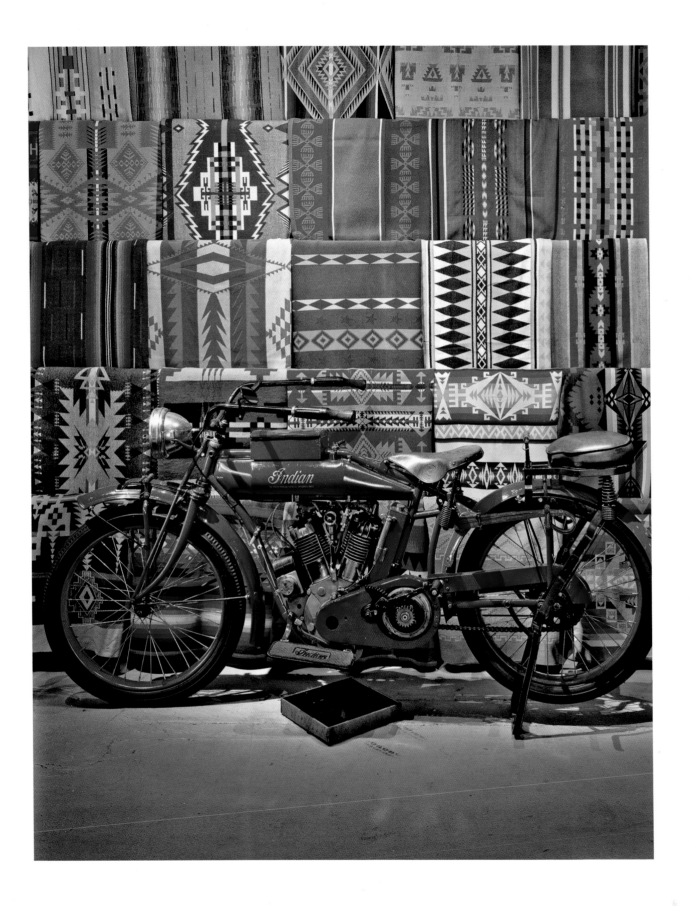

(previous pages)
Northwest Room
The Boathouse
Seattle, Washington, 2007

< Edward Curtis prints
Northwest Room, The Boathouse
Seattle, Washington, 2007

> Indian motorcycle with trade
blankets
Northwest Room, The Boathouse
Seattle, Washington, 2001

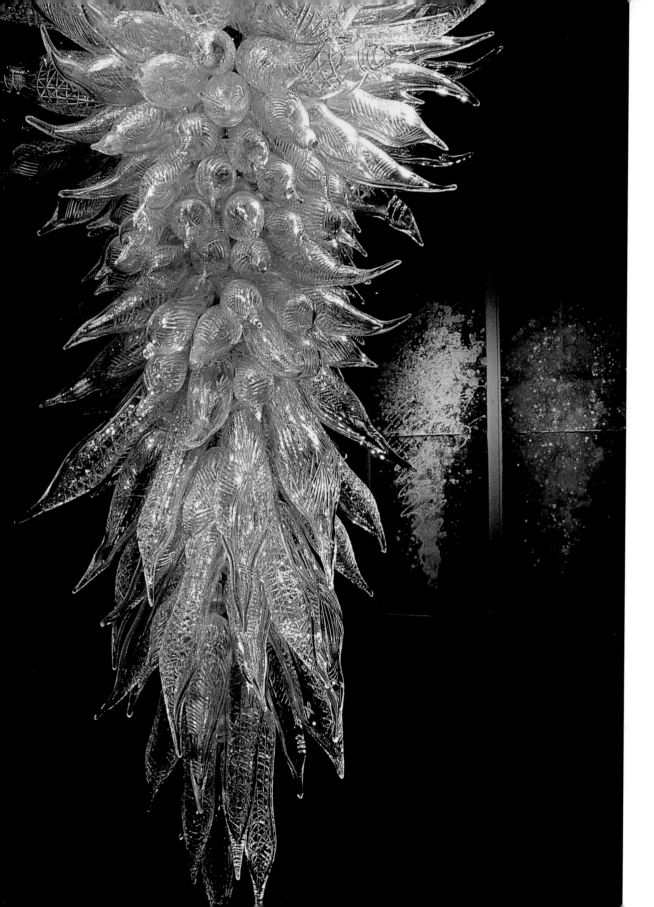

Waterford Crystal Chandelier
(detail)
Oklahoma City Museum of Art
Oklahoma City, Oklahoma,
2002
3.8 x 1.5 m (12½ x 5 ft.)

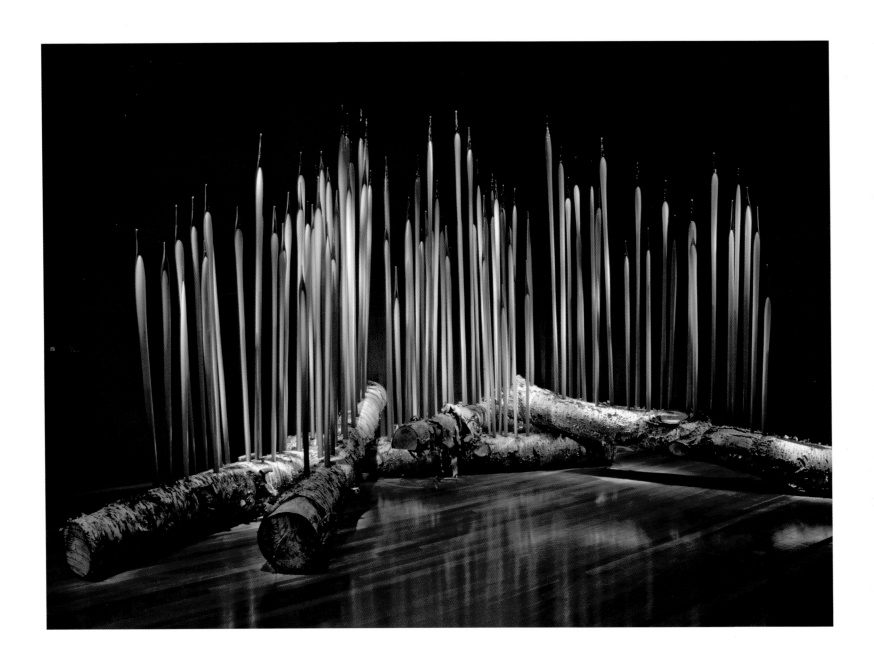

Neodymium Reeds
de Young Museum
San Francisco, California, 2008

THEATRICAL SPACES

the story of *Pelléas et Mélisande* allowed my imagination to go in many directions, and the ambiguity of the opera gave me great freedom. I began to envision immense glass forms on a black glass stage. A giant glass flower—the garden. A red tube—Golaud's broken heart. A pile of yellow glass—Mélisande's hair that was "longer than she." I wanted to suggest the essence of each scene in a way that was far more visual, visceral, intuitive than conceptual.

Chihuly's stage set for Bartók's
opera *Bluebeard's Castle*
Seattle Symphony production
Seattle, Washington, 2007

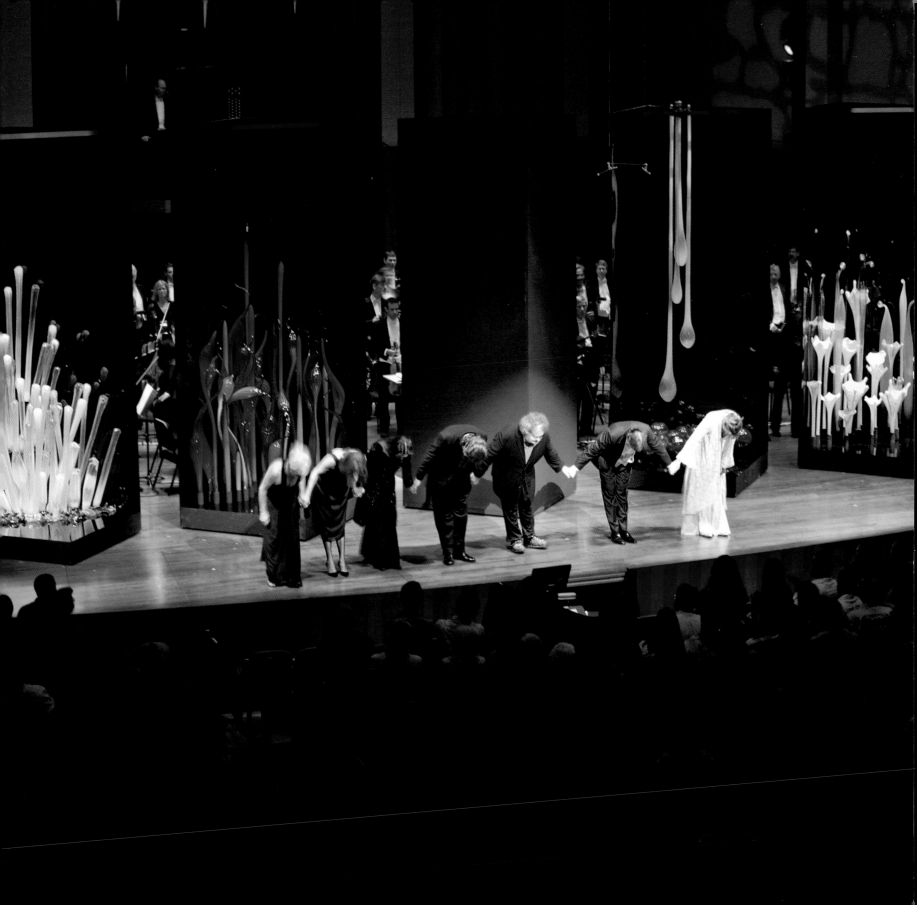

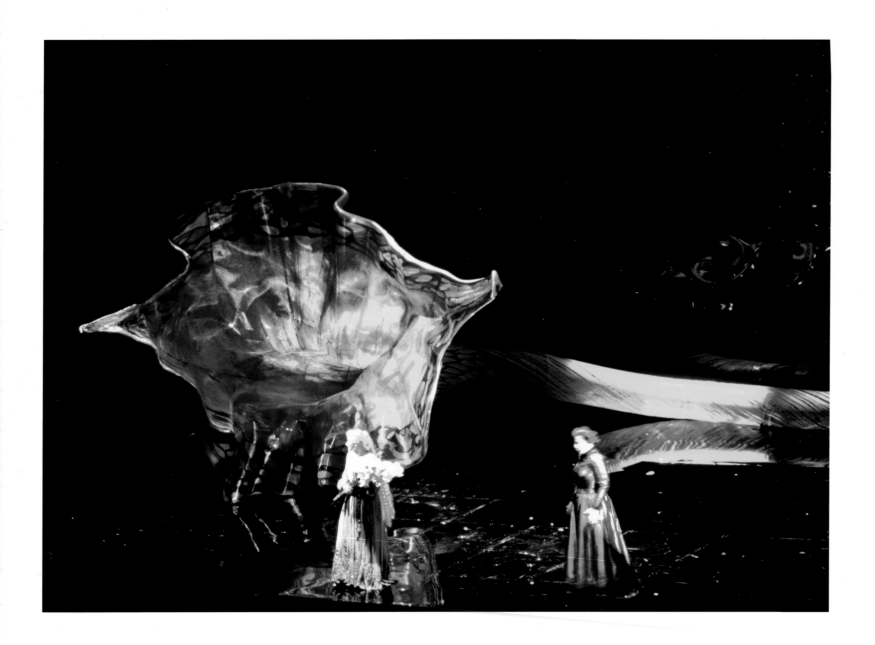

Before the Castle
Chihuly's stage set for Debussy's
opera *Pelléas et Mélisande*, act 1,
scene 3
Seattle Opera production
Seattle, Washington, 1993

A Room in the Castle
Chihuly's stage set for
Debussy's opera *Pelléas et
Mélisande*, act 1, scene 2
Seattle Opera production
Seattle, Washington, 1993

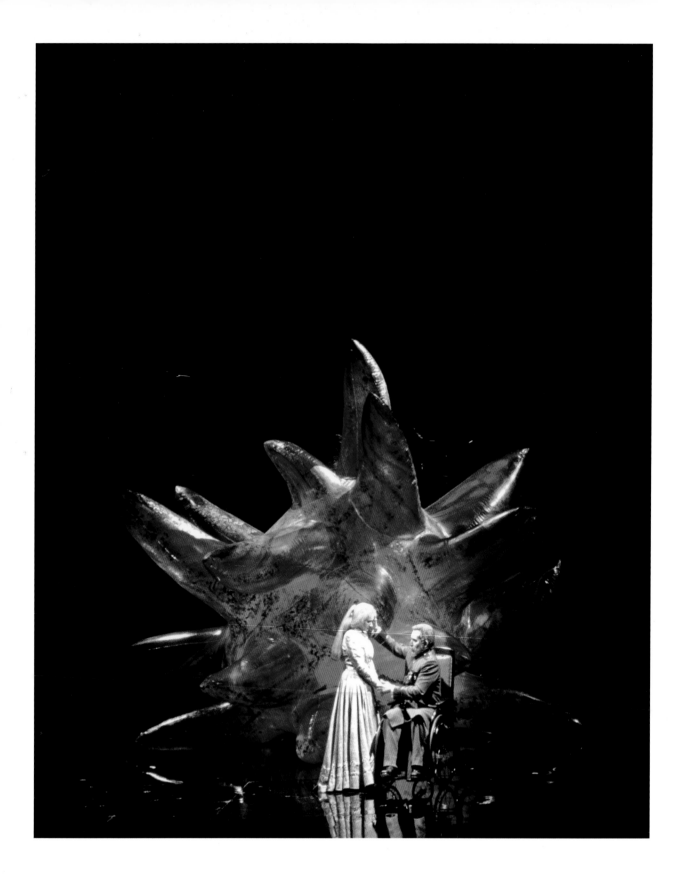

A Room in the Castle
Chihuly's stage set for
Debussy's opera *Pelléas et
Mélisande*, act 4, scene 1
Seattle Opera production
Seattle, Washington, 1993

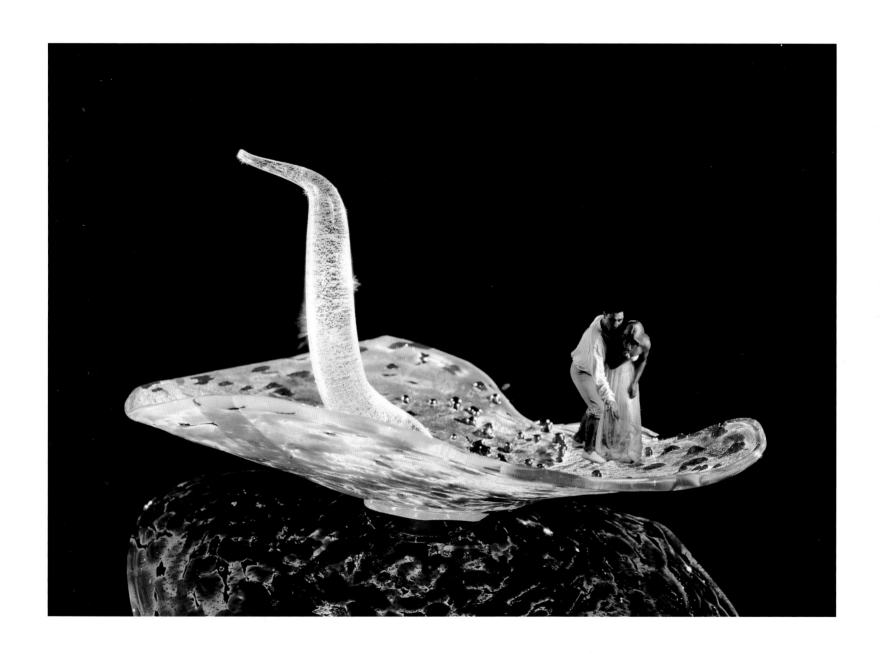

A Well in the Park
Chihuly's stage set for Debussy's
opera *Pelléas et Mélisande*, act 2,
scene 1
Seattle Opera production
Seattle, Washington, 1993

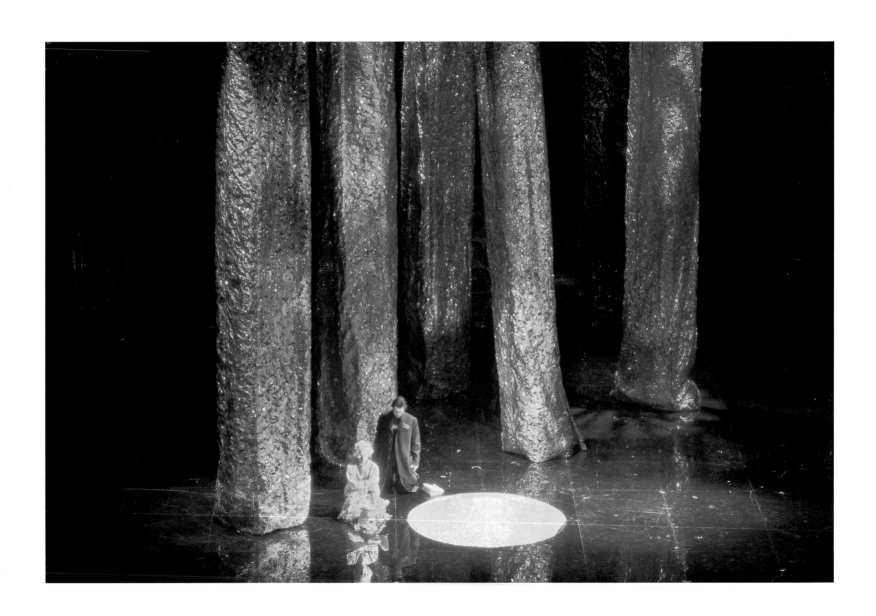

The Forest
Chihuly's stage set for
Debussy's opera *Pelléas et
Mélisande*, act 1, scene 1
Seattle Opera production
Seattle, Washington, 1993

NOTES

Chihuly: Through the Looking Glass

Quotation on p. 25 from Dale Chihuly, "On the Road," in *Chihuly: Color, Glass, and Form*, by Dale Chihuly, Karen Chambers, and Michael W. Monroe, with a foreword by Henry Geldzahler (New York: Kodansha International, 1986).

Quotations on pp. 28 and 33 from Dale Chihuly, *Chihuly: 365 Days* (New York: Abrams, 2008), 33, 164.

Quotation on p. 38 from Dale Chihuly, "Kitchen Sessions," interview by Mark McDonnell, March 1, 1998, typescript, Chihuly Studio Archives, Seattle.

Quotation on p. 41 is Dale Chihuly quoted in Jeff Davis, "Glass Master," *St. Louis Dispatch*, July 16, 1996.

1. Mark Rosenthal, *Understanding Installation Art from Duchamp to Holzer* (New York: Prestel, 2003), 26–27.

2. Dale Chihuly, interview by Richard Gerstman and Herb Meyers, 2006, typescript, Chihuly Studio Archives, Seattle.

3. William Morris, who worked with Chihuly for many years, perhaps comes the closest with some of his works.

4. Dale Chihuly, "Kitchen Sessions," interview by Mark McDonnell, March 1, 1998, typescript, Chihuly Studio Archives, Seattle.

5. Chihuly, "Kitchen Sessions," March 1, 1998.

6. Chihuly, "Kitchen Sessions," March 5, 1998.

7. Chihuly, "Kitchen Sessions," March 1, 1998.

8. See Dale Chihuly, *Team Chihuly* (Seattle: Portland Press, 2007), for the names and photographs of these artisans.

9. Dale Chihuly, *Chihuly Bellagio* (Seattle: Portland Press, 2007), n.p.

10. See *Chihuly in the Hotshop*, DVD, directed by Peter West, liner notes by Matthew Kangas (Seattle: Portland Press, 2006). Most of the Chihuly DVDs lavish loving attention on the making of the glass, as the hot glass forms are manipulated on the end of the long pontil, all to the accompaniment of a lyrical musical score.

11. Davira Taragin, *Chihuly Cylinders* (Seattle: Portland Press, 2010), 4–13.

12. Taragin, *Chihuly Cylinders*, 4.

13. Davira Taragin, *Chihuly Macchia* (Seattle: Portland Press, 2010), 7–13.

14. Dale Chihuly quoted in Dale Chihuly, Mark McDonnell, Lisa C. Roberts, and Barbara Rose, *Gardens and Glass* (Seattle: Portland Press, 2002), 154, 156.

15. Chihuly, "Kitchen Sessions," March 15, 1998.

16. Dale Chihuly, *Chihuly: 365 Days* (New York: Abrams, 2008), 52.

17. See Edward Lucie-Smith, *The Story of Craft: The Craftsman's Role in Society* (Ithaca, N.Y.: Cornell University Press, 1981), chapter 7, for a general discussion of the Renaissance manner of shop operation.

18. See Martin Eidelberg and Nancy A. McClelland, *Behind the Scenes of Tiffany Glassmaking: The Nash Notebooks* (New York: St. Martin's Press in association with Christie's Fine Arts Auctioneers, 2001), for a rather negative assessment of Tiffany's involvement in his own Favrile glass; and Martin Eidelberg, Nina Gray, and Margaret K. Hofer, *A New Light on Tiffany: Clara Driscoll and the Tiffany Girls* (London: New York Historical Society in association with D. Giles, Ltd., 2007), for the role of women artists in designing Tiffany's famous lamps.

19. Chihuly, "Kitchen Sessions," March 1, 1998.

20. Chihuly, *Chihuly: 365 Days*, 34.

21. The current Boathouse is the descendant of several earlier facilities that Chihuly created in Providence and Seattle; in characteristic Chihuly fashion, it remains a work in progress.

22. Chihuly, *Chihuly: 365 Days*, 166.

23. At one time he collected cars, but at this time he only retains two vintage sports cars that have personal meaning, displayed in the Boathouse in Seattle.

24. Dale Chihuly, "Dale Chihuly: Glassmaker," 1982 National Council on Education for the Ceramic Arts Conference slide presentation, *NCECA Journal 3*, no. 1 (1982): 49–52.

25. See Frances Larson, *An Infinity of Things: How Sir Henry Wellcome Collected the World* (New York: Oxford University Prtess, 2009).

26. Chihuly, *Chihuly: 365 Days*, 305.

27. See Nathan Kernan, "The Drawings of Dale Chihuly: Gesture as Image," in *Chihuly Drawing* (Seattle: Portland Press, 2002), 170–71.

28. These themes are explored in many publications; see, in particular, Dale Chihuly, "Collecting Trade Blankets" and "The Indian Influences Upon My Work," in *Chihuly's Pendletons and Their Influence on His Work*, by Dale Chihuly and Charles J. Lohrmann (Seattle: Portland Press, 2000), 9–13, 173–77; quotation from p. 177. Chihuly also loved Diné (Navajo) blankets, but could not afford them when he started collecting in the 1970s, and thus started (and has stayed) with the less-expensive blankets made for trade by Pendleton and many other firms. His collection includes hundreds of examples.

29. Barbara Rose, *Chihuly Black* (Seattle: Portland Press, 2008), 21–37, 53–69.

30. Chihuly, interview by Gerstman and Meyers.

31. See John W. Smith, ed., *Possession Obsession: Andy Warhol and Collecting* (Pittsburgh, Pa.: Andy Warhol Museum, 2002).

32. See, for example, Chihuly, interview by Gertsman and Meyers, in which Chihuly comments on Warhol's "lasting impression" on him.

33. Mihalyi Csikszentmihalyi and Eugene Rochberg-Halton, *The Meaning of Things: Domestic Symbols and the Self* (Cambridge: Cambridge University Press, 1981), 230–32; see also 28–29.

34. Thomas Hoving, "Reflections on Dale Chihuly," in *Chihuly Fire and Light*, book and DVD (Seattle: Portland Press, 2010), 17.

35. A Chihuly *Macchia* vessel was referenced in an episode of the Seattle-based sitcom *Frasier*, according to many sites on the Internet. I am grateful to Patrick McMahon for bringing this nugget to my attention.

36. Tina Oldknow, *Pilchuck: A Glass School* (Seattle: Pilchuck Glass School in association with the University of Washington Press, 1996).

37. David Pye, *The Nature and Art of Workmanship* (Cambridge: Cambridge University Press, 1968).

38. Jo Lauria, Steve Fenton, et al., *Craft in America: Celebrating Two Centuries of Artists and Objects* (New York: Clarkson Potter, 2007), 216.

39. Glenn Adamson, *Thinking Through Craft* (New York: Berg, 2007), 65–67.

40. Janet Koplos and Bruce Metcalf, *Makers: A History of American Studio Craft*, a project of the Center for Craft, Creativity, and Design, Hendersonville, North Carolina (Durham: University of North Carolina Press, 2010), 411.

41. Chihuly recognized early on that works of art command higher prices than works of craft, and took care to sell through art galleries (including Cowles and Marlborough) and to position his work in the marketplace as art. This strategy has proven successful in many respects.

43. See Martha Drexler Lynn, *Sculpture, Glass, and American Museums* (Philadelphia: University of Pennsylvania Press, 2005), 25–26.

44. Chihuly, *Chihuly: 365 Days*, 73.

45. Chihuly, *Chihuly: 365 Days*, 44.

Chihuly at the Museum of Fine Arts, Boston

Quotation on p. 45 from Dale Chihuly, "Kitchen Sessions," interview by Mark McDonnell, March 1, 1998, typescript, Chihuly Studio Archives, Seattle.

1. Davira Taragin, *Chihuly Persians* (Seattle: Portland Press, 2010) provides a well-illustrated introduction to the series and is accompanied by a DVD. See also Henry Geldzahler, *Chihuly Persians* (Bridgehampton, N.Y.: Dia Art Foundation, 1988), for an early appraisal of the series, and Tina Oldknow, *Chihuly Persians* (Seattle: Portland Press, 1996), which is especially strong in linking Chihuly's *Persians* to their historical antecedents in Islamic and Venetian glass. Some recent *Persians* are featured in Dale Chihuly, *Chihuly 2010* (New York: Marlborough Chelsea Gallery, 2010).

2. Illustrated in Taragin, *Chihuly Persians*.

3. For an illustrated treatment, see Dale Chihuly, *Chihuly Bellagio*, book and DVD (Seattle: Portland Press, 2007).

4. See Davira Taragin, *Chihuly Venetians*, book and DVD (Seattle: Portland Press, 2010), 7. See also Ron Glowen, *Venetians: Dale Chihuly*, 2d ed. (Seattle: Portland Press, 1999). The importance of drawings to the *Venetian* series is also discussed in Nathan Kernan, "The Drawings of Dale Chihuly: Gesture as Image," in *Chihuly Drawing* (Seattle: Portland Press, 2003), 166–67.

5. See Thomas Hoving, *Chihuly Fire and Light*, book and DVD (Seattle: Portland Press, 2010), 30–39, for a representative installation. More than one hundred *Venetians* are also displayed in pigeonholes along the *Chihuly Bridge of Glass*, completed in 2002, in Tacoma. For an illustration, see Taragin, *Chihuly Venetians*, 13.

6. Taragin, *Chihuly Venetians*, 8. These include the smaller *Piccolo Venetians* and, more recently versions in black glass and silvered glass. See also Davira Taragin, *Chihuly Putti*, book and DVD (Seattle: Portland Press, 2010).

7. Taragin, *Chihuly Venetians*, 11–12.

8. See Davira Taragin, *Chihuly Ikebana*, book and DVD (Seattle: Portland Press, 2010).

9. See Davira Taragin, *Chihuly Chandeliers and Towers*, book and DVD (Seattle: Portland Press, 2009) for an overview. See also Patterson Sims, *Dale Chihuly: Installations, 1964–1992* (Seattle: Seattle Art Museum, 1992).

10. See Dale Chihuly and Harriet Bullitt, *Dale Chihuly Icicles: The Icicle Creek Chandelier. An Outdoor Glass Installation at Sleeping Lady Retreat and Conference Center in Leavenworth, Washington* (Seattle: Portland Press, 1998) .

11. See Dana Self and William Warmus, *Chihuly over Venice* (Seattle: Portland Press, 1996).

12. Taragin, *Chihuly Chandeliers and Towers*, 4.

13. Margery Aronson, *Fire: Dale Chihuly* (Seattle: Portland Press, 2006), 118. Examples of *Reeds* are illustrated on pp. 119–23.

14. Dale Chihuly and Shosh Yaniv, *Chihuly Jerusalem 2000* (Seattle: Portland Press, 2000), 34–41 (*Red Spears*, Finland and France), 52–57 (*Green Grass*, Czech Republic), 126–33 (*Yellow Spears*, France).

15. Thomas Hoving, "Reflections on Dale Chihuly," in *Chihuly Fire and Light*, 14.

16. See Davira Taragin, *Chihuly Mille Fiori*, book and DVD (Seattle: Portland Press, 2010). Taragin notes that the Chihuly Studio defines the *Mille Fiori* series as "primarily post-2003 clusters of different plantlike forms, including *Pods*, that are assembled on small, standardized bases like window boxes or as orchestrated gardens on platforms ranging up to fifty-six feet [seventeen meters] in length" (7).

17. Hoving, "Reflections on Dale Chihuly," 14. Representative *Boat* installations are illustrated in Aronson, *Fire: Dale Chihuly*, 154–57, and the de Young examples in Hoving, *Chihuly Fire and Light*, 68–75.

18. Hoving, "Reflections on Dale Chihuly," 13. See also Davira Taragin's *Chihuly Baskets* (Seattle: Portland Press, 2009) and *Chihuly Cylinders* (Seattle: Portland Press, 2010), each with accompanying DVD, and Dale Chihuly and Charles J. Lohrmann, *Chihuly's Pendletons and Their Influence on His Work* (Seattle: Portland Press, 2000).

19. Paul Bloom, *How Pleasure Works: The New Science of Why We Like What We Like* (New York: W.W. Norton, 2010), 129–37.

Spaces in Nature

Quotation on p. 52 from Dale Chihuly, *Chihuly: 365 Days* (New York: Abrams, 2008), 75.

Spaces In Situ

Quotation on p. 74 from Dale Chihuly, *Chihuly: 365 Days* (New York: Abrams, 2008), 178, 195.

Architectural Spaces

Quotation on p. 96 from Dale Chihuly, *Chihuly: 365 Days* (New York: Abrams, 2008), 138.

Exhibition Spaces

Quotation on p. 114 from Dale Chihuly, *Chihuly: 365 Days* (New York: Abrams, 2008), 244.

Theatrical Spaces

Quotation on p. 138 from Dale Chihuly, *Chihuly: 365 Days* (New York: Abrams, 2008), 61.

SELECTED BIBLIOGRAPHY

Chihuly's works and installations

Many of Chihuly's installations are covered in detail in two principal overviews: the early years are examined and catalogued in Sims, *Dale Chihuly: Installations, 1964–1992*, which is especially useful, and the later years in Chihuly, Rose, and Lanzone, *Chihuly Projects*. Monographs on Chihuly's major individual projects are included below. Burgard's *The Art of Dale Chihuly* contains the most succinct and cogent biography of Chihuly. For the most up-to-date and comprehensive information about Chihuly and his work, see Chihuly's Web site at http://www.chihuly.com. The Chihuly Studio Archives in Seattle are a rich source of primary materials.

Alden, Todd, et al. *Chihuly at the Royal Botanic Gardens, Kew.* Seattle: Portland Press, 2005. Book and DVD.

Aronson, Margery. *Fire: Dale Chihuly.* Seattle: Portland Press, 2006.

Bannard, Walter Darby, and Henry Geldzahler. *Chihuly: Form from Fire.* Daytona Beach, Fla.: Museum of Arts and Sciences in association with University of Washington Press, 1993.

Blake, William. *Chihuly Mercurio.* Seattle: Traver Gallery, 2009.

Burgard, Timothy Anglin. *The Art of Dale Chihuly.* San Francisco: Chronicle Books and the Fine Arts Museums of San Francisco, 2008.

Chihuly, Dale. *Chihuly Bellagio.* Seattle: Portland Press, 2007. Book and DVD.

———. *Chihuly Jerusalem Cylinders.* Seattle: Portland Press, 1999.

———. *Team Chihuly.* Seattle: Portland Press, 2007.

———. *Chihuly: 365 Days.* New York: Abrams, 2008.

Chihuly, Dale, and Harriet Bullitt. *Dale Chihuly Icicles: The Icicle Creek Chandelier. An Outdoor Glass Installation at Sleeping Lady Retreat and Conference Center in Leavenworth, Washington.* Seattle: Portland Press, 1998.

Chihuly, Dale, and Ron Glowen. *Venetians: Dale Chihuly.* 2d ed. Seattle: Portland Press, 1999.

Chihuly, Dale, and Nathan Kernan. *Chihuly Drawing.* Seattle: Portland Press, 2003.

Chihuly, Dale, and Charles J. Lohrmann. *Chihuly's Pendletons and Their Influence on His Work.* Seattle: Portland Press, 2000.

Chihuly, Dale, Barbara Rose, and Dale Lanzone. *Chihuly Projects.* Seattle: Portland Press, 2000. Distributed by Harry N. Abrams, New York.

Chihuly, Dale, and Shosh Yaniv. *Chihuly Jerusalem 2000.* Seattle: Portland Press, 2000.

Dale Chihuly: New Work. New York: Marlborough Gallery, 2006. Includes a section on Chihuly at the New York Botanical Garden, June 24–October 29, 2006.

Earle, Sylvia, and Joan Seeman Robinson *Chihuly Seaforms.* Seattle: Portland Press, 1995.

Geldzahler, Henry. *Chihuly Persians.* Bridgehampton, N.Y.: Dia Art Foundation, 1988.

Hobbs, Robert. *Chihuly alla Macchia from the George R. Stroemple Collection.* Beaumont: Art Museum of Southeast Texas, 1993.

Hoving, Thomas. *Chihuly Fire and Light.* Seattle: Portland Press, 2010. Includes a chronology. Book and DVD.

Kuspit, Donald B., with an introduction by Jack Cowart. *Chihuly.* 2d rev. ed. Seattle: Portland Press, 1998. Distributed by Harry N. Abrams, New York.

Kuspit, Donald B., and Kathryn Kanjo. *Chihuly: The George R. Stroemple Collection.* Portland, Ore.: Portland Art Museum, 1997.

New, Lloyd Kiva. *Chihuly Taos Pueblo.* Seattle: Portland Press, 1999.

Norden, Linda, and Murray Morgan. *Chihuly Baskets.* Seattle: Portland Press, 1994.

Oldknow, Tina. *Chihuly Persians.* Seattle: Portland Press, 1996.

Opie, Jennifer Hawkins, ed. With essays by Jennifer Hawkins Opie, Reino Liefkes, and Dan Klein. *Chihuly at the V&A.* London: V&A Publications in association with Portland Press, 2001.

Rose, Barbara. *Chihuly Black.* Seattle: Portland Press, 2008.

Rose, Barbara, Lisa C. Roberts, and Mark McDonnell. *Chihuly Gardens and Glass.* Seattle: Portland Press, 2002. Book and DVD.

Self, Dana, and William Warmus. *Chihuly over Venice.* Seattle: Portland Press, 1996.

Sims, Patterson. *Dale Chihuly: Installations, 1964–1992.* Seattle: Seattle Art Museum, 1992.

Taragin, Davira. *Chihuly Baskets.* Seattle: Portland Press, 2009. Includes a chronology. Book and DVD.

———. *Chihuly Chandeliers and Towers.* Seattle: Portland Press, 2009. Includes a chronology. Book and DVD.

———. *Chihuly Cylinders.* Seattle: Portland Press, 2010. Includes a chronology. Book and DVD.

———. *Chihuly Ikebana.* Seattle: Portland Press, 2010. Includes a chronology. Book and DVD.

———. *Chihuly Macchia.* Seattle: Portland Press, 2010. Includes a chronology. Book and DVD.

———. *Chihuly Mille Fiori.* Seattle: Portland Press, 2010. Includes a chronology. Book and DVD.

———. *Chihuly Persians.* Seattle: Portland Press, 2010. Includes a chronology. Book and DVD.

———. *Chihuly Putti.* Seattle: Portland Press, 2009. Includes a chronology. Book and DVD.

———. *Chihuly Seaforms.* Seattle: Portland Press, 2010. Includes a chronology. Book and DVD.

———. *Chihuly Venetians.* Seattle: Portland Press, 2010. Includes a chronology. Book and DVD.

Tuchman, Phyllis. *Chihuly Marlborough.* New York: Marlborough Gallery, 2001.

Warmus, William. *Chihuly in the Light of Jerusalem.* Seattle: Portland Press, 1999.

———. *The Essential Dale Chihuly.* Kansas City, Mo.: Andrews McMeel, 2000.

Contemporary glass and installation art

Many works deal with installation art. Three that are especially helpful are De Oliveira, Oxley, Perry, and Archer, *Installation Art*; Bishop, *Installation Art: A Critical History*; and De Oliveira, *Installation Art in the New Millennium: The Empire of the Senses*. For an overview of installations and architectural work by many international artists from 1980 to 2004, see Oldknow, *Twenty-five Years of New Glass Review*, 157–208, and some related images in the "Sculpture" section (59–124).

Bishop, Claire. *Installation Art: A Critical History*. New York: Routledge, 2005.

De Oliveira, Nicolas. *Installation Art in the New Millennium: The Empire of the Senses*. New York: Thames and Hudson, 2003.

De Oliveira, Nicolas, Nicola Oxley, Michael Perry, and Michael Archer. *Installation Art*. Washington, D.C.: Smithsonian Institution Press, 1994.

Diaz de Santillana, Anna Venini. *Venini: Catalogue Raisonné*. Milan: Skira, 2000.

Fairbanks, Jonathan L., Pat Warner, et al. *Glass Today by American Studio Artists*. Boston: Museum of Fine Arts, 1997.

Fox, Howard N., and Sarah Nichols. *Glass: Material Matters*. Los Angeles: Los Angeles County Museum of Art, 2006.

Frantz, Susanne K. *Contemporary Glass: A World Survey from the Corning Museum of Glass*. New York: Harry N. Abrams, 1989.

Frantz, Susanne K., and Matthew Kangas. *Viva Vitro! Glass Alive! Venice and America*. Pittsburgh, Pa.: Carnegie Museum of Art, 2007.

Klein, Dan. *Artists in Glass: Late Twentieth Century Masters in Glass*. London: Mitchell Beazley, 2001.

———. *Glass: A Contemporary Art*. New York: Rizzoli, 1989.

Koplos, Janet, and Bruce Metcalf. *Makers: A History of American Studio Craft*. A Project of the Center for Craft, Creativity, and Design, Hendersonville, North Carolina. Durham: University of North Carolina Press, 2010.

Lauria, Jo, Steve Fenton, et al. *Craft in America: Celebrating Two Centuries of Artists and Objects.* New York: Clarkson Potter, 2007.

Layton, Peter. *Glass Art*. London: A & C Black; Seattle: University of Washington Press, 1996.

Lucie-Smith, Edward. *The Story of Craft: The Craftsman's Role in Society*. Ithaca, N.Y.: Cornell University Press, 1981.

Lynn, Martha Drexler. *Sculpture, Glass, and American Museums*. Philadelphia: University of Pennsylvania Press, 2005.

Oldknow, Tina. *Pilchuck: A Glass School*. Seattle: Pilchuck Glass School in association with the University of Washington Press, 1996.

———. *Twenty-five Years of New Glass Review*. Corning, N.Y.: Corning Museum of Glass, 2005.

Oldknow, Tina, with a contribution by Cristine Russell. *Voices of Contemporary Glass: The Heineman Collection*. Corning, N.Y.: Corning Museum of Glass in association with Hudson Hills Press, 2009.

Rosenthal, Mark. *Understanding Installation Art from Duchamp to Holzer*. New York: Prestel, 2003.

DVDs

More than fifty videos, many documenting Chihuly's installations, can be accessed on Chihuly's Web site; others can be obtained on DVD through Portland Press. See also the DVDs accompanying some publications.

Chihuly in the Hotshop. DVD. Directed by Peter West. Liner notes by Matthew Kangas. Seattle: Portland Press, 2008.

Chihuly and the Masters of Venice. DVD. Directed by Peter West, Ken Samuelson, and Michael McCallum. Seattle: Portland Press, 2001.

Chihuly at the Royal Botanic Gardens, Kew. DVD. Directed by Peter West. Seattle: Portland Press, 2006.

Chihuly at the V&A. DVD. Directed by Peter West. Seattle: Portland Press, 2001.

Chihuly Gardens and Glass. DVD. Directed by Peter West. Seattle: Portland Press, 2003.

Chihuly in the Light of Jerusalem. DVD. Directed by Peter West. Seattle: Portland Press, 2000.

Chihuly River of Glass. DVD. Directed by Michael Barnard. Seattle: Portland Press, 2004.

Chihuly Short Cuts. DVD. Directed by Peter West, Michael Barnard, and Ken Samuelson. Seattle: Portland Press, 2004.

PHOTOGRAPHY CREDITS